Advance Praise for *Artistry Unleashed*

'In a world suffocating in data, *Artistry Unleashed* is a breath of fresh air. Hilary Austen shows how mastery in the arts depends on connoisseurship, judgment, and "feel." With captivating examples, she explores the powerful implications of these artistic facilities in business, education, and daily life. This book is an invigorating reflection on processes that are too often misunderstood and undervalued, but vital to success in every field.'

Sir Ken Robinson, educator; *New York Times* bestselling author of *The Element: How Finding Your Passion Changes Everything*

'*We're all artists now.* That's the urgent aspiration at the heart of this provocative, rigorous, and profoundly important exploration of work *as* art. This is not a liberal arts extracurricular. It goes right to the heart of the most vital ambitions of leaders today. How do we redefine what it means to win? Can we create organizations as human as the human beings within them? And how do we wake ourselves up to exercise our best gifts in the world? *Artistry Unleashed* is an absorbing and insightful guide through the thicket of those crucial questions.'

Polly LaBarre, co-author of *Mavericks at Work*, editorial director, Management Innovation eXchange

'Here is the big idea: The new MBA is an MFA. *Artistry Unleashed* could be the most important business book you'll ever read. It will open your eyes and your mind to a new way of seeing and thinking.'

Alan M. Webber, co-founder, *Fast Company* magazine and author of *Rules of Thumb: 52 Truths for Winning at Business without Losing Your Self*

'No one ever marveled at the "science of leadership"; great leadership is about developing great judgment. Hilary Austen's brilliant book helped me to see that it is the "art of leadership" that will lead in the twenty-first century.'

Chip Conley, founder, Joie de Vivre Hospitality; author of *PEAK: How Great Companies Get Their Mojo from Maslow*

'When artists create art, it is usually perceived as a kind of sorcery that a more left-brained person might appreciate, dismissing their own ability to make the same kind of magic. To remedy this divide, Austen has produced an elegant volume that connects the quantitative world of business with the qualitative world of artists. Not the usual "7 Secrets of a Leader" you'd normally find in

the business section, this book provides important new tools in an incredibly digestible form.'

John Maeda, President, Rhode Island School of Design

'One sign of mastery in any realm – whether it be jazz, painting, or negotiation – is the ability for successful, artistic improvisation. Austen has captured brilliantly what is involved in such mastery, in a way that lays out a clear road map for how to pursue and accelerate its development. A must-read for every reflective practitioner of anything.'

Bruce Patton, co-founder, Harvard Negotiation Project; co-author of the bestselling *Getting to Yes: Negotiating Agreement without Giving In*

'Hilary Austen has written a gem of a book on bringing artistry to business. If not a "must-read," it's certainly a "should-read" for businesses to learn how to compete in today's marketplace.'

Ellen Langer, author of *Mindfulness* and *On Becoming an Artist*

'This is a great book that provides as much insight to those familiar with artistry as it does to those who are new to the concept. So many of us pursue our passions outside of our work. Here is an argument for bringing artistry back to work. It certainly helps me think about how I develop my own ideas.'

Tim Brown, CEO and President of IDEO; author of *Change by Design*

'*Artistry Unleashed* makes a compelling case for the role of artistry in our lives – from how we work to how we live. Clear, entertaining, and eminently readable, Austen's book belongs on the bedside table of anyone engaged in creative work, but also of anyone interested in bringing artistry into unexpected parts of their lives.'

Richard Florida, author of *The Rise of the Creative Class* and *Who's Your City?*

'Artistry in business? At first glance an odd, even uncomfortable, pairing of concepts, but Austen shows us how it's done. She unpacks the experience of artistry and gives us an insightful glimpse into how a diverse group of accomplished practitioners simultaneously produce excellence and fulfillment at work.'

Amy C. Edmondson, Novartis Professor of Leadership and Management, Harvard Business School

'Don't just read this book, use it. Now that capturing and transferring the capabilities of our most experienced, skillful, and innovative people are

critical, this book delivers. It will radically change how we learn within organizations.'

<div align="right">Bill Underwood, Director of Organizational
Development, Granite Construction</div>

'We all know there's something more to life and to work than what our analytic, quantitative way of thinking tells us – this way of thinking fails to address the messy side of life, our best laid plans fail, and our most rigorous judgments turn out to be mistakes. But we lack what Austen offers: a language for talking about qualities and a conceptual map for developing the ability to think collectively and systematically in more qualitative terms. For those of us who aspire to excellence outside the arts, it is a godsend.'

<div align="right">Diana McLain Smith, author of Divide or Conquer</div>

'Faced every day with difficult, often unexpected challenges, it is now clear that we need a different, deeper mode of thinking. In her book, Austen provides a path to this deeper thinking she calls "qualitative intelligence." Bridging art and complex decision-making, Austen inspires everyone to venture beyond traditional analytics.'

<div align="right">Steve Luczo, CEO and Chairman of the Board, Seagate Technologies</div>

'Taking the head-scratching out of the path to masterful execution must have been a monstrous endeavor and its completion is to be applauded. *Artistry Unleashed* is a well-structured road map to achieving artistry, regardless of the field. A must-read for the student with big dreams, and the teachers who drive them.'

<div align="right">Dr. Stephanie Burns, adult learning specialist, Sydney, Australia</div>

HILARY AUSTEN

Artistry Unleashed

A Guide to Pursuing Great Performance in Work and Life

UNIVERSITY OF TORONTO PRESS
Toronto Buffalo London

© University of Toronto Press Incorporated 2010
Rotman/UTP Publishing
Toronto Buffalo London
www.utppublishing.com
Printed in Canada

ISBN 978-1-4426-4130-3

Printed on acid-free, 100% post-consumer recycled paper
with vegetable-based inks.

Library and Archives Canada Cataloguing in Publication

Austen, Hilary
Artistry unleashed : a guide to pursuing great performance in work
and life / Hilary Austen ; foreword by Roger Martin.

Includes bibliographical references and index.
ISBN 978-1-4426-4130-3

1. Creative ability in business. I. Title.

HD53.A975 2010 650.1 C2010-904480-0

University of Toronto Press acknowledges the financial assistance to its
publishing program of the Canada Council for the Arts and the Ontario
Arts Council.

 Canada Council Conseil des Arts ONTARIO ARTS COUNCIL
for the Arts du Canada CONSEIL DES ARTS DE L'ONTARIO

University of Toronto Press acknowledges the financial support for its
publishing activities of the Government of Canada through the Canada
Book Fund.

To Jack,
the guy who is and will be holding my hand
all the way to the end of road

CONTENTS

FOREWORD

ROGER MARTIN
Dean, Rotman School of Management

The kinds of nets we know how to weave determine the kinds of nets we cast.
These nets, in turn, determine the kinds of fish we catch.

Elliot Eisner, *Cognition and Curriculum*[1]

We live in a world preoccupied with science, predictability, and quantitative analysis. Economic forecasters crank out precise predictions of economic growth using massive econometric models. CEOs give to-the-penny guidance to capital markets on next quarter's predicted earnings. Market researchers analyze reams of consumer data to predict what we will buy and how much we'll pay for it. Geneticists sequence the whole of the human genome, predicting the knowledge gained will lead to the elimination of numerous diseases. We live by adages like 'Show me the numbers' and 'If you can't count it, it doesn't count.'

Where has this obsession gotten us? Not far, I would argue. The slaves to the quantitative world have gotten it consistently wrong. Take the economists: As late as the middle of 2008, none of the world's leading macroeconomists or forecasting organizations were predicting that the economy would shrink that year, let alone crater as disastrously as it did. But undaunted, the same economists who totally missed the recession turned back to the same quantitative, scientific models to predict how the economy would recover. Likewise, CEOs continue to give quarterly guidance based on sophisticated financial planning systems and continue to be wrong – getting slammed not for bad performance but for failing to predict exact performance in advance. Products and businesses that extensive market testing showed to be sure-fire hits have failed again and again in the marketplace. And as for the human

genome, it turned out that the entire project raised more questions about the complicated interaction among genes than it answered about what each gene meant.

Our deep-seated desire to quantify the world is not surprising: given the complexity we face on a regular basis, we naturally seek ways to understand and control whatever we can. But, as is painfully apparent, the world isn't responding well to our attempts. Instead, it is making it clear that it refuses to be organized, understood, and controlled in a purely quantitative fashion. Our complex world is not unlike a spirited racehorse: the harder we tug on the reins to control it, the more it resists the bit to prove a point. It is not a machine that responds the way a user manual suggests it will; rather, our world is an intensely complicated, ambiguous system of systems that defies comprehensive quantification.

All of this is not to dismiss the strengths of the quantitative paradigm: when used in a suitable context, its methods produce reliable data. However, the paradigm breaks down when the phenomenon under study is complex and ambiguous. The greatest weakness of the quantitative approach is that it takes the context out of human behavior, removing an event from its real-world setting and ignoring the effects of variables not included in the model.

As Elliot Eisner so aptly put it: the nets we know how to weave determine which fish we're likely to catch.

It would be lovely if, when predicting gross domestic product (GDP), we could simply add up all existing loans to determine 'credit outstanding' and then plug those quantities into an economic model. But it isn't that easy. Unfortunately, not all loans are the same, and some – like 2008's subprime mortgages – aren't worth the proverbial paper they're written on. It would be wonderful if, when trying to predict next quarter's sales, we could simply extrapolate from last month's sales. But it may well turn out that those sales aren't as solid a base for growth as we'd hope, especially if the customer relationships underpinning them are weak. It would be far easier if, when projecting consumer behavior, we could rely on what customers say they will do, or what they have done in the past, to determine what they will actually do in the future. But all too often we cannot. And it would have been fantastic if, after the genome was sequenced, scientists could have said, 'This particular gene causes lymphoma and this one causes Alzheimer's.' But it didn't turn out that way.

The fundamental shortcoming is that all of these scientific methods

depended entirely on *quantities* to produce the answer they were meant to generate. They were all blissfully ignorant of *qualities*. Hilary Austen, author of this important book, describes the difference between qualities and quantities:

> Qualities cannot be objectively measured, as a quantity like temperature can be measured with a thermometer. We can count the number of people in a room, but that tells us little about the mood – upbeat, flat, intense, contentious – of the group's interaction.[2]

Why are qualities so important? Because to make sense of an ambiguous and uncertain world, understanding, measuring, modeling, and manipulating quantities just won't cut it. Adding up the quantity of credit outstanding won't tell us nearly enough about the role it will play in our economy. Adding up sales won't tell us what kind of a company we really have. Totting up responses to consumer surveys won't capture the complexity of buyer behavior. Enumerating genes won't cure diseases. We need to have a much deeper understanding of their qualities – the ambiguous, hard-to-measure aspects of all of these features. To do so, we need to supplement the quantitative techniques brought to us by the march of science with the artistic understanding of and facility with qualities that have been brushed aside.

But gaining a better understanding of qualities is a real challenge, given the sharp swing that our formal education system has taken toward quantitative thinking. To again quote Austen:

> In school, the sciences (and sometimes even the liberal arts) are routinely taught as perfect expressions of quantitative thinking. We're all exposed to basic mathematics, statistics, chemistry, and physics: subjects typically driven by quantitative, single-answer problem solving. These disciplines provide formulas that allow us to repeat our work predictably and reliably. Results on tests with right and wrong answers clearly rank us against other members of our class. Quantitative thinking allows us to be precise and to share understanding; we use it to define fairness and rationality and effectiveness. It's this utility that has led so many people to equate quantitative thinking with intelligence.[3]

The allure of defining intelligence as equivalent to quantitative thinking has led higher education to force millions of kids to take the SAT, ACT, GRE, MCAT, LSAT, or GMAT to earn their spots in university or

graduate school. Whether purportedly testing mathematics or English, these tests are dominantly assessments of single-answer problem solving. And despite their rather famous inability to predict anything about the likely life-performance of the test taker, these tests are sacrosanct. The prospective student tends to become a single-point, one-dimensional creature in the eyes of admissions departments – 'She is a 750 GMAT.' Note it is not 'She *scored* 750 on her GMAT' but 'She *is* a 750 GMAT.'

Unfortunately, that is just the beginning of this obsession for students. Typically, once the walls of higher education are breached, yet more quantitative tools, models, and methodologies are poured into the minds of our students, and more single-point-answer testing ensues to ensure that the quantitative toolbox provided to students is both usable and well used. As a result, the majority of students graduate capable of using their newly gained conceptual knowledge as a recipe or paint-by-numbers kit to produce analyses that tell them what is right and wrong, true or false. And if they happen to graduate in one of the so-called STEM fields (science, technology, engineering, or mathematics), the National Research Council (NRC) and the National Science Foundation (NSF) will jump for joy because these are the fields that they have declared to be of most importance to a country's competitiveness in the world.

The NRC and NSF may indeed be right that America is producing too few STEM graduates for its competitiveness – though there is (ironically) no particular quantitative evidence given to buttress the claim. And whenever comparisons are made, they compare the relative quantities of STEM graduates with little regard to their qualities – not surprisingly. But if indeed the challenges of the world are increasingly going to feature ambiguity, complexity, uniqueness, and indeterminacy, then that STEM training won't be the salvation. As education scholar Elliot Eisner points out: 'Not everything that matters can be measured, and not everything that can be measured matters.'

Austen posits that there is a different form of intelligence that needs to be built to handle the problems of the world, and that is qualitative intelligence:

> When you allow action to generate outcomes rather than use action to pursue pre-established goals; when you reason with sensory experience rather than with abstract symbols; when you act without hesitation with what you know, while courting the possibilities of surprise; and when you

use a combination of immediate and remembered experience to predict and then revise immediate action – these are the times when you're exercising qualitative intelligence.[4]

For Austen and others, including the late management scholar Don Schön, this qualitative intelligence is in fact synonymous with artistry and is at the very heart of excellence in complex professions. To Schön:

> The artistry of painters, sculptors, musicians, dancers and designers bears a strong family resemblance to the artistry of extraordinary lawyers, physicians, managers and teachers. It is no accident that professionals often refer to an 'art' of teaching or management and use the term artist to refer to practitioners unusually adept at handling situations of uncertainty, uniqueness and conflict.[5]

In Austen's view, the implications are serious: to deal with the holistic challenges of the modern world, rather than with narrow sub-segments, we need artistic capacity.

> In short, without the explicit development of qualitative thought that artistry demands, sophisticated mental operations like judgment, coping with ambiguity and uncertainty, balancing consequences, and responding effectively to surprise remain elusive.[6]

No matter what we do for a living, we need to be able to go beyond using our knowledge as a recipe and aim higher than crunching quantitative data to produce single-point answers.

To some, this may seem an extreme claim, and of course, there are many legitimate and conflicting views on the subject. Implicitly, institutions such as the NRC and NSF see the situation differently, and countless popular management books have been written exhorting business people to become even *more* analytical and quantitative in their approaches. But from my vantage point of business strategy and management education, I have become utterly convinced that we need to train and develop 'business artists' more than we need to develop business analysts.

While it has not always been a popular view, more and more business executives are seeing the shortcomings of a quantitatively obsessed world. In June of 2008, I interviewed Scott Cook, the cerebral billionaire founder of Intuit, onstage at a design conference in San Francisco. In

a very reflective mood, he freely admitted: 'What I learned about the old style of business – about analytic and deductive models – [is that] it's no longer up to the task. I find it destroying value, instead of creating value.' He was not disparaging his company's ability to crunch the numbers, but indicating that it just wasn't enough anymore: his people needed to observe more, to let themselves be surprised.

Cook shared the story of the origins of QuickBooks, the product that transformed his company and drove its tremendous growth. Prior to QuickBooks, Intuit's leading product was Quicken, a personal financial-management program. Early consumer research showed that half of Quicken users were using it not at home but at the office. It was a curious finding, one the company at first chose to explain away as meaningless or just plain wrong. 'We ignored it,' Cook says 'and continued on our merry way.'

But the same strange result kept showing up, and after a few years, Cook decided to stop ignoring it. He set out to investigate it, visiting and talking to users to figure out what was going on. His team discovered that there was indeed a large segment of customers using the product in ways Intuit had not intended. These were small businesses that chose to use the simple, friendly Quicken personal software instead of complex professional accounting software. Conventional wisdom was that these businesses wanted and needed traditional debit-and-credit accounting software – and so nothing else was available to them – until Quicken.

Faced with this new understanding, Intuit could have continued ahead as it had before, focusing on the home user and enjoying the additional boon of these office users. Instead, Cook chose to embrace the surprise. 'I'm a big believer in savoring surprises,' he explains. 'If there's something that's really a surprise – upside or downside – that's generally the real world speaking to you, saying there's something that you don't yet understand. And in that thing that you don't yet understand could come a major mindset change, a paradigm shift that could rock your world.' So it was for Intuit. It created a Quicken-like, easy-to-use financial-management software specifically targeted to the needs of small businesses. Within a month, it was the market leader. QuickBooks came about when the firm listened to its customers. Only by cultivating surprise and being willing to imagine new and different conceptions of its customer was Intuit able to build on and maintain its success. Cook summed up the transformation as follows:

In our own company, we've had to swing the pendulum drastically from a deliberative, top-down model with lots of debates and Power-Point presentations to an emergent model – where the solutions and decisions emerge from individual action based on observation, based on trying things, on experimentation, not based on what the boss says. And the more I see patterns in successful firms, the more I see this is actually underneath it all, the patterns with some of the most successful changes in business in the last 25 years.[7]

At the same conference, I held an onstage discussion with Claudia Kotchka who masterminded a similar pendulum swing at Procter & Gamble. In explaining how the most qualitatively sensitive design-ers differed from her more quantitatively driven colleagues at P&G, she commented: '[The designers) are not looking for *the answer*. In design, there is no one right answer. It's a very different view from science.'

Austen, Eisner, Schön, Cook, and Kotchka seem to be fellow travelers. But what are the implications of their pattern of insights for business?

First, I hope it is now clear that decision making is not only about equations and symbols. We must use all of our senses as we form opin-ions and make decisions. Numbers can help to describe sensory experi-ence, but they cannot serve as a substitute for it. For the businessperson, quantitative data holds a danger not unlike wine ratings do for a novice wine drinker. For the budding oenophile, ratings that say one wine is better than another obfuscate their own experience and prevent them from determining what they taste, what they like, for themselves. As former P&G Chairman and CEO A.G. Lafley – one of the best CEOs in the world during his tenure – once told me: 'The analysis never tells you the answer. The best it can do is inform your judgment in a help-ful way. If you expect the analysis to give you the answer, you will be disappointed with the answer you get.'

Second, never dismiss strong feelings that you have but cannot explain. In areas in which your qualitative capacity is nascent, your feelings will run ahead of your ability to explain them to another per-son – largely because you cannot yet explain them to yourself. But that doesn't mean that they are wrong. The task, rather than dismissing these feelings, is to integrate them into your quantitative analysis.

Third, cultivate surprise, and learn to embrace it. If the course of action you have chosen – i.e., your model – produces an outcome

that you didn't expect, don't get upset and throw out the experiment. Instead, learn from it and adjust your model.

Finally, read this book as if your career depended on it. It is that important. But even how you read it matters. If you read it looking for a recipe, it will defeat the purpose. If instead you read it to help build your conceptual knowledge for experiencing qualities and growing your artistic sensitivities, then you will have done yourself a great service. To be a great businessperson, you have to nurture your artistry, and this book is the best primer in existence for doing so. In this sense, it is a business book masquerading as an artistry book. But it is also a book for anyone who wants to grow his or her qualitative capacities, regardless of the level of his or her quantitative skills.

ARTISTRY UNLEASHED:
A GUIDE TO PURSUING GREAT PERFORMANCE IN
WORK AND LIFE

INTRODUCTION:
ON BUSINESS, AND OTHER ARTS

The executive functions … are 'feeling,' 'judgment,' 'sense,' 'proportion,' 'balance,' [and] 'appropriateness.' It is a matter of art rather than science, and is aesthetic rather than logical.

Chester Barnard, *The Functions of the Executive*[1]

This is a business book. It's published under a business-school imprint and presents ideas taught in a business-school curriculum. Why, then, are we about to meet a horseman, visual artists, and a chef alongside CEOs, managers, and other professionals?

My answer begins with a simple premise: that the most difficult problems we face are the ones that push us to the edge of what we know. Many people like to say that such problems occur more often or faster in today's world than ever before. But every population that's ever worked to push forward past the edge of certainty has felt the same daunting challenge.

In business and the professions, we are surrounded by problems that draw us to this edge. I call them *enigmatic problems*, and theirs is a complexity not merely of degree but, more importantly, of kind. Again and again, dedicated professionals encounter the same conundrum. Even as we develop ever more powerful analytical tools, even as our deductive capabilities increase, still the smartest among us crash headlong into new and recurring problems that we haven't yet learned to solve. New examples arrive with each morning's news.

Our best solutions to such problems, I contend, lie not just in better analytical tools but in a fundamentally different approach to our work –

an approach that follows from cultivating *qualitative intelligence* in our given profession or medium. Chester Barnard's words from more than seventy years ago indicated as much; still, the promise of this notion has yet to pay off. It's rare to find a school of management and professional practice that explicitly teaches the qualitative executive functions of 'feeling,' 'judgment,' 'sense,' 'proportion,' 'balance,' and 'appropriateness' – that is, the art of any discipline.

That's not to say that we can't still find good teachers if we are willing to search. Seasoned guides are working all around us. To find them, we just have to look in the unlikeliest of places.

We have to look to artists.

Think about that. Artists guiding executives? At first blush, the notion looks heretical from both directions. Reduced to their stereotypes, the executive sees the artist as a directionless fool who couldn't make a rational decision to save her life. The artist sees the executive as a prisoner of her own spreadsheets. But people aren't stereotypes. And spreadsheets aren't as stultifying as creative types make them out to be; they truly are powerful tools to help us solve *part of the problem*. What's important to recognize is that when it comes to solving the enigmatic problems that stymie so many practical efforts, artists are among the most effective people you'll find.

The focus of this book is on helping practitioners, professionals, managers, and executives develop the overlooked qualitative powers that artistic people employ routinely. I'm not suggesting that anyone burn the numbers. Instead of *either* this solution *or* that solution, what I'm proposing is an approach to qualitative intelligence that you can deliberately cultivate alongside your best quantitative practices. Neither excludes the other, though the partnership is seldom an easy one.

In Search of El Dorado

Is the artistic approach to practical work as enduringly elusive as the mythical golden city of El Dorado, a fantasy best left to romantic thinkers? I think not, but there certainly are camouflaging screens that conceal what it is and how it works. Two, in particular, hide artistic potential from common view.

First, the structures of formal education, advancing technology, and large corporations can stand between us and artistic involvement. Efficiency, mechanization, standardization, and automation are powerful forces that drive production, convenience, and reliability. Yet, while

these sophisticated systems enhance our lives, allowing us to do more than any of us working alone could do, they also erect an insidious barrier. We may not even notice it happening, but their helpful support replaces the need to master the very executive functions that Barnard identified. Protocols replace feel; rules replace personal judgment; policy replaces the active creation of balance. Convenience stands between us and the opportunity to engage, in a word, *artistry*.

The second barrier is less substantial but no less hindering. Neuroscientists have shown us that our highly complex brain is surprisingly easy to fool. Chemicals can replace the natural flavors and aromas of real food; virtual experience can stand in for genuine experience; imagination can be confused with actual events; and vicarious thrills stimulated by watching others, television, and movies can be confused with real involvement. Accepting these replacements, we unknowingly substitute them for the real thing. The key to learning at the edge of what we know is to be engaged with the actual substance of the problem, not its synthetic replacement.

I'm not suggesting that pursuing artistry in your chosen domain is a simple solution. Let's say you find the one person whose practice you'd like to emulate. Learning from seasoned practitioners, those artists who seem best situated to help, is surprisingly difficult. The problem here is that talking to artists about their native capabilities introduces an inherent communication gap.

Speaking of Artistry

The only thing harder than achieving artistry yourself is getting other people to tell you about how they managed to do it – especially if you're looking in disciplines outside the fine arts. If asked directly about artistry, many people will say, 'I am not an artist.' Others compare what they do to some fine art or other: 'What I do is like not like painting, but more like conducting.' As intriguing as these analogies may be, they're hardly informative when our goal is to understand concrete operations and how to achieve them. Still others speak passionately but abstractly about 'feel' or 'flow' or 'finding their muse.' They say things like, 'I don't know; it just happens.' And finally there are those who won't speak about artistry at all, fearing that even uttering the word will frighten it away, leaving them devoid of inspiration.

In the face of this ill-defined and seemingly impenetrable phenomenon, many hopeful students of artistic performance eventually resort

to grabbing the most common form of assistance – a recipe. This is the very response I hope to change with this book.

How do I know so much about the difficulties of communicating with artists about their work? From firsthand experience. To develop an understanding of artistry that is useful to learning, I spent years looking for a way to reveal its operations and to specify them without oversimplifying them and without turning them into the very recipes I hoped to replace. My own solution was to adopt a hands-on approach to this problem. Over several years and across a range of disciplines, I found people at the top of their game who allowed me to work with them directly. Together, we'd record and analyze their work in action; each time, I took on the task of learning their discipline myself. That way, I could experience firsthand what they described. The findings throughout this book are a result of that collective effort.

This research generated my ideas about the critical elements of artistic practice – the presence of qualities, the features of enigmatic problems, the interdependence of ends and means, and the emergence of artistry from an underlying personal Knowledge System that until now has remained invisible. My hope is that this collection of material provides a way forward for anyone interested in developing artistry in his or her own discipline.

The Way Forward

In everyday life the fundamentals of artistry are as natural to us as walking and breathing. As biological organisms we find our way forward by being involved in our surroundings, responding automatically to what we encounter, pursuing what we want, and overcoming obstacles along the way. Some people find artistry with relative ease in more specialized activities: as natural athletes, born politicians, or predestined leaders. But for most of us – for some reason the scientists have not yet understood, in some areas (and different areas for different people) – *we have to learn it*. Unfortunately, this often occurs in two of the most critical areas of our lives: when pursuing our dreams, and when pursuing our careers. If you're a person who wants to, or has to, consciously develop artistic capabilities, this book provides a way forward.

The findings, ideas, and advice I offer rest on the foundation built by two brilliant men, both emeritus professors at Leland Stanford Junior University: Elliot Eisner and James G. March. I present many of their ideas throughout these pages. They are the theoretical guides for this

I.1 Elliot Eisner I.2 James G. March

work. Elliot Eisner has spent his career championing the arts, clarifying
the value of artistic thought to the development of mind, and stand-
ing up for the qualitative approach to education research. Firmly con-
vinced of the knowledge value provided by qualitative work, Eisner
once made the controversial assertion that a novel could be accepted in
place of a doctoral dissertation 'if it does the job.' Since that time several
have succeeded.

Jim March is the organization researcher's researcher. His academic
writing and poetry explore decision making and risk, leadership and
ambiguity, passion and discipline, and the challenges of individual
and organizational learning. His own quantitative brilliance places
him among the best in the business of teaching business; his qualitative
sensibilities show us the contemporary leadership lessons we can all
draw from such literary characters as Othello, St Joan of Arc, and Don
Quixote.

A Map of the Territory

From Don Quixote, can it then be such a reach to begin a business book
with a cowboy? Well, maybe so. Yet there's method in it. What my
research has clearly shown me is that artistry can never be understood
in isolation from the medium in which it's being pursued. With that in
mind, every chapter in this book is written in the context of someone
engaged in a practice. The people you'll meet have already achieved
a hard-won excellence in their discipline. Their stories and reflections
will guide us as I build the analytical model of the Knowledge System

that underpins artistry across disciplines, and as I demonstrate ways that you can use it to build your own practice. In the meantime, here's a preview of how the model comes together:

- Chapter 1, 'Yesterday's Horse,' focuses on a professional horseman as he teaches a novice the fundamentals of riding a western performance horse. Their exchange highlights the basic characteristics of artistry, as well as four universal dynamics that render artistry difficult to transfer and achieve.

- Chapter 2, 'Presidents and Painters,' closely watches a watercolor painter as she creates a new image and demonstrates similarities between her judgments and those of the U.S. president as they both work. This chapter clarifies the importance of qualitative thinking and contrasts it with the kind of quantitative, analytical, or deductive thinking with which most students and professionals are probably more familiar.

- Chapter 3, 'Angelo's Kitchen,' unfolds in the kitchen of a Michelin-starred Italian chef. Drawing from his fifty years of experience, it introduces the components of a Knowledge System model that anyone can use to develop artistry in his or her own field.

- Chapter 4, 'The Territory, the Map, and a Compass,' looks more deeply at the three main components of the Knowledge System model: Experiential Knowledge, Conceptual Knowledge, and Directional Knowledge. Each kind of knowledge is illustrated with examples from several disciplines.

- Chapter 5, 'In Its Best Light,' shows how the three knowledge categories work together in action to produce artistry by following a fine-art photographer as he works through an early morning shoot in California's Alabama Hills.

- Chapter 6, 'An Uneasy Partnership,' explains the 'dynamic disequilibrium' that comes from encountering, by turns, the conservative forces of mastery and the disruptive forces of originality that together lead to artistry. Two very different examples illustrate how the interplay of these conflicting forces ultimately generates artistry: the personal story of a self-taught painter, and then Erik Larson's rendering of Guglielmo Marconi's struggle to develop long-distance wireless communication.

- Chapter 7, 'Learning Artistry,' highlights an innovative organiza-

tion-development consultant whose practice illustrates the two critical learning loops – each with its own character – that must be established to sustain progressive, artistic learning in any personal Knowledge System.

- Chapter 8, 'Tensions, Traps, and Alternatives,' reveals how to deal effectively with the predictable learning traps that everyone on the path toward artistry will encounter: ongoing tensions, the ambiguities of experience, inevitable clashes of ideals, confusing feelings with feel, misunderstanding failure, and beginner status.
- Chapter 9, 'The Seven Hallmarks of Artistry,' pulls together all the book's ideas and summarizes these in the seven hallmarks of artistic practice.

Throughout these chapters I use the words *novice, amateur, beginner, professional, practitioner*, and *student* to refer to seekers of artistry. Different learners are in different roles in this respect, and you may find yourself in different roles in different activities. I hope this book can speak across these roles and contexts. When it comes to developing artistry, we are pretty much in the same boat regardless of our level or stage.

The Business Gallery

Over the years, I've interviewed many business people and professionals in order to gain a deep understanding of their approach to practice. The following folks have kindly allowed me to share their thoughts on my subject throughout the chapters:

- *Gerry Mabin* founded the Mabin School in Toronto in 1980. She was born and educated in England where she taught for nine years before coming to Toronto. She joined the Institute of Child Study, University of Toronto, in 1971, teaching children and mentoring early childhood student teachers for nine years, the latter three in the position of principal. While Gerry retired as principal of her school in 1998, she remains closely involved.
- *Craig Keller* joined the asset management firm of Litman/Gregory in 2003 and became a partner of the firm in 2007. Craig provides investment advisory services to high-net-worth individuals, family groups, foundations, endowments, and retirement plans. Prior to joining Litman/Gregory, Craig managed pension, foundation, and

endowment relationships for Global Asset Management in London and Sydney. Craig is a graduate of the University of British Columbia and the London Business School.

- *Joanne Weir* is many things: a world traveler, a James Beard Award-winning cookbook author, a cooking teacher, a chef, and a television personality. Joanne spent five years cooking with Alice Waters at Chez Panisse in Berkeley, California, studied with Madeleine Kamman in New England and France, and was awarded a Master Chef Diploma. In 1999 Joanne received the very first IACP Julia Child Cooking Teacher Award of Excellence.

- *Scott Cook* cofounded Intuit Inc. in 1983 and now serves as the chairman of its Executive Committee. Before founding Intuit, Cook managed consulting assignments in banking and technology for Bain & Company, a corporate strategy consulting firm. He previously worked for Procter & Gamble, the household products giant, in various marketing positions, including brand manager, for four years. Cook earned an MBA from Harvard University and received a bachelor's degree in economics and mathematics from the University of Southern California.

- *Claudia Kotchka,* as a senior executive and change agent, successfully led an innovation culture transformation at Procter & Gamble. She is recognized for integrating design, innovation, and strategy. She globalized the design capability at P&G by establishing design centers around the world. P&G is now a leader in the strategic use of design for innovation. In recent years, she has been a guest lecturer at various business schools and universities, including Stanford University, Syracuse University, the University of Miami, and Wake Forest University.

- *Dr Melanie Carr* finished her fellowship in psychiatry in 1989 and completed a clinical research fellowship at the Toronto Hospital looking at issues related to mental health in women. Melanie remained on the clinical and teaching staff of the Toronto Hospital until 1993, when she established a part-time private psychotherapy practice. Melanie is currently an assistant professor of psychiatry at the University of Toronto and has been an adjunct professor at the Rotman School of Management since 2004. Her involvement at Rotman has been focused on the development of the school's integrative-thinking program.

- *Steve Luczo* is best known for his involvement with Seagate Technol-

ogy, which he joined in 1993 and where he served as CEO from 1998 to 2004. Steve currently serves as chairman of the Seagate Technology board. Over the last three years Steve has concentrated on building a new company, Balance Vector. Through a variety of operating entities, Balance Vector has successfully blended for-profit business ventures, with all profits reinvested into the support of numerous charitable causes. Steve is an active surfer, snowboard rider, and mountain biker.

Though few of these people would have called themselves artists at the time of our interviews, their words reflect otherwise. They all recognize the features of enigmatic problems and the importance of qualities and involvement, and they all share the purpose and passion that artistry demands.

So, yes. This is a business book. But I hope you'll find that it's also something more.

YESTERDAY'S HORSE

In each instance, the practitioner allows himself to experience surprise, puzzlement, or confusion in a situation he finds uncertain and unique … He is not dependent on categories of established technique, but constructs a new theory of the unique case … He does not keep means and ends separate but defines them interactively as he frames a problematic situation.

Donald Schön, *The Reflective Practitioner*[1]

Eric Thomas is a modern-day cowboy, a Clint Eastwood-style man, whose image hints at guns, brawling, liquor, and carousing but whose recent proclivities turn more toward green tea and the desire to be a skinny Buddha. Once a philosophy student at Berkeley, he now lives with his family on a sixty-acre ranch where he rides and trains cutting, reining, and reined cow horses. He also teaches horsemanship to hopeful students.

Eric: You know how to do this. I know because you've done it, and this exercise can't happen by accident. You've got to focus and ride. Remember, a rectangle is four straight sides and four ninety-degree angles, and not a bunch of other stuff. Now go do it!

The student is a small middle-aged woman on a small gray horse named Fatboy Slim. Reining is a precision sport, and the horse and rider are working together on a precision task: riding a perfect rectangle. When this sport is performed at its highest levels, the maneuvers include dramatic sliding stops, circles galloped at high speed, immediate speed changes, and rapid rollbacks – all achieved by a horse that responds to

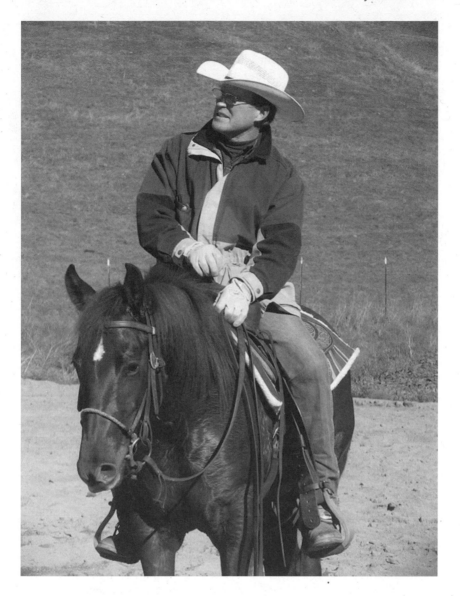

1.1 Eric Thomas

a skillful rider's seemingly invisible cues. But at the moment, things aren't going so well. Their turns are soft and their straight lines wobbly. Not precise, and not dynamic. The student stops for a moment, and Eric takes this chance to do some coaching.

ERIC: We're putting a lot of effort into trying to get these turns better, and then every third or fourth turn you just drop the ball and don't do anything. What is that about?

STUDENT: I'm too early and then too late, and then he reacts and I can't tell what to do.

ERIC: You're trying to do too much. Stop thinking, and pay attention to your horse. It's about trying to feel what is happening underneath you right now. You can't ride yesterday's horse. You can't ride what might happen. Everybody who rides has the same problem: we're hoping what we learned yesterday will always apply. You often ride the problem you had a minute ago, or for the goal you want to achieve. But this is not a recipe. It changes every second, and you've got to change with it.

This is a deceptively simple system: one rider and one horse, both trying and both learning, while Eric shapes this learning into something productive and progressive. The rider must make split-second decisions, based on attention to subtle indications seemingly too numerous to count. Eric must find a way to provide help that keeps up with the action. How can they possibly keep track and know how to advance?

ERIC: You have standards – my standards. Ride for those. When your hand moves to the left, he moves to the left. Not in a stride or two. Now. He melts away from that rein. Responsiveness is something you feel. You feel how fast and how deeply he responds. If he doesn't, you have to show him what you want every single time. You have to be consistent in response to what you feel now. He needs that to be a useful horse.

STUDENT: I know, but I can't keep up with him. I'm still behind his motion.

ERIC: The reason it took you longer is, of course, that you're looking for a particular feel that you don't know yet. And your skill level isn't there yet, either. But the only way it gets there is if you make yourself aware and set that internal standard and feel it inside. From that standard you feel what's good about his turns and what's bad about them.

You don't have to wonder, 'What do I really want here?' You have a short list. Good steering is first. Then you don't want him bent the wrong way, you don't want him stumbling, you don't want him worried, and so forth.

You have got to know what you want. You want him balanced, responsive, straight, and engaged. Those are things you have to feel, because I'm not on the horse. You are.

Ok, let's pick up the right lead here, and we'll try a circle.

Call It Artistry

I'm here recording and analyzing this lesson trying to sort out the mystery of learning. Not just any kind of learning, but a particular kind. And not just learning to ride a horse, either, although that's the subject at hand. What I want to understand is how the hopeful and bumbling efforts of a beginner can transform into the flowing precision of advanced performance. I want to understand a way of working that's possible in the professions, sports, and other fields, a way of working that helps learners grapple with such enigmatic features as ambiguity, uncertainty, change, uniqueness, and complexity. I especially want to understand how people across fields – be they chefs, teachers, painters, athletes, or entrepreneurs – can learn to respond effectively to these features by using their immediate interpretation of the *qualities* they experience.

An Entrepreneur's Perspective
You've got to start with observing real people in depth. Burn the market research. Go out there with your own eyes. Stand there. Do it yourself as the businessperson. Be there with your own eyes. *Scott, Intuit founder*

This way of working – call it artistry.

Artistry is rooted in qualities. Reining presents the student in this example with such qualities as 'balance,' 'responsiveness,' 'straightness,' and 'engagement' in a horse. To become a proficient rider in her own right, she needs to perceive these qualities and interpret them herself; until she does that, she's merely applying a collection of disconnected generic techniques – and haphazardly, at that. If she can become focused enough and then use this awareness to respond effectively to these qualities, she'll be able to improve her own efforts and those of her horse. She faces the same learning challenge that students of every demanding discipline face if they wish to leave routines and recipes behind and become creative and masterful practitioners in their own right.

Eric helps this student make that shift. The difficulty of the effort is

evident to both Eric and the student. Even the horse rises to the occasion. Dirt explodes against the barn wall with a startling bang as he surges forward. Suddenly, the little gray becomes a powerful 800-pound mass of pumping muscle as his hindquarters dig into the ground and send him forward at a gallop. The pair go around the arena at a speed that seems dangerously out of control to the untutored eye – now they're dynamic, if not yet precise.

ERIC: Good! Let him go. If he's thinking fast, let's gallop a few circles. You're all right. You're fine. Relax!

Fine? It doesn't seem fine. It seems out of control, precarious, even terrifying. As the speed increases, so must Eric's volume. He successfully commands his student's arms and legs to act on vehement directions that both she and the horse do seem to understand.

ERIC: Even though I said you're fine, I expect you to do something about it when he is not where he needs to be! Things change. This isn't a machine. A little leg here; get his head at the vertical. Push him up into that bridle until his face yields to your hand. Good! There. One more fast circle after this. Right leg. Sit down. Keep riding! Don't weaken through the center. Use your legs. Your legs are your solution to his frame.
　　Good! When you get back to the center, we'll slow down. GOOD!

Dirt billows and hooves pound as Eric directs the action. This organizes the concentrated energy of horse and rider into unified motion. Velocity and momentum gather into a compact ball of flexible tension. In one gymnastic move, horse and rider drop from a gallop into a slow, almost hovering lope. After traveling in a perfect small circle, the horse tucks its back legs and slides into a balanced, immediate halt dead center in the middle of the arena. After a moment of quiet, horse and student walk over to stand with Eric.
　　He takes this moment of rest to do a little more explaining.

ERIC: Just because he has a little more energy than you're used to doesn't mean you have to freak out about it. Ride it, for Christ's sake! One of the reasons we ride horses is because they're dynamic. So, when things are a little different, you should appreciate that and not be scared of it. Scared is a distraction. Utilize him!

I recognize this vulnerable state, when fear, anxiety, or embarrassment creates a self-absorbed distraction. Yet in the heat of the moment it's nearly impossible to ignore these reactions. Some observers might find Eric's pressure on his student to deal with these reactions harsh. But both she and Eric know that unless she can master this, she and her horse will never reach a peak level of performance.

ERIC: It takes more focus, but that's what this game is about. When we talk about asking a horse for a hundred percent, we're asking a person for a hundred percent. It means we have got them right to the point where they are either going to perform or explode! If they perform to their maximum ability, they will do the best they possibly can. If you get it just right, and you're sitting on a hundred percent of a horse, all you can do is pull your hat down and hope you don't screw up.

From the look on Eric's face, I can see he lives for this kind of intense ride – 100 percent of a horse and 100 percent of himself in motion. A ride where the time, effort, and resources it has taken to get there pale in comparison. He wishes the same for his student someday. He's trying to take her across an invisible barrier that divides amateur riders from genuine horsemen. For this horseman, riding is about intensity and unity with his mount. He lives in a coherent world where feel, skill, understanding, and motivation come together. Horsemanship is a 'way of life,' not merely a hobby, a technical activity, or a set of abstract principles.

ERIC: I can think back on some rides I've had and some memorable rides I have watched, that was exactly it. Everything was being given. When it worked out, it was because the rider was also there to give everything. That's why I ride.

What would giving, and receiving, 100 percent feel like in this activity? How would it feel in any other, for that matter? What would it take to do it? Is it the same for everyone, or different? What kind of learning must occur for this to take place?
I want to find out.

ERIC: So, a large part of your education is learning to keep yourself paying attention a hundred percent of the time, so you can be there when your

horse is there. It has to become your way of life and his. He can't get there without you. If you can learn what that groove feels like and ride for that feel every second, then getting to the centerline or getting stopped in the center won't be so much of an issue. It won't be those goals but the feel that you are riding for. Because when your horse is right and you recognize that feel, having him stay there is really all you need. The rest will take care of itself. Or it won't. But you have to do it that way, then take a leap of faith.

This teacher is telling his student what's important, describing the what, the how, and the why of the skill she's trying to master. He wants to direct and then motivate the right kind of effort. In this moment, it's a seemingly contradictory combination of control and surrender that she must achieve to find the 'groove.' This kind of learning effort goes on every day in every discipline. Teachers work to transfer knowledge, skill, know-how, judgment, and the commitment needed to achieve advanced performance, while students strive to absorb them.

A CEO's Perspective
You have expectations. People perform to expectations, or not. And part of it is, as you get older, you don't spend so much time thinking you know what's going to happen and setting expectations, as opposed to just paying attention to what's happening now. *Steve, Seagate CEO*

While this effort is familiar, the real prize of this kind of learning is something rarely addressed directly. This prize – at once critical and elusive in practice – is the capability I call *artistry*.

Artistry is neither well defined nor well understood, yet it hovers in the background of much of what we do. Just walk into any well-stocked bookstore and you'll find books with 'art' in the titles. In the business section there's *The Art of Innovation*, *The Art of Problem Solving*, and *Leadership as an Art*. In the sports section, you'll find books about the art of tennis, golf, football, fencing, horsemanship, and juggling. In the cooking section, authors celebrate the art of cooking in cuisines from around the world. Human-performance titles include the art of possibility, healing, friendship, war, peace, teaching, and happiness. Raymond Chandler offers us *The Simple Art of Murder*. Apparently, artistry is possible in just about everything we do.

Indeed these titles do imply a promise. When we take these books in

hand, we hope they'll explain how to achieve artistry, something magical, in the activities and professions they discuss. Instead, most raise questions rather than give direct answers. Thumb through these volumes and what you'll not easily find is a clear definition of what 'the art of' really means.

Seemingly indispensable across so many disciplines, the development of artistry has remained a hit-or-miss proposition. When it does occur, the teaching and learning of artistry is a supreme challenge for both teacher and student. This difficulty is evident in Eric's interchanges with his student. He's trying to help her find *feel*, *focus*, and *immediacy*, then connect these experiences to the qualities her horse exhibits, so she can then use this connection to meet a high standard of performance. When missing this integration of immediacy, understanding, and clarity of purpose, she can't achieve the timing so critical to the horse and the sport. Without all these elements, the artistry to which all three aspire cannot emerge.

So the questions are: What is artistry, and how do you achieve it? Which elements constitute artistry? What effort does artistry demand? How can you find *feel* in any activity? What can you do when you work so hard to focus yet still miss important things? How can you handle situations when fear, discouragement, or boredom takes over? How can you proceed when your skill level fails? How can you deal with the difference between goals and awareness in the moment? How can you integrate awareness, understanding, skill, and motivation?

The answers to these questions are critical to students and teachers of every demanding discipline. They can lead the dedicated student to achieve that state we call artistry, that state where the tentative plucking of notes becomes the compelling music that rouses our strongest emotions, or where the routine chopping of onions turns mere groceries into the aromas and flavors that make us drool. Answering these questions allows beginners to become exceptional, pedestrian performances to become memorable, and the ordinary to become extraordinary.

Why does this transformation occur so rarely? What can a learner do to cultivate artistry? Answering all these questions is my reason for writing this book. It is also the reason I ride regularly with Eric. Yes, the struggling student in that arena is me. I put myself in Eric's hands and in the hands of many artistic practitioners – a photographer, a chef, an organization consultant, a painter, and others – to use my personal experience across disciplines to inform a larger pursuit of artistry.

Artistry Isn't for the Faint of Heart

The information in these chapters comes not just from my own experiences, but from my studies of many teachers and students working to achieve artistry, from extensive interviews with artistically inclined practitioners across disciplines, and from participating firsthand in many different learning environments (corporate, academic, and public) where artistry was an underlying though often overlooked feature of the subject at hand. These experiences have helped me identify what works and what doesn't when it comes to achieving artistry.

One undeniable trait of artistry is that pursuing it has never been for the faint of heart. Till now, four dynamics have routinely foiled efforts to achieve it. Eric and I face all these difficulties in our lesson.

1. Those who achieve artistry aren't great at telling amateurs what's involved.

Having reached an artistic level of performance, practitioners often find it hard to describe to novices exactly what they're doing in the moment. Their actions – and, even more, the how and why behind these actions – have become automatic and natural. So much so, that they defy description.

In an effort to help me, Eric relies heavily on the word 'feel.' While he certainly does ride by feel, the word is frustratingly opaque to someone who has never felt the feel he's talking about. Eric also gives specific instructions, hoping I will implement them well enough to create the qualities in my horse that he wants me to feel. He tries to explain his reasoning, and he directs me to 'ride every stride,' so that when something important occurs I'll have a chance to notice and learn.

An Educator's Perspective
You can't impose yourself. You have to get [students] to come to you, to trust you, to open up. *Gerry, Mabin School founder*

As much as he can say, there's more going on than anyone could describe. And what he can say can only point the way. While teachers can certainly help, artistry ultimately comes from the inside out. This inescapable situation leads to the next dynamic.

2. Artistry cannot be learned vicariously; it must be lived.

Artistry cannot be learned while sitting on a couch. Nor can it be

learned in classrooms, from reading books, or from watching others act. Instead, artistry develops as action unfolds. Students of artistry cannot escape undergoing the risks, the emotional demands, the hours of practice, the investment of resources, or the impacts of outcomes they generate. There's no sugar-coating it: this is stressful.

As Eric often reminds me in critical moments, when things seem on the edge to me, I have to ride the horse even when I lack awareness and skill, even when I'm scared. This frustration and risk cannot be avoided. However vehemently Eric yells, cajoles, rewards, and explains, I can learn only when I find a way to undergo, comprehend, and then make this experience part of myself. Learning artistry is a transformative process.

3. Artistry is emergent.

In our goal-oriented society, artistry defies conventional wisdom. The harder you try to make it happen, the more elusive it becomes. Artistry emerges when you pursue a connection, or a feel for a discipline, rather than when you pursue particular goals. It comes to people who make judgments in response to change, rather than those who depend on the skills learned in yesterday's lesson. At the same time, of course, these skills and goals cannot be abandoned, and this apparent contradiction can create confusion.

An Entrepreneur's Perspective
The strategy, I'm coming to believe, should be emergent, as opposed to dictated. Whether in small companies like Twitter, ourselves in the medium-sized range, or P&G where the decisive leader-driven strategy failed – in all these cases, it was the emergent stuff that no leader could have expected that actually drove the business to success. *Scott, Intuit founder*

As Eric helps me find the center of my circles, he wants me to clear up my confusion on this subject. The harder I try to get to the center, the worse my performance becomes. He suggests that precision will come not from making my goal the centerline but from my ability to focus on the quality of my horse's movement – his balance, his responsiveness, and so on. This willingness to stay in the moment requires, in Eric's view, the 'leap of faith' that reaching the center will ultimately emerge.

If artistry is an emergent state, it has to emerge from something. This something, which Eric describes as a 'way of life,' I describe as a

Knowledge System that can be deliberately developed. Until now, most educational efforts have overlooked this Knowledge System.

4. Artistry is fluid and progressive.

Artistry is not a final destination. What works in one moment probably won't work in the next. Today's success can be tomorrow's failure, and today's failure can magically transform into tomorrow's success. Even a brief review of history reveals that our ability to judge the real efficacy of innovations, flops, today's achievements, and yesterday's struggles is iffy at best.

In addition, artistry plays a different role in every level of performance, from beginning to advanced. At my stage of learning in reining, artistry emerges in rare and fleeting moments when sensitivity and skill integrate, moments when I can give my horse the right support at the right time. For Eric, day-to-day artistry weaves through much of what he does, and it peaks during the performances where he and his horse find the unity that he describes as 100 percent. As each of us develops, what we experience as artistry will shift and advance. For both of us, there's no end to what's possible.

Given that anyone pursuing artistry will face these four challenging dynamics, it's fortunate that artistry provides rewards to compensate for the inevitable heartache along the way. Eric describes what motivates him:

> Now that is a thrill for a horseman. When your horse is light in your hands, balanced, willing and relaxed, and when you ask he is there, better than last time you rode. He is tuned just the way you want him, ready and waiting. Nothing else has kept my interest. Nothing demands as much of me.

In whatever discipline you pursue – it may be horsemanship, painting, cooking, or even organization consulting as we'll see in chapter 7 – achieving artistry gives you access to intense and nuanced experience in the discipline you pursue. It means reaching an advanced level of performance that's both skillful and original in character. Finally, it generates the internal motivation required to generate tomorrow's commitment.

chapter 2

PRESIDENTS AND PAINTERS

Every quantitative measurement we have shows we're winning the war.
Robert McNamara, U.S. Defense Secretary, on Vietnam, 1962[1]

How does the President of the United States make decisions?

That's a question John F. Kennedy's speechwriter tackled in the 1963 book *Decision-Making in the White House*. Ted Sorensen argued that whether a given president is strong or weak, or whether he initiates or avoids particular decisions, the same basic forces and factors shape those decisions.

A President may ignore these forces or factors – he may even be unaware of them – but he cannot escape them. As a painter mixes his colors, or a chef prepares his sauce, so he must mix these ingredients – omitting some if he wishes, or preferring others he likes, but mixing them nevertheless, in his own style and to his own taste, until the final product is fashioned.[2]

The Kennedy administration, exemplified by Robert McNamara's whiz kids, was legendary for its rational approach to problem solving. Yet Sorensen, one of Kennedy's closest advisers, summed up his conviction this way:

White House decision-making is not a science but an art. It requires not calculation but judgment. There is no unit of measure that can weigh the substantive consequences of a decision against the political consequences,

or judge the precise portions of public opinion and congressional pres-
sure, or balance domestic against foreign, short-range against long-range,
or private against public considerations. Every decision a president makes
involves uncertainty. Almost every decision involves an element of pre-
diction and at least latent disagreement with others.[3]

Finally, Sorensen concluded, presidential decision making is dif-
ferent from anything else. It's unlike what CEOs of corporations do,
unlike what cabinet secretaries do, unlike even what past presidents
have done. In short, he said, it is unique.

From my view, the work of presidents is unique in degree but not in
kind. The dynamics presidents must harness are the same ones paint-
ers and chefs – indeed, practitioners in every demanding field – wres-
tle with every day of their working lives. Overlooking the universality
of mental operations – such as judging options, balancing trade-offs,
grappling with uncertainty, and acting with confidence in one's own
style and to one's own taste – means overlooking fundamental capabili-
ties of the human mind.

In the Eye of the Beholder

Imagine yourself faced with the apparently simple problem of choos-
ing and eating a meal. Are you likely to grab the nearest convenient
food and swallow it down without a second thought? Or do you search
out the unpredictably best ingredients at the farmers' market, imag-
ine the flavors and textures you might create with these raw materials,
take them home, shape them into the final dishes that their qualities
inspired, modifying your technique and intention in response to how
things go and taste in the pan, and then finally use your palate to assess
the results of your work, making note of what you might do differ-
ently next time to achieve results closer to your own style and your
own taste?

These are the two extreme responses a person can make when faced
with the problem of having a meal. The first approach is simple and
efficient. The second approach is more risky, demanding more focus,
more time, more energy, more skill, and more involvement. The first
approach makes sense when you think of getting a meal as a task. The
second makes sense when you think of getting a meal as an opportu-
nity for artistry.

Learning to Love Enigmatic Problems

In our working lives, all of us are faced with different kinds of problems to solve. Simple problems are comfortingly clear: you know where to go and how to get there. Simple problems often come with a clear set of instructions. Anyone following them can come to the same solution. The steps involved are relatively few; the difficulty level, relatively low.

But few of the problems we encounter in professional practice are so simple. When the definition of means and ends becomes less clear or when the number of factors involved increases, the difficulty of problem solving intensifies. Many people, especially organization researchers, have coined terms for these demanding problems: 'social messes,' 'wicked problems,' and 'big hairy problems.' These problems are characterized by such features as ambiguity, uncertainty, instability, and complexity. Additionally, these kinds of problems tend to occur in the domain of qualities, not quantities. If you choose to tangle with these kinds of problems, you'll find that where you want to go and how you ought to get there are up for grabs. Different people will do and try to achieve different things; it will also be hard to tell who might have the single best grasp of the situation, or who might have the single best solution.

In the context of artistry, I call them *enigmatic problems*. The enigmatic problems associated with artistic work have an additional feature I want to highlight by using this term. Not only are the ends and means unclear, they are also interdependent. As your effort to solve an enigmatic problem proceeds, the ends evolve as means are generated. Likewise, as means unfold, new ends become possible; these may in turn demand new means.

This interdependent relationship between ends and means is a hallmark of artistic work.

This distinction between simple tasks and enigmatic problems is one theorists have wrestled with for decades. (See 'Learning to Love Enigmatic Problems,' above.) I'm certainly not the first to do so. Nor am I the first to suggest artistry as an alternative approach to action. Indeed, Sorensen's words from four decades ago point directly to this idea. Yet

while the features that characterize problems in the arts – uncertainty, ambiguity, complexity, change, surprise, choice, subtlety, indeterminacy, and uniqueness – are present in any demanding activity, little has been done to make use of this observation. Few presidents, managers, teachers, or doctors have looked to artists for help when it comes to being effective in solving real-world problems.

Executives looking to artists for help? At first blush, it seems absurd. Let's face it: artists don't have great reputations in rational circles as problem solvers. When we think of effective people, artists are the last group most of us think of.

An Executive's Perspective

A.G. Lafley said we have to have design thinking in the company. He didn't say what that meant. I knew he wanted more than to make things pretty. What I wanted to do was build a design-thinking capability into the company broadly. But what I'm faced with is: here's a corporate culture that's the opposite of what we had to build. So that's the wicked problem. *Claudia, P&G vice-president*

But perhaps we've been missing something. What's important here is the approach artists take to work in their medium. True artists see the features identified above – that cluster I call *enigmatic problems* – not as obstacles but as exciting opportunities. They consciously work to become skillful with these problems. And here's the kicker: *in the face of enigmatic problems true artists display a greater intelligence in their medium than many of us do in our own professional medium.*

This is a dramatic reframing of the intelligence of artists, and it implies important lessons that working professionals can take from artists' approach to their work. Artists seek rather than fear ambiguity in their medium. They embrace rather than avoid or ignore surprises; instead, they court the solutions that surprises stimulate and the growth that surprises make possible. Taking this approach, artists tend to enjoy intensity, effort, challenge, ownership, motivation, satisfaction, creativity, learning, and even transformation as they work in their medium.

Can we learn from artists how to use problems as a route to these most human of experiences? Can we model our ways of working after artists to our benefit? Can apparently simple tasks be turned into artistic problems? Can the demanding problems that continually plague our daily activities, and the wicked problems that pervade demanding jobs like presidencies, be treated as opportunities for artistry?

Achieving this artistic alternative starts with learning to use such faculties as judgment and imagination in our own work. Beyond that, turning a simple problem into an artistic problem means crossing an oft-forbidden boundary. It means entering a world that is open to artists but seldom to the rest of us – the world of qualitative thought and experience.

Quantitative versus Qualitative Thinking

Whether Ted Sorensen was aware of it or not, his comments place him on the field of an ideological battle that spans centuries and disciplines, a battle that even today is driven by powerful thinkers on both sides. In academic circles, the two armies divide into proponents of *quantitative* and *qualitative* thought.

This enduring conflict between structure and openness can surface in any number of guises. In public education it fuels competition between proponents of standards and proponents of child-centered approaches. In business, organizations are pulled between strategies that focus on the exploitation of current skills and the exploration of innovations. In self-improvement circles, right-brain and left-brain partisans offer conflicting advice on how to achieve well-being.

A Professional's Perspective
What I love about psychiatry is that it's a blend of art and science. No matter how much we are able to see patterns and make predictions based on our scientific understanding, no two people are ever exactly the same. So, as a practitioner, your eyes have to remain 'fresh.' *Melanie, psychiatrist*

Sir Ken Robinson is a thought leader in the development of creativity, innovation, and human resources. In 2005 he was named one of *Time/Fortune*/CNN's 'Principal Voices.' His 2001 book, *Out of Our Minds*, critiques our culture's narrow view of intelligence at a time when corporations and governments require something different.

Many companies are facing a crisis in graduate recruitment. It's not that there aren't enough graduates to go around; there are more and more. But too many don't have what business urgently needs: they can't communicate well, they can't work in teams and they can't think creatively. But why should they? University degrees aren't designed to make people

creative. They are designed to do other things and often do them well. But complaining that graduates aren't creative is like saying, 'I bought a bus and it sank.'[4]

Further on, Robinson develops his critique:

The preoccupation with academic ability has specific historical roots in Western culture … This has led to a view of knowledge and intelligence dominated by deductive reasoning and ideas of scientific evidence. These ideas have been reinforced since then by the styles of formal education, promoted especially through the public schools and universities. These methods of thought have had spectacular success in shaping our understanding of the world and in generating technological advances. But there has been a terrible price too.[5]

At the root of this war of ideas lies a dispute over the very definition of intelligence: over which processes of mind our society chooses to value, educate, and reward and which it chooses to marginalize. Like so many such battles, this one inflicts collateral damage as it rages on. Perhaps the highest cost is in the barrier it has created against artistic performance across disciplines – a barrier I've spent my career working to dismantle.

What's the big difference between quantitative and qualitative thinking? Of the two, quantitative thinking is the easier to define. We can all count, and we're comfortable applying numeric values to such day-to-day activities as shopping, driving, and scheduling. We count change, observe the speed limit, and set meeting times. We measure intelligence quotients to identify smart people. We judge Olympic athletes on a scale of 1 to 10. We measure businesses by accounting conventions that tabulate gross profit and net earnings. We measure the health of economies by the point-value changes of stock indices. We measure daily temperatures on a Centigrade or Fahrenheit scale. We mark our lives by passing units of time.

An Educator's Perspective
In public schools, the curriculum is constantly pummeled down. And so a teacher has to teach in units. You know, we're going to do our unit in geometry for a certain number of days, and then move on to the next unit. There's no revisiting, no integration. It's all tightly boxed. It's a killer. *Gerry, Mabin School founder*

In school, the sciences (and sometimes even the liberal arts) are routinely taught as perfect expressions of quantitative thinking. We're all exposed to basic mathematics, statistics, chemistry, and physics – subjects typically driven by quantitative, single-answer problem solving. These disciplines provide formulas that allow us to repeat our work predictably and reliably. Results on tests with right and wrong answers clearly rank us against other members of our class. Quantitative thinking allows us to be precise and to share understanding; we use it to define fairness and rationality and effectiveness. It's this utility that has led so many people to equate quantitative thinking with intelligence.

The Intelligence of an Artist

But before we accept that premise outright, consider a painter at work in her medium, in this case watercolor painting, as she uses her qualitative responses to create an image. Let's take an in-depth look at how problems are solved in the creation of a particular image. The right-hand sidebar highlights how this painter works with qualities to create her image.

This painter's work is accomplished in a medium that brings with it physical limits and opportunities. In this case, this includes paper, brushes, and water-soluble paint.

The painter sits before a sweep of smooth white paper, thirty inches by forty-two inches, paper that's been wetted, then taped and stapled to a finished plywood sheet, and finally left to dry to make a surface ready for her watercolor paints. Three wide-mouth glass jars hold brushes: some are small and thin and very pointed; others are big and soft and bushy. Three paint palettes are filled with generous amounts of brilliant pure colors: yellow to yellow-orange in one; orange-red to red to scarlet to purple in the second; and purple-blue to blue to blue-green to green to yellow-green in the third.

She arranges her palettes to display the qualitative relationships between colors.

How does this painter work in her medium?

With the proverbial blank slate in front of her, she's faced with a problem that's both demanding and enigmatic; it has little pre-existing structure; it contains multiple inter-acting elements that generate unexpected events; her solutions must be personal; if asked, another painter would handle the situation differently; even as the problem is being resolved, its form shifts.

To put it simply, the painter must decide what image to paint. What is important and how to deal with it are both personal decisions. 'Something has to demand my attention for me to be interested in painting it,' she says. 'The images I'm interested in are the ones that, when I look around the world, somehow look back at me. Most of the things I like to paint are alive. They move quickly, and they are gone. I guess I want to capture my experience of some-thing fleeting.'

She decides to paint an image of a black swan. Yet even as she sets this straightfor-ward goal, it expands to encompass mul-tiple elements: she'd like to bring a static image to life; the swan must emanate fore-boding and strength; the composition must be dramatic. A successful image must be more than just a picture of a swan; it must contain all these multiple qualities. These hopes inform her technical goals: to paint good edges; to make the feathers look like they're both soft and shiny with reflected light; to make the bird and the water look organic; to show light passing through and coming from the eyeball so it looks round and alive.

'When I paint,' she says, 'I have a head-ing. Many events are going to happen that will go in directions that take me surprising

Rather than pursuing clearly defined, pre-set, measurable goals, this artist establishes personally meaningful, multiple, qualitative goals. These goals include some that are clear, some that are ill-defined, and others that are emergent.

Some of these qualitative goals include 'attention grabbing,' 'alive,' and 'capturing fleeting experience.'

Other qualitative goals include bringing a 'static image to life,' and creating an image that 'emanates foreboding' and 'strength.' Technical visual qualities include achieving 'good edges,' feathers that appear 'soft and shiny,' and the illusion of 'reflected light.' All these qualities and more must be achieved with paint and paper for this image to work.

She anticipates surprise and expects qualitative interactions to change

places.' As she works, the painter maintains a sense of direction and momentum without sticking to clear or precise goals. 'Each time you add a brush stroke, everything changes.'

So far, it's the kind of problem that Sorensen and Kennedy would surely have recognized. But it's also rooted in a particular medium – in this case, watercolor painting. As every medium does, this one imposes constraints and offers its own possibilities.

With watercolors, the painter says, you can neither control nor fix the paint once it's on the paper. She likens it to a performance. 'Once you start,' she says, 'the curtain's up. You can't stop halfway and say, "Wait a minute! I want to try again." There's no luxury of wiping paint away and starting again. That is just not the way it works.' With this exacting nature come the transparency and luminous color characteristics of watercolors. You don't get one without the other.

Watercolors are made of finely ground minerals. Each has its own texture with both a staining quality and a granular quality; different colors sink into the paper or sit on the surface in different ways. 'Burnt sienna is granular, and French ultramarine blue is staining,' the painter says. 'If you put them on a wet piece of paper and they're very wet, they'll settle onto the paper at different times, and you get a kind of mottled texture. But if you mix those same two colors on your brush and put them on dry paper, they dry as a solid mixed color.' Without control over these physical qualities of the paint, she won't get the visual qualities she's hoping for.

what she imagines will happen.

She understands the inherent nature of her medium and uses this knowledge to create the qualities she wants.

Knowing how her paints and paper interact, she can predict what will happen on paper and respond automatically to adjust created qualities as they occur.

This painter knows that in action, control and lack of control exist simultaneously.

On the other hand, she says, 'a lot of what watercolors do is determined by the nature of the paint and not by me; it seems to have a life of its own. The irony is, 'It takes a lot of control to paint with a pigment that is so out of your control.'

As the swan painting progresses, two features demand particular attention. She works first on the swan's eye. 'The aliveness of the animal is shown there more than anyplace else,' she says. 'It helps me relate to the picture.' Relying on knowledge about avian anatomy as well as the technical dynamics of painting with watercolors in small adjacent spaces, she proceeds. 'Two technical things I do are, first, look for and define a highlight, a pure spot of white paper. And, secondly, after I put color on the eyeball, I blot it off just before it dries. This pulls paint off to let the paper, and therefore the impression of inner light, come through.'

Painting the eye early on produces an unexpected result. 'I love the fact that his eye is ringed with orange,' she says. 'It establishes the dynamic between the blue-black of the water and the feathers, and the face of the bird. It sets the color dynamic I didn't plan, but it should work for the rest of the painting.' What began as an attraction to the subject develops into an organizing force that drives the image composition. Color theory, technical demands, unpredicted immediate events, and her personal response to the qualities she creates weave together to guide her progress. (For a color version of the painting, see plate 1 in the color section.)

Next, she turns to the second major feature of the swan: the feathers. 'Orange and blue are opposite colors, so they should be

The qualities that she creates direct her attention and inform her actions.

The physical attributes of brush and paint on paper are translated into qualities that create a believable image.

She uses the relationships between particular qualities to create overall qualities. Her use of qualities is informed by a combination of intentions, theory, unexpected events, and the qualitative response she has to what she creates.

electric together, in tension but unifying at the same time.' She makes the black for the feathers by mixing green, red, and French ultramarine blue, then adding a little burnt sienna to warm it up. 'Burnt sienna will relate the blue in the black to the vermilion of the beak.'

Her concern while painting the feathers is whether they'll 'read' – that is, lead a viewer to believe what he or she sees. Again this is a matter of feeling. 'You see the shapes of these feathers?' she asks. 'They're layered one on top of another, on top of another, on top of another. Each feather has to feel like it's lying over the top of the feather below it.' This visual illusion must be achieved on a flat surface.

She uses tensions between particular qualities to generate high-order qualities like 'unity' in the image, 'layering' on a flat surface, and 'believability' in an illusion.

To do this, she paints one feather, then moves on to another part of the body as the previous feather dries. 'I'll jump around the body leaving white dry spaces in between the painted feathers to be filled in later. As I paint, I have to visualize what it's going to look like from a partial picture. Each new area painted can change how the rest looks. I'll have to try and respond to that change, which can be very subtle.'

She can visualize how the qualities of paint she creates, though disconnected in time and space, will interact to create the compositional and dimensional results she likes.

In all of this, one of the painter's most important tasks is, as she says, 'seeing from different perspectives.' As she paints, she looks at the work from far away, then up close, moving back and forth again. 'You can't make a lot of judgments up close,' she says. 'The integrative judgments have to happen by stepping back.'

When she's finished, the painter reflects on what she's done. 'I'm happy with a lot of it, but not all of it,' she says, noting that she lost some of the highlight in the face and that she struggled with some of the tex-

2.1 *Black Swan*

tures. She finds the lower part of the neck and the breast less believable than the body, the wing, and the head.

'I think the feathers on the lower part of the wing are beautiful – they look soft and dense, and like they could lift up into the air. And the face is just how I imagined it. Those are the best parts of the picture.' In the end she concludes that the overall qualities of the image 'hold it together.' She has captured enough 'essence of the swan' and its 'drama' so that the shortcomings don't destroy the overall feeling it evokes.

To determine effectiveness, she assesses and evaluates qualities rather than measuring them.

When you allow action to generate outcomes rather than use action to pursue pre-established goals; when you reason with sensory experience rather than with abstract symbols; when you act without hesitation with what you know, while courting the possibilities of surprise; and when you use a combination of immediate and remembered experience to predict and then revise immediate action – these are the times when you're exercising qualitative intelligence.

Working with Qualitative Intelligence

Working with qualitative intelligence in any medium, artists:
- depend on a nuanced perception of the qualities they encounter and create;
- rely on personally meaningful preferences to initiate and pursue multiple, open-ended qualitative goals that are discovered, clarified, and reshaped as work unfolds;
- know how their tools and techniques can be used to create the qualities they intend;
- sustain the tension between control and openness. Doing this they can achieve what they intend, as well as allow surprising events and qualities to occur and redirect action;
- use the interactions and relationships between particular qualities to create higher-order or pervasive qualities that organize the work overall;
- think in the qualities of their medium to imagine, predict, and create qualitative outcomes;
- assess the effectiveness of the qualities they create, and the methods they use to create them, by evaluating rather than measuring.

The president weighs the effects of public opinion and congressional pressure, then makes a far-reaching decision on civil rights or health-care reform; the painter sees an interplay between orange and blue, and structures the rest of her image around that emerging relationship. As they work, neither the president nor the painter limits his or her judgment strictly to the quantitative intelligence or deductive reasoning that Ken Robinson describes in his critique of the academy.

To perform artfully, committed practitioners must rely on *both quantitative and qualitative* intelligence in their work.

Qualities in Everyday Life

Stepping away from the paper and out of the studio, we ask the question: How do qualities work in everyday life? Can we learn from artists

and take the facility with qualities into the activities that matter to us? There's no question about it: compared to quantitative thinking, qualitative thinking is much harder to sort out.

Just what are qualities? Tones, textures, movements, flavors, interactions, relationships, and materials all have qualities. Qualities are physical and tangible rather than abstract: we perceive and feel them. Qualities cannot be objectively measured, as a quantity like temperature can be measured with a thermometer. We can count the number of people in a room, but that tells us little about the mood – upbeat, flat, intense, contentious – of the group's interaction. Also, different people may experience different qualities; or, they may experience the same qualities differently.

A CEO's Perspective

Some business leaders are amazing visionaries. They think of something, and they make it happen. But do they build great teams? I'm good at picking teams. And it's not the team that most people would find obvious. I'm not building a team that knows the answer. What I'm doing is building the team that knows they have to get to the answer. *Steve, Seagate CEO*

Although few of us will be presidents or painters, we do all think in qualities every day. Without qualitative thinking, we could note the speed limit but couldn't maneuver a car in the ever-changing flow of traffic; we could keep score in a game but couldn't throw a curveball to achieve a strikeout. Without qualitative abilities, we couldn't appreciate the unfolding stages of a relationship, the beauty of a well-designed machine, or the impact of a powerful speech.

Elliot Eisner and the Case for Qualitative Intelligence

Elliot Eisner, a researcher and professor emeritus at Stanford University, has spent much of his career writing about qualitative thinking and its importance to many human endeavors including the arts, education, educational research, and human development – virtually any practical endeavor.

Four of Eisner's ideas are particularly relevant here.

1. At the root of qualitative thinking is the ability to perceive qualities that cannot be quantified.

Different disciplines composed of their different materials present

practitioners with different qualities they must learn to perceive. Watercolors are transparent; music is tonal. The different qualities of colors evoke different responses, as do different notes and different note combinations in a line of music. The ability to feel and shape these different qualities means artists can use qualities to create qualitative products, images, and music that other people can experience as well.

Every discipline comprises qualities that elude measurement. Managers learn to perceive such qualities as commitment, respect, and responsibility in their employees. To enhance learning, teachers foster such qualities as confidence and enthusiasm in their students and fend off qualities like discouragement. Athletes judge distance and speed by feel rather than by yardstick. In the perception of different kinds of qualities, different sensibilities are in play – feel, taste, vision, hearing, smell, intuition, balance – and these same sensibilities are used differently depending on the characteristics a particular medium or discipline presents. Achieving a facility with qualities demands that you expand and refine awareness in what you do.

In short, being effective with qualities means cultivating access to information and experience that the quantitative approach cannot reveal.

2. To use qualities to create something, you need to unify the mind and the senses. The result of this unity is 'feel' in a medium.
We typically think of thinking as a rational, abstract process that takes place in a mind. And, true enough, many kinds of thought – logical, algorithmic, symbolic – can happen with minimal input from the senses. But when we are working qualitatively, thinking cannot happen separately from the medium in which the work is made. This is an active process that depends on the ability to perceive and manipulate the qualities of materials. Because qualities are felt as sensory experience, thinking and feeling are integrated as the work unfolds, as problems are solved, as results are produced.

Often, we're encouraged to rely solely on quantitative information in order to remain objective. Conventional wisdom tells us that a mind clouded by feeling and involvement cannot escape the kind of subjectivity that impairs judgment. But imagine how you might accomplish your work if you were limited to quantitative information alone. Try choosing a business partner, a spouse, a home, or a career using only quantitative means.

In short, the unity of thinking and feeling on which qualitative work depends develops through work in a medium.

3. Because qualities vary across disciplines, we can experience the world in many different ways that elude the language and numbers that characterize quantitative thinking.

'Artistic tasks ... develop our ability to judge, to assess, to experience a range of meanings that exceed what we are able to say in words,' Eisner writes. 'Monet painted the very same haystacks four times during the same day not because he was interested in haystacks but because he was interested in the way light illuminated them at different times of the day.'[6] Using a light meter could provide a measure of light waves; skillful use of his paint and brush allowed Monet and viewers of his work to experience illumination in a way that using words or numbers could not.

Any medium or material treated artistically can provide a different avenue into different qualities; hence, a different avenue into human experience. Each new activity, profession, problem, hobby, and project we pursue exposes us to qualities that we must learn to perceive and appreciate. Each new endeavor means building new skills and capabilities, finding new avenues for communication and self-expression, and formulating new ways of seeing, understanding, and shaping the world. This kind of work satisfies the overriding human drive for growth.

In short, because qualities are characteristic to medium and discipline, each new activity brings a unique opportunity for personal development and growth – the fuel for internal motivation.

4. When we solve problems using our immediate experience of qualities, the solutions to those problems can be multiple and unpredictable.

Sorensen's ideas and Eisner's resonate strongly in this area. Solutions to artistic problems – or presidential problems – don't have single, certain, or correct answers. People dealing with problems like these depend, as Eisner says, on the 'most exquisite of human capabilities – judgment.' As work in the arts proceeds, it 'depends on the ability to cope with ambiguity, to experience nuance, and weigh the tradeoffs among alternative courses of action. These skills not only represent the mind operating in its finest hour, but are the skills that characterize our most complex adult life tasks.'[7]

This characteristic of artistic work demands a flexibility that is both responsive to change and focused on progress. Eisner often notes that artists delight in surrendering to surprise and to the unanticipated pos-

sibilities that their unfolding work reveals to them, because this means new opportunities can emerge and new experience can be had.

An Entrepreneur's Perspective

I'm a big believer – and this is something I've come to learn – in savoring surprises. If there's something that's really a big surprise, upside or downside, that's generally the real world speaking to you, saying there's something you don't yet understand. *Scott, Intuit founder*

In short, without the explicit development of qualitative thought that artistry demands, sophisticated mental operations like judgment, coping with ambiguity and uncertainty, balancing consequences, and responding effectively to surprise remain elusive.

Innovation and creativity require leaving the predictable behind. What makes this capability possible? A facility with qualities.

Qualitative Involvement in the Real World

'Not everything that matters can be measured, and not everything that can be measured matters,' Elliot Eisner would often tell his students. Practical activity across disciplines demands involvement rather than just measurement. The pleasures of involvement provide the motivation that demanding action requires. Enthusiasm, creativity, curiosity, and motivation all depend on involvement.

Qualitative involvement can productively integrate feeling and reasoning. When this integration occurs, artistic practitioners achieve unity with their medium; it's this unity rather than protocol that allows them to make judgments, develop ideas, create objects, imagine the future, make trade-offs, reach decisions, act in the moment, and design solutions.

Take my lesson with Eric Thomas (see chapter 1). He's teaching me to perceive qualities in my horse and use them to make judgments about action in response to changing circumstances. He struggles to explain something that can't be said but that must be felt. For my part, while trying to pursue a goal, I must simultaneously surrender my intentions to the unexpected qualities my horse presents without becoming dangerously hesitant. Until I can perceive these qualities and use them to shape how we move together, I'll be a precarious passenger rather than an artful rider. For both Eric and me, the qualities of experience that involvement in riding makes possible are unique to the sport; they can't

be achieved in any other medium. Like the painter in her studio, the two of us are working qualitatively, but in a discipline outside the arts.

A Financier's Perspective

What we do is always, always driven by the tangible, objective outcome. How did we do for you today or this week or this month or this five-year period? We're always being evaluated by how I invest your money. But a thousand people could do that. And the outcomes might be skewed a couple of percent this way or that way. Ultimately it's the relationship, and that's what we really try to achieve. The closer I am to the core, the greater the impact I have. It's not just how I do performance-wise, it's the impact on the life. *Craig, portfolio manager*

This connection between qualitative work in the arts and work in other disciplines has a venerable history. Standing out is a seminal 1983 book called *The Reflective Practitioner*, in which MIT professor Donald Schön highlights the similarities between fine artists and professionals across practice disciplines. Schön says:

> The artistry of painters, sculptors, musicians, dancers and designers bears a strong family resemblance to the artistry of extraordinary lawyers, physicians, managers and teachers. It is no accident that professionals often refer to an 'art' of teaching or management and use the term *artist* to refer to practitioners unusually adept at handling situations of uncertainty, uniqueness and conflict.[8]

The practitioners his book describes – an architect, a psychoanalyst, a manager, a town planner – achieve extraordinary results working outside the purely quantitative realm.

A few others have tried to tear open the intelligence envelope. Harvard University researcher Howard Gardner has written extensively on multiple intelligences. And such authors as Daniel Goleman have highlighted the importance of emotional intelligence to everyday life.

Despite these efforts, the purposeful development of qualitative abilities rarely happens outside the arts. Quantitative thinking is still equated with intelligence and remains the primary focus of educational programs. Qualitative thought tends to be overlooked, even shunned, in most mainstream schools. Its powers, like that of a mysterious magical object, are either feared or left to those willing to embrace perilous experimentation.

On the surface of things, this makes sense. Qualitative approaches

often seem dangerously vague and hard to pin down. Critics deem them too subjective and too individualized to rely on. Indeed, qualitative work is often hard to explain, record, or duplicate effectively. Ask musicians how they turn a string of notes into music, how they develop an ear, or how they pluck a string to create one mood or another with a single note, and you'll get different answers. Ask a chef how she develops a palate, layers flavors, or harmonizes ingredients to create balanced flavor in a dish, and she can't easily say. Ask a quality-sensitive teacher how he paces learning, judges student involvement, or designs learning that motivates, and he'll say it depends on the student, the subject, and the moment. When qualities are used to guide action, what works for one person can seldom be used by another to get the exact same results in another time and place.

An Educator's Perspective
All schools would probably say, 'We want students to be creative thinkers and to go as far as they are academically able.' But not everybody can put that into practice. It is very difficult to measure those things because it is so qualitative. There aren't measures we can use. *Gerry, Mabin School founder*

A qualitative approach embraces the unexpected, the subtle, the open-ended, the unique, the poetic; it escapes rules, single answers, or single perspectives. These features are by their very nature hard to pin down and can be quite unnerving to people who want precise information and specific answers. The quantitative approach gives us the means to predict and control what we can measure, to record and codify what can be clearly defined, to collect shareable facts, and to identify universal rules and laws. Yet to those who value situational solutions, this orientation can seem too confining, handcuffing their ability to use personal responses to immediate experience to generate solutions responsive to the moment at hand.

Real people doing pragmatic work are beginning to see the value of qualitative capabilities in areas normally reserved for those with quantitative expertise. At a 2009 design conference, Scott Cook, founder of Intuit, shared his thinking on how this dynamic plays out in the competitive world of corporations.

What I learned about the old style of business – about analytic and deductive models – it's no longer up to the task. I find it destroying the value, instead of creating value. And I think in our own company, we've had

to swing the pendulum drastically from a deliberative, top-down model with lots of debates and PowerPoint presentations to an emergent model – where the solutions and decisions emerge from individual action based on observation, based on trying things, on experimentation, not based on what the boss says. And the more I see patterns in successful firms, the more I see this is actually underneath it all, the patterns within some of the most successful changes in business in the last 25 years.[9]

The apparently dualistic battle between these two modes of thought is not the by-product of ill-intentioned people; instead, it's driven by an outdated response to the naturally competing dynamics that drive learning. My study of practitioners across disciplines produced information that makes sense of this tension. When you scratch the surface of real-time practice, this apparent rupture between quantitative and qualitative thinking transforms into *a dynamic interaction between two sides of the same coin*. If you know how to handle the interaction, you can turn it into a force that fuels action and progress.

chapter **3**

ANGELO'S KITCHEN

E difficile! How can I explain how I cook? It comes spontaneously. You feel a passion for it. I couldn't have done it without *passione*. Otherwise you are just a cook who makes food!

<div align="right">Angelo Cabani, Locanda Miranda restaurateur[1]</div>

A steep, narrow road takes travelers down through terraced olive groves and vineyards into the seaside town of Tellaro. Redolent of wild fennel and marjoram, the streets are bounded by medieval courtyard walls encircling kitchen gardens where potatoes, onions, zucchini, and tomatoes grow in the soft maritime climate brought in from the Gulf of Spezia. This is Liguria, and the people, the dialect, and the cuisine all reflect its deeply layered history.

I traveled here to meet Angelo Cabani, spend a week in his kitchen, and learn what he could teach me about cooking and artistry. When Angelo cooks, people come for the pure pleasure of eating his food. As is traditional in Italy, he cooks in the style of his region; seafood is his specialty. His restaurant, Locanda Miranda, is perched above Tellaro's Bay of Poets, a bay so beautiful it drew both Shelley and Byron to its shore.

Miranda is a gastronomic hotel with a restaurant that seats up to forty guests each night. Angelo serves his patrons with the minimal help of his family and one prep assistant. Angelo's son, Alessandro, plates each dish; Angelo's wife, Giovanna, makes the restaurant's desserts and serves tables with one helper. His kitchen is expansive and spotless, his fish fresh each morning. The aromas emanating from his giant stockpots are intoxicating. I'll never forget my first dinner at his table: potato gnocchi with scampi. Happily, this was also the first dish

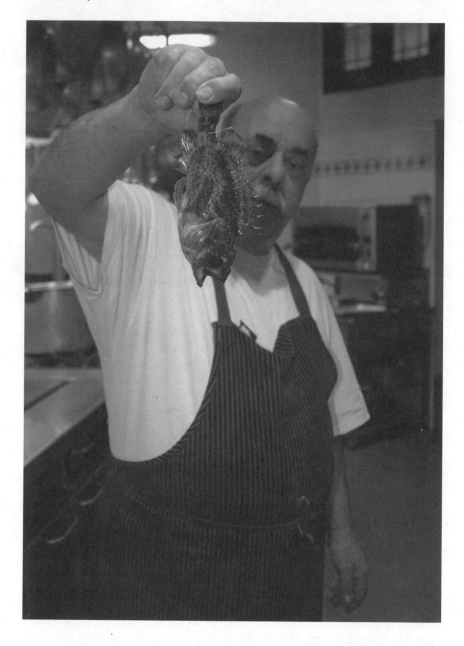

3.1 Angelo Cabani

he taught me to make. After three days of nonstop cooking and tasting, we took a break to sit and talk over coffee.

Angelo is a robust man whose demeanor is at once gruff and generously good-hearted. In the kitchen we understood each other pretty well across our language divide, but here we needed the help of our translator, food traveler Peggy Markel, who made my visit to Angelo's kitchen possible. Though willing to talk, Angelo was also a bit annoyed by my persistent questions.

ANGELO: *Voui parlare? Parla!* If you want to talk, talk! Ask your questions! You squeeze me like an orange! What do you want to know? You should learn the Italian language. *Molto bello!*
HILARY: Tell me about how you learned to cook.
ANGELO: I liked to play with pots and pans, but I also went to school. I studied to be a priest!

Giovanna pipes in from the kitchen, 'Until he smelled the scent of a woman at thirteen, then that was the end of that!'

ANGELO: I started to cook at home. I think it was just a part of my DNA. While everyone was out working or collecting olives, I prepared the food. My father worked as a cook. I started out with my mother and my aunt. We cooked simple food like spaghetti alle vongole [with clams], fried fish, and so on. I watched what they were cooking. It was the women who knew how to cook. Before the war everyone knew how to cook. Now, no!

I taught myself. Cooking is an evolution. The more you cook, the more you know, the more you can change what you're cooking. There weren't cooking schools back then. There were books, and you had to read to learn.

We opened the Miranda in 1959. In 1965, we spent five years in the mountains. Giovanna and I started cooking together. We had our own small restaurant cooking Tuscan food. Then we came back to Tellaro in the summers and we worked all seasons: meat in the mountains, and fish at the sea.

In 1970, cooking changed. It became Nouvelle Cuisine!

Angelo is colorful, engaging, and passionate, so listening to his tale is easy. My task, however, is to connect what he says to the development of artistry.

An Artistic System of Knowledge

As I wrote in chapter 1, artistry is an emergent capability that cannot be approached directly. People pursuing a new discipline too often try to replicate finished performance, which inevitably leads to frustration and disappointment. Much more productive is an approach to artistry that grows from an underlying system of knowledge that is made up of both qualitative and quantitative elements.

I've developed the model for a Knowledge System that supports the kind of artistry we've been exploring. Understanding how this system works to organize and integrate knowledge *that we use to guide our practice* is the key to achieving artistry. Students who understand this system can better use what artistic practitioners say about what they know and do, even when what they say is incomplete or inconsistent. In addition, students can use this model to learn effectively on their own. The model is composed of three different kinds of knowledge: **Directional, Conceptual,** and **Experiential**. In turn, each knowledge category tells you where you are headed, how to get there, and what to do to make it happen.

Directional Knowledge includes purposes, ideals, motivations, identities, directions, traditions, contexts, and missions. *These elements provide meaning, motivation, focus, and orientation.*

Directional Knowledge:
- Identity
- Motivation

Conceptual Knowledge includes concepts, theories, equations, themes, categories, heuristics, schema, recipes, standards, criteria, and models. *These elements provide understanding and organization and help practitioners preserve what they know about their medium.*

Conceptual Knowledge:
- Understanding
- Organization

Experiential Knowledge includes know-how, skills, sensitivities, feel, intuition, techniques, methods, expression, and awareness. *These elements allow you to experience and shape qualities in your medium to produce results.* Artistic performance is possible when all three kinds of knowledge are developed and work together seamlessly.

Experiential Knowledge:
- Awareness
- Skills

These three different kinds of knowledge are linked as they develop and as they're applied in action. Using my conversation with Angelo about cooking, I'll introduce the Knowledge System and demonstrate how it works (see figure 3.1).

I listen to Angelo with the goal of understanding his Knowledge System; as I do, his story becomes a window into his artistry. He describes the way of life that leads to his artistic handling of food. His words also point to the sometimes turbulent dynamics that move a Knowledge System forward; artistry is never static.

He has already revealed that his cooking is guided by the traditions of Liguria and Tuscany. This sense of place is a dominating feature of his **Directional Knowledge**. He is a man of Liguria and makes the dishes that such a heritage dictates. Regionality is also primary; when in Tuscany, he cooked like a Tuscan. As he says: 'Meat in the mountains, and fish at the sea.' The right food in the right place. When the local fishermen go on strike, Locanda Miranda closes its doors – a choice unimaginable to a chef motivated by a different directional ideal such as customer needs rather than by regional traditions.

At the same time, Angelo Cabani has been influenced by three social revolutions in the Directional Knowledge that guides his medium as a whole. There was a time when everyone in Italy, especially women, knew how to cook. Later, men became the workers who cooked in restaurants. And later yet, Nouvelle Cuisine changed everything. As Angelo and I talked further, he said more on this subject.

ANGELO: Listen to me. Before 1970, the cook was a fat figure in dirty aprons no one ever considered. They never even saw him; he was in the kitchen. They saw the waiters. They never thought to go in the kitchen and say, 'Good meal!' Then, around 1972, Nouvelle Cuisine was developed, and the wine steward became a sommelier, and cooks were elevated to a place they weren't used to. A mechanic is a mechanic; you didn't go raving about how he fixes your motorcycle! A cook prepared food; it wasn't special. Now it is different.

Changes in Directional Knowledge tend toward the revolutionary. They change our self-concept and our reasons for doing things. Happening within or around us, these revolutions change the meaning of our actions and choices; they change our place in society relative to others. Most recently in cooking, blue-collar kitchen workers have achieved rock-star status. Chefs now have their own TV networks.

As these global changes occur, they often lead to changes in a person's **Conceptual Knowledge**. As Angelo said, cooking is an evolution.

ANGELO: Cooking changed. It became Nouvelle Cuisine. I got interested and went to France to do a *stage* with Roger Verge. It was fantastic information.
HILARY: What did you learn?
ANGELO: I learned technique. Not technique, per se, but how they moved in the kitchen, how they organized. How you prepare to cook for twenty people by yourself. How you make a menu, how you look at the big picture, and then slowly bring it into form. How you fillet your fish in preparation for the dishes you want to use it for … How you compose the sauces and broths.
HILARY: Do you mean how to prepare dishes?
ANGELO: No, *no, NO,* the formation of the menu! How you set yourself up, so you can execute easily. With twenty people in front of you, you must prepare every dish exactly the same way. You can't serve one person more salt, less salt, more pepper, less pepper. Unless they ask … Always the same! To build a house you have to have a design, no? You can't build a house without a design. You have to prepare your ingredients the same.

Here Angelo reveals how his Directional and Conceptual Knowledge interact. He is a restaurant chef, not a home chef. He needs a way of organizing his work to create a large number of consistent dishes, so he works to build Conceptual Knowledge that helps him achieve this. And yet while he revised his way of shaping his kitchen and dishes based on his experience in France, he did not change his fundamental orientation toward food.

ANGELO: I am curious about all cooking, but I am not interested in the modern interpretation. A cook is not a scientist. It's gastronomical! You need to enjoy yourself at the table, have a nice glass of wine, seduce a woman … Maybe I am old-fashioned!

Angelo is guided by tradition, regionality, and sensuality. He organizes his work to achieve these, with a way of working that ensures ease and qualitative consistency as he cooks the same dishes over and over again. I still want to understand the **Experiential Knowledge** that Angelo uses to create and judge the particular dishes he serves. After all,

not all Ligurian chefs cook as he does, and not every dish is exactly the same. To better understand this aspect of his cooking, I ask him how he created his menu at Miranda and what makes the dishes unique to him.

HILARY: Angelo, tell me about Miranda's menu. What makes it yours?
ANGELO: No … I didn't create anything! I learned for years from oth-
 ers. No cook invents a dish. No one! In classical cooking, the various
 glace give food its characteristic taste. With rabbit you have to use
 rabbit; you can't use fish stock. If you make a beef filet, you want to
 use meat stock. Then of course you must make it to your own taste!

In this denial, his answer to my question highlights one of artistry's dynamic tensions – how *mastery* and *originality* interact (see figure 3.1). This dynamic is revealed in apparent contradictions that appear in his story. He is true to his classic roots; at the same time, he invents ways to produce the signature qualities he wants in his food.

ANGELO: For my stock, I wake up in the morning, and I put the broth
 on. This is classical. I have one white, neutral, that simmers for four
 or five hours. Then we make a red one, *pesce ungo* (not too concen-
 trated) for cooking the pasta. From the various broths, you can cre-
 ate the various sauces.
 In fact, this year I created another broth, an aromatic herb broth,
 to create an aroma that harmonizes with my white fish broth. It is
 the neutral white broth with a little white wine and various herbs.
 Marjoram, thyme, laurel, and more; these herbs give aroma to the
 sauces. Classical cooking also uses flour to thicken their sauces. In
 my case, I use a cooked potato, not potato starch, to make my sauces
 creamy. It's more delicate. It has a more genuine taste and is light
 for the fish.

A painter has a palette of colors and a conceptual theory of color mix-ing to guide her work. Based on his classical training, Angelo creates a 'palette' of seasoned, aromatic flavors with which to work. Angelo uses his theory of flavor mixing to imagine the flavors and aromas he wants in each dish. Then, to produce each dish, he must predict how his ingredients will taste, use these predictions and techniques to make the flavors he wants, then be able to recognize the tastes, textures, and aromas he wants when he achieves them. This is Experiential Knowl-edge at work.

On the surface of things, it may seem obvious that Angelo has this Experiential ability. Every cook must achieve this familiarity with the qualities of food; without it, he'd have to rely solely on recipes. However, the number of chefs who achieve this integration of imagination, skill, and palate to Angelo's level of performance are few indeed. Yet even as he achieves this refinement in the traditional dishes he so loves, Angelo also creates dishes to his own taste. To create the qualities he wants, he invents a new broth with a harmonizing aroma and replaces flour with fresh-cooked potato to achieve the lighter creaminess he wants in his sauces for fish. Arriving at this point of artistry, he has integrated mastery and originality in his work.

Figure 3.1 illustrates this relationship. The forces that drive mastery are conservative. Mastery brings predictability and control to action. By contrast, originality is driven by often unpredictable responses to immediate experience. Finding originality means leaving behind some of what you know. Artistry is driven forward by the interplay of these two competing forces.

Working within this tension, Angelo relies on the traditions established by others; at the same time, he follows his own taste. He learns from books; at the same time, he learns through his own work in the kitchen. He follows classic technique; at the same time, he cooks spontaneously in response to his ingredients. He uses broths as they have always been used; at the same time, he invents his own to give his dishes the qualities of aroma, lightness, and creaminess that he wants. Earlier, he told me he built on the recipes of others; later, he tells me recipes are not important. If you really want to learn to cook, he says, you must 'throw recipes away and learn from the pan.'

ANGELO: It's difficult, as there is no mathematics to describe cooking. There is no grand precise system to becoming a good cook or chef. The cook becomes a cook from experience. Your palate and your nose learn how to distinguish flavors. You need to understand; it is not in the head. It is the combination of aromas that is important. The more you stay simple, the more delicious it will be. You have to be spontaneous!

The dynamic interaction between mastery and originality – in Angelo's case, between tradition and his spontaneous response to his ingredients – contributes to the special performance we recognize as artistry in the work of others. It is a capability not easily won. For Angelo, it has taken a lifetime of passionate work.

Figure 3.1: The Knowledge System Model
This model demonstrates all the components of a personal Knowledge System: Directional Knowledge, Conceptual Knowledge, and Experiential Knowledge. By understanding these components, as well as the links between them, students can take more responsibility for their own learning and drive their own path toward artistic practice.

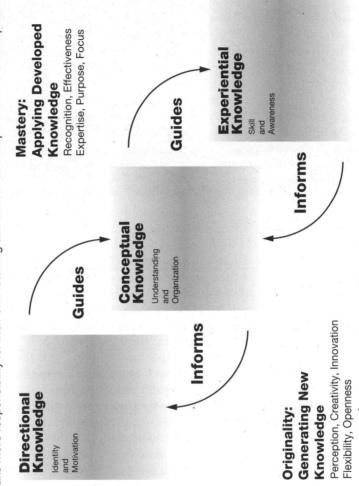

Directional Knowledge
Identity and Motivation

Mastery: Applying Developed Knowledge
Recognition, Effectiveness
Expertise, Purpose, Focus

Conceptual Knowledge
Understanding and Organization

Experiential Knowledge
Skill and Awareness

Originality: Generating New Knowledge
Perception, Creativity, Innovation
Flexibility, Openness

Guides

Guides

Informs

Informs

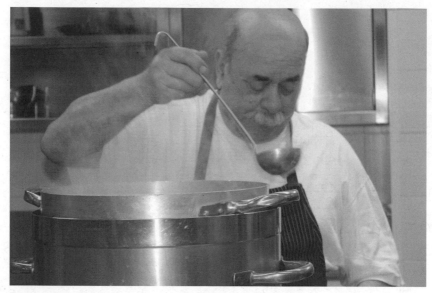

3.2 Angelo's Pan

ANGELO: Either you have a passion to cook or you are someone who
would rather buy food already cooked. You can't explain how you
arrive to be a good cook. It's true! First, the school teaches you tech-
nique. From the pan you learn to be a cook. You have to learn how
to balance flavors in the pan. From your ingredients you learn!
HILARY: Yes, but how do you learn from ingredients?
ANGELO: Oh ... I've been doing this for fifty years. It is something you
just know! Cooking is not something you can just read about; it's
subjective. You must understand that for spaghetti you need garlic,
olive oil, and tomato. You have your ingredients, but you are the
one who cooks it.

Angelo responds to this question as many artists do, with a passion-
ate burst of generalized declarations. After fifty years of cooking, how
he learned has faded from his mind, while the passion that drove him
to learn still burns on.

ANGELO: *E difficile!* It's difficult to explain after fifty years. How can
I explain how I cook? It comes spontaneously! You feel a passion

for it. Otherwise, this type of work one wouldn't do. It's *pesante*! [heavy]. For instance, my son is thirty-five years old. I have never seen him take a swim in the sea. What does that mean? I have sacrificed my life in this kitchen. That means I couldn't have done it without *passione* for it. Otherwise, you are just a cook who makes food!

Listening to Angelo talk about his sacrifice, his commitment to the work, and the passion that drives him, it might be easy to feel discouraged. After all, most of us don't have fifty years of immersion in a food culture ahead of us and might not even want such a demanding life. Does this mean that artistry is not an option? If you want to be more than just a cook who makes food, how do Angelo's story and the notion of a Knowledge System help?

More Than Just a Cook Who Makes Food

Figure 3.2 summarizes Angelo's personal Knowledge System. Replicating Angelo's Knowledge System or the Knowledge System of any other artist is not the point of taking this approach. In any field, there are as many different Knowledge Systems as there are artists. Had I talked with a young French Nouvelle chef, or a culinary proponent of the Slow Food movement, or a mother of five, I would have heard a very different story about how each handles her ingredients, what was important to each, and the kinds of eating experience each wants to create. What would have been common to all is the categorical structure of their knowledge and the evidence of robust content in each category.

Using this Knowledge System concept as a way of looking, students can learn from any particular artist about the make-up of that artist's unique system. Students will experience what any particular Knowledge System can and can't produce by looking to the products it generates. Students can uncover the connections that allow knowledge to work effectively, as well as understand the utility of different elements. They can understand differences between artists, and they can more easily make sense of what artists say and do as they try to explain or teach. Ultimately, students of artistry must develop their own Knowledge System based on the learning opportunities – people and experiences – they encounter and design. Making this a conscious effort is the secret to achieving artistry in any field when it doesn't come naturally.

The subsequent chapters will describe each knowledge category in

Figure 3.2: Angelo Cabani's Personal Knowledge System

Using the Knowledge System model, we can capture and give meaning to what Angelo says about his personal approach to cooking. As students of artistry, we can use this model to interpret the often abstract, paradoxical, and inconsistent things that Angelo, like most working artists, says as he describes his practice.

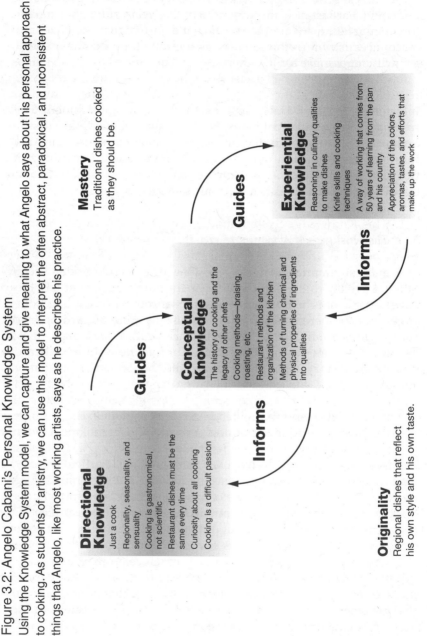

Directional Knowledge

Just a cook

Regionality, seasonality, and sensuality

Cooking is gastronomical, not scientific

Restaurant dishes must be the same every time

Curiosity about all cooking

Cooking is a difficult passion

Guides

Conceptual Knowledge

The history of cooking and the legacy of other chefs

Cooking methods—braising, roasting, etc.

Restaurant methods and organization of the kitchen

Methods of turning chemical and physical properties of ingredients into qualities

Guides

Experiential Knowledge

Reasoning in culinary qualities to make dishes

Knife skills and cooking techniques

A way of working that comes from 50 years of learning from the pan and his country

Appreciation of the colors, aromas, tastes, and efforts that make up the work

Informs

Informs

Mastery

Traditional dishes cooked as they should be.

Originality

Regional dishes that reflect his own style and his own taste.

detail, reveal how a Knowledge System develops, and show both students and teachers how they can use it to design learning that enhances their efforts. Here I'll summarize how a Knowledge System can make reaching artistry a real possibility – especially for those who find artistry discouragingly elusive.

Traditional approaches to artistry tend to be fragmented. Students rely on resources scattered among classroom curricula, formal and informal internships, and in large part the school of hard knocks. These resources are typically driven by the underlying belief that artistry is a natural talent rather than a developed capability; hence, they place little emphasis on the design of learning and teaching artistic capabilities. Learning designed around the Knowledge System concept has five distinct advantages that these typical strategies do not.

1. This Knowledge System model reveals the previously mysterious workings that generate artistic performance.
Every personal Knowledge System has the same Directional, Conceptual, and Experiential elements. Knowing what these elements are and how they interact gives students a way of identifying what they need to learn. Students will be able to track the impact of gaining knowledge on their performance level. The Knowledge System approach gives students a way to identify gaps in knowledge and to design learning to fill them. An explicit record of a Knowledge System can be used like a map to record, explore, and develop effective personal knowledge.

2. The orientation a Knowledge System provides can neutralize the overwhelming emotional experiences generated by early inexpert efforts.
Emotional reactions to novelty, uncertainty, and personal incompetence tend to distract, confuse, and mislead students. But with map in hand, the Knowledge System allows students to put their attention where it's most useful. Each category of knowledge requires a specialized learning approach, as do the connections between categories. Characteristic difficulties can be anticipated, so learning can be appropriate, focused, and systematic. Concepts acquired cognitively need to be grounded in experiential practice if they are to be used effectively. Equally critical, the relevance of concepts is determined by the identity and outcomes that motivate action. The alignment of these three categories produces the unity of awareness and action that makes artistry possible.

3. The Knowledge System approach to artistry allows students to transform failure's discouraging blows into usable information.
Understood simply as Knowledge System failures, rather than as indicators of stupidity and incompetence or predictors of missing potential, errors can usefully reveal three important gaps in a Knowledge System: (1) incomplete knowledge in any category, (2) inconsistency in knowledge across categories, and (3) breaks in the connections between knowledge categories. Again, different means are needed for different ends, and a different learning effort is needed to overcome each of these gaps. Knowing where and how to invest energy is a distinct advantage for any learner.

4. Taking a Knowledge System approach to failure means that the potential conflicting forces that drive mastery and originality can now be used effectively.
Proponents of mastery typically value reliability, efficiency, and automatic skillfulness. They seek to constrain surprise and so reduce errors caused by lack of skill and unpredictable events. By contrast, proponents of originality value openness and creativity. They seek to fend off predictability and constraint and so escape errors caused by the blind application of routine and outdated theory. When practitioners focus on developing an artistic Knowledge System instead of merely avoiding errors and accomplishing predetermined goals, they're more able to respond to unanticipated qualities and events skillfully and openly. When the development of a Knowledge System is your focus, learning is driven by the passionate pursuit of new experience, which can then be further refined.

5. A Knowledge System can be used to understand change and deal with it.
Change is often as disturbing as it is unavoidable. Three different kinds of change drive progress in artistry, each characteristic of one of the three knowledge categories. Changes in Experiential Knowledge come incrementally and adaptively during hours of practice in a medium. Changes in Conceptual Knowledge tend to be evolutionary in nature. Conceptual advances come from the accumulation of practice time, and are experienced as large and small revisions to how experience is understood and organized. When changes in Directional Knowledge occur, they often bring transformation; new ways of seeing and being in the world emerge. All three kinds of change are unavoidable once

artistry is established as a goal. Explicit development of a Knowledge System allows students to anticipate, even seek, the kind of growth that will help them move forward in all three knowledge categories.

Thus far, we've looked closely at a few practitioners who employ qualitative skills and intelligence, and we've introduced the underlying knowledge that enables their artistry. In the following chapter, we will step directly into the workings of this Knowledge System and learn about the elements, forces, and mechanisms that make it run.

THE TERRITORY, THE MAP, AND A COMPASS

I felt short of breath when I saw a shot of the Danish explorers Knud Rasmussen and Peter Freuchen, men of wild courage yet keen intellect, huddled beneath the Greenland Icecap. We call them explorers, but I knew that look in their eyes. They were seekers, and that is a different thing. They sought that spot from which in every direction lay one of the essentials of self-knowledge – uncertainty.

Alvah Simon, *North to the Night*[1]

When we take a quantitative approach to physical science, we engage the world around us with instruments in our hands and numbers in our minds. We calibrate these instruments with standardized units to measure not just mass and weight, but sounds and colors and tastes. (The Dorset Naga chili pepper, reputed to be the hottest in the world, rates 960,000 Scoville heat units.) Even in the 'softer' social sciences, we assign numeric values to qualitative features when instruments are unavailable; with these numbers we create standardized methods to record and generate statistical information – rating customer satisfaction, for example, on a scale from 1 to 10.

In the best of all quantitative worlds, we eliminate the human element.

But, as we've seen, quantitative methods often break down in the face of enigmatic problems. What then? Sure, some advanced mathematicians and physicists have found quantitative ways of working with uncertainty and ambiguity. For most of us, though, these features call for nothing less than our personal involvement. When this happens, the human element returns to the forefront; these are the times that test our facility with qualities.

The chef, the horseman, the painter, the president, the CEO – all the people we've met thus far – learned to work qualitatively, even when that was never part of their formal education. How do they achieve such qualitative expertise? They do it by relying on the *Knowledge System* that underpins artistry across every discipline. And even if few seasoned practitioners are consciously aware of the Knowledge System they use every day in pursuit of their craft, still that Knowledge System allows them to replace quantitative instruments with their own qualitative involvement when that's what their work demands. For those of us in the early stages of learning a profession or pursuing a dream, a conscious understanding of this Knowledge System will help experience to become a better teacher.

In this chapter, we explore three distinct kinds of knowledge that grow separately but together in the cultivation of any practice. They are *Experiential Knowledge*, *Conceptual Knowledge*, and *Directional Knowledge*.

The Territory of Experience: Awareness and Skill

Gaining useful Experiential Knowledge means developing an awareness of qualities, as well as the skills to create and manipulate these qualities in a particular medium.

Experiential Knowledge in the service of artistry is composed of two elements: awareness and skill (see figure 4.1). Chefs who deftly blend these two elements in their work are at once sensitive to flavors and accurate with their knives as they work to create delicious food.

An Educator's Perspective

I think young children are born wanting to learn. They're interested. They're eager. They're enthusiastic. They enquire. They touch things. So, for me, I want to be harnessed by that and be pulled along by them, rather than pushing them. *Gerry, Mabin School founder*

Photographers are at once aware of different intensities of light and skillful at using their equipment to capture that light in compelling images. Riders respond to what they feel, and they use the bit, the reins, their seat, and their legs to shape the horse's body and motion into adept maneuvers.

The goal of developing Experiential Knowledge is to unite awareness and skill in a particular medium.

Figure 4.1: Experiential Knowledge

Of the three knowledge categories, Experiential Knowledge is the one most directly involved in the hands-on qualities of the work; it comprises the practitioner's nuanced awareness of those qualities, as well as the skill to shape them.

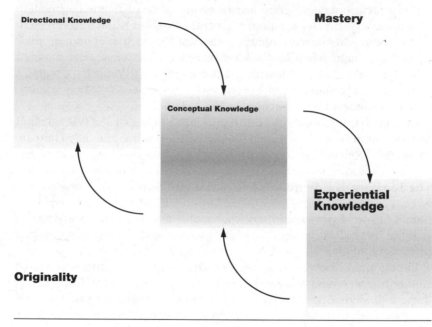

Seems straightforward, right? Well … it isn't. Unfortunately, awareness and skill seldom develop simultaneously, and they usually develop from different kinds of practice.

Awakening Awareness

The following excerpt from Elle Newmark's novel *The Book of Unholy Mischief** chronicles the adventures of a fifteenth-century street urchin in Venice. Follow the narrator's experience as his awareness of taste awakens.

* Reprinted with the permission of Atria books, a Division of Simon & Schuster, Inc., from *The Book of Unholy Mischief: A Novel* by Elle Newmark. Copyright © 2008 by Elle Newmark, Inc.

The chef's remarks about the pomegranate reminded me of his approach to chopping an onion. Did paying attention to food really change the experience of eating it? I eyed the green grapes and the buttery Fontina cheese on the table, and I wondered whether a grape would taste any different if attention were paid.

I picked off a single grape and observed it. The color was something like that of a green apple, but with a fragile translucency and a dull sheen. I turned it in my fingers, pressed lightly, and felt the firm, plump surface give under my fingertips. I said a silent *grazie a Dio* before placing it on my tongue, and then I rolled it around in my mouth, postponing the bite. The anticipation reminded me of Francesca – when would I see her again? The thought made me bite down hard. Still I forced myself to take note of how the skin offered a teasing resistance. The grape split and flooded my mouth with a flavor so delicate it was almost an aroma. I closed my eyes and sucked on the burst grape, enjoying the opposing textures of skin and pulp. I chewed slowly and allowed the nectar to saturate my palate. It seemed as though I'd never before eaten a grape so exquisite as that one. I looked at the bunch of grapes on the table and thought about eating them all that way, paying attention, each one a perfect little miracle. I frankly found the prospect exhausting, but I chewed my grape with reverence for a long time, and it felt like eating all the grapes in the world at once. It was just a grape, but somehow it felt like a beginning.[2]

How can we achieve this kind of awareness? How does new awareness change us? Qualitative sensitivity comes only as you immerse yourself into qualities themselves. You can ingest food, listen to sound, play and build, observe colors, light, and objects, or interact with others and even industries to find out what you can make of them. This is a process of learning to see, taste, hear, and feel; of discerning and discriminating through participation and observation; of making distinctions, becoming a connoisseur; and of developing a personal intimacy with the qualities that emanate from the activity of your interest.

An Executive's Perspective
Design thinking is a very different outlook on problem solving. If you learn problem solving in business school or in a science program, it's very analytical. You analyze the problem and identify possible solutions. Then you ask, 'What are the pros and cons of the solution.' But designers never start by analyzing the problem; they start with the *user*. They just observe. They're not looking for *the answer*. In design, there is no right answer. *Claudia, P&G vice-president*

Once you've experienced it, this intimacy is indelible. It changes you forever by establishing a new level of awareness that few people can easily forsake. But, however attractively profound these advances may be, they are not easy to come by. Just exposing ourselves to qualities doesn't mean we'll perceive them. Developing the ability to be aware isn't automatic; it requires an active, effortful search.

Research on perfect pitch challenges our popular notions about qualitative talent by showing that qualitative awareness is a learned capability. George Kembel, executive director of the Hasso Plattner Institute of Design at Stanford, demonstrated this challenge at a recent Chautauqua Institution conference.[3] First, he plucked a note on a ukulele and asked the members of his audience to identify the pitch. Only a small handful recognized the G-sharp. If you polled the general population of the United States and Europe, he said, you'd find that only one person out of 10,000 displays perfect pitch. But in populations of children intensively exposed to music at a young age, the figure rises to 14 percent. And, when children are exposed to both music and a tonal language, such as Mandarin Chinese, the proportion displaying perfect pitch rises to a startling 75 percent. Drawing from research conducted by Diana Deutsch,[4] a psychologist at the University of California at San Diego, Kembel made his case: that this capability we see as being so rare is actually a learned trait, provided people 'are given the right exposure at a critical period.' Deutsch's research and his own observations on creativity, Kembel said, demonstrate that humans have a lot more qualitative potential than we realize.

Qualitative learning is indeed challenging. When we're exposed to unfamiliar sensations, it's often difficult even to notice them, much less to experience them deeply. Still more elusive is the understanding of what sensations *mean* relative to our efforts.

In the beginning stages, awareness develops mainly as a sensory process. Awareness – of taste, touch, balance, sound, atmosphere, interactions – reaches its highest level when the apparent division between the artist and the qualities in his medium disintegrates into that unity I introduced earlier. *Unity means thinking can happen in the qualities of the medium itself; the need for translation disappears.*

If the idea of unity with a medium is hard to comprehend, consider the following experience, related by Ana Sortun, the James Beard Award-winning chef of restaurant Oleana. In her book *Spice: Flavors of the Eastern Mediterranean*, Sortun describes the moment when this unity

first emerged for her. As a young chef, she worked under Tunisian-born chef Moncef Meddeb, a man famous for bringing upscale, cutting-edge Mediterranean food to Boston when it was still a town steeped in New England fare. Sortun writes:

> Moncef pushed me toward a deeper understanding of food and flavors. I was twenty-four at the time, working on my own style and identity in the kitchen. One night after work he called, and I told him I was starving. He told me that I should keep fruit around for late-night snacks, but all I really wanted was eggs and bacon. At this point, Moncef launched into a 20-minute discussion about oranges. He described in depth the fragrant spray of oils releasing as the skin of the orange is broken and the juices running down one's hand as the fruit is peeled. After listening to him, my hunger for an orange was nearly unbearable. What happened to me that night as a chef was a milestone. I was able to taste food when I thought about food.'[5]*

Achieving this kind of knowledge, Sortun and people like her establish a seamless connection with their medium; it's a connection they usually find difficult to describe. When this artistic awareness is achieved – that is, when work becomes a process of living through qualities – then work in a medium becomes a way of being that is difficult to reduce to words. Attempts at description are often futile: the words that do come tend to be vague or poetic.

Skill Follows Awareness, Not Recipes or Routines

However enjoyable or intense, awareness without skill is frustratingly impotent in practice. Developing skill also takes a lot of work, intention, and participation – but of a different kind. Chefs learn the steps of browning, braising, and poaching. They learn the knife skills of slicing, dicing, and deboning. Musicians learn to hold their instruments and the fingering necessary to produce sound. They spend years practicing scales and exercises to develop the dexterity and precision needed to play compositions for pleasure or performance. Athletes invest hours in conditioning their bodies and perfecting plays and maneuvers. Developing skill takes practice – practice, practice, and more practice.

The demanding effort required to develop high levels of skill in any activity is a familiar story.

The following passage is from an essay called 'Federer as a Religious Experience' that David Foster Wallace wrote for the *New York Times Magazine* in 2006.* Notice the ways in which deep awareness and complex skill blend:

> By way of illustration, let's slow things down a bit. Imagine that you, a tennis player, are standing just behind your deuce corner's baseline. A ball is served to your forehand – you pivot (or rotate) so that your side is to the ball's incoming path and start to take your racket back for the forehand return. Keep visualizing up to where you're about halfway into the stroke's forward motion; the incoming ball is now just off your hip, maybe six inches from point of impact. Consider some of the variables involved here. On the vertical plane, angling your racket face just a couple degrees forward or back will create topspin or a slice, respectively; keeping it perpendicular will produce a flat spinless drive. Horizontally, adjusting the racket face ever so slightly to the left or the right, and hitting the ball maybe a millisecond early or late, will result in a cross-court versus down-the-line return. Further slight changes in the curves of your groundstroke's motion and follow-through will help determine how high your return passes over the net, which, together with the speed at which you are swinging (along with certain characteristics of the spin you impart), will affect how deep or shallow in the opponent's court your return lands, how high it bounces, etc. These are just the broadest distinctions, of course – like there's heavy topspin vs. light topspin, or sharply cross-court vs. only slightly cross-court, etc. There are also the issues of how close you're allowing the ball to get to your body, what grip you're using, the extent to which your knees are bent and/or weight's moving forward, and whether you're able simultaneously to watch the ball and to see what your opponent's doing after he serves. These all matter too. Plus there's the fact that you're not putting a static object into motion here but rather reversing the flight and (to a varying extent) spin of a projectile coming toward you – coming, in the case of pro tennis, at speeds that make conscious thought impossible. Mario Ancic's first serve, for instance, often comes in around 130 m.p.h. Since

it's 78 feet from Ancic's baseline to yours, that means it takes 0.41 seconds for his serve to reach you. This is less time than it takes for you to blink quickly, twice.[6]

If you were Federer, the next thing you'd probably do is hit the winning point without a second's thought. An artist's unity with his medium means awareness and skill come together in action that occurs within the blink of an eye. When he achieves this unity of awareness and skill, he no longer needs translation time. Fans enjoy seamless performance they can barely comprehend; artists enjoy an incomparable thrill.

This sensory and kinesthetic unity supports artistry in two ways. First, when awareness guides action, the application of skill can leave the realm of mere mechanics. Skill then flows in response to awareness of immediate or anticipated qualities. This means skill works automatically and responsively, rather than in reference to a recipe or a routine.

An Executive's Perspective
First of all, every problem is fun. The bigger the problem, the more fun it is. That's just a mindset that designers have. They love big hairy problems. If it's real simple, then it's not interesting. Designers are not going to follow the simple cookbook approach. *Claudia, P&G vice-president*

Second, it is the intense experience associated with this accomplishment – the effort it takes to fully taste a grape or to send a ball into perfect flight – that makes practicing meaningful to the cultivation of artistry. When practice is disconnected from this kind of intense personal experience, it can become all too rote, laborious, dull. By contrast, when awareness guides skill, working in any medium becomes an irresistible activity full of pleasures and rewards.

The legendary big-wave surfer Dave Kalama talks about the compelling nature of this immediacy. 'There is something about riding a sixty-to eighty-foot faced wave,' Kalama says, 'that draws something out of you, where you call upon and experience the deepest sense of who you are. The wave commands so much focus and attention, it's the only thing that matters for a few seconds. It's very purifying because, as far as you are concerned, nothing else exists.'[7]

Nothing motivates practice more powerfully than this kind of intensity.

Getting to this advanced level is never easy. Until artistic unity between actions and the medium is achieved, those actions are often disconnected from immediate events, and they're likely to be ill-timed as events unfold. Meanwhile, the student suffers the anguish of failure in all its forms: from disappointment in a product or performance to brain-rattling pain when the wave comes crashing down. When we miss or misunderstand qualitative information, the effects of our actions are unpredictable and disappointing, and our results fall short or diverge from everything we intended. We play sour notes, produce unappealing dishes, crash into sand and rocks, miss the ball, and lose control of a thousand pounds of galloping horse. Little else in life is as discouraging as this.

Beginnings are always transient and fragile. When your sensitivity and your skill first unify in action, it will be all too fleeting, its scope all too limited. This is the dynamic territory of experiential learning that we'll explore later. Understanding the obstacles and the pitfalls of this territory will help you persist through the fragile and erratic early steps.

Building your Conceptual Knowledge in a medium will also help flatten experiential hills and valleys by allowing you to sort out, evaluate, organize, prioritize, and sequence what you encounter and produce. Conceptual Knowledge can both buffer the impact of disorienting or disruptive outcomes, and help guide unity as it emerges (see figure 4.2).

Maps of the Conceptual World: Understanding and Organization

Learning from one experience is difficult. Surprisingly, writes organizational theorist James G. March, learning from many experiences is hardly easier. Unless they're disastrous or fantastic, we simply miss many experiences. Many others, we misunderstand. This difficulty makes the development of Conceptual Knowledge critical.

Conceptual Knowledge records what we understand about quantities and qualities, often in a sharable form. It gives us the ability to imagine how our actions will shape our medium, understand what we encounter, and then evaluate what we produce as we work.

Using Conceptual Knowledge helps us organize, conserve, and evaluate what we do and feel as we act in a medium. A cooking recipe is simple example. Consider the following recipe for osso buco, a classic Italian dish of braised veal shanks.

Figure 4.2: Conceptual Knowledge

Of the three knowledge categories, Conceptual Knowledge is the easiest to share between people; it comprises qualitative and quantitative theories, models, and rules of thumb in any discipline. This is the interpretive knowledge that allows people to organize and understand what they experience so they can pursue their ideals.

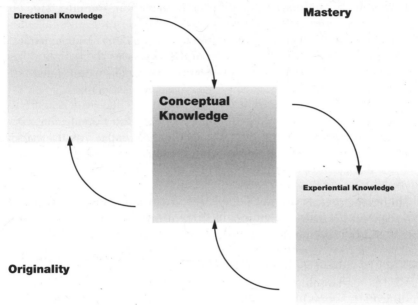

Classic Osso Buco

Preheat oven to 325–350°F
4 lbs. veal shanks cut 1.5 inches
flour
equal parts olive oil and butter

Season, flour, and brown shanks very dark golden in olive oil and butter. Set meat aside. (Or add 2–3 tbsp of flour at the end of browning the vegetables.)

2 onions chopped very fine (2 cups)
1 carrot chopped very fine (1 cup)
1 celery (or fennel) chopped very fine (1 cup)

Sauté vegetables until golden. Add wine, deglaze, and reduce by half.

½ bottle dry white wine (1.5 cups)
14.5 lbs. chopped tomatoes and juices
6 garlic cloves, chopped
grated zest of 2 oranges
1 cup rich stock (3–4 cups cooked
down)

Add wine and cook down to ⅓. Add all ingredients (hold back stock till last) and cook a bit. Add meat. The liquid should come at least halfway up the shanks – add stock as needed. Bring to a boil. Braise until meat is falling off the bone – approx. 2 hrs.

Remove meat. Defat and then reduce sauce if necessary.
Strain if you want a more refined sauce. Balance seasoning.

Gremolata
4 garlic cloves minced
1 bunch parsley
grated zest of 2 lemons

Chop garlic, parsley, and lemon zest together and sprinkle over the shanks to serve.

This recipe reveals some of what chefs have learned after centuries of experience with making the same dish. It records a list of typical ingredients and the routine sequence of activities that create the right texture and taste. It provides quantitative information (some of it precise, some less precise) about amounts of ingredients and cooking temperatures, as well as such qualitative indicators as 'golden brown,' 'very fine,' and 'falling off the bone,' so chefs can identify when they achieve the correct qualitative results. It assumes skill in a range of techniques, including chopping, sautéing, browning, deglazing, reducing, defatting, and the like. And it leaves some choices up to the judgment of the chef-of-the-moment: reduce sauce if necessary; strain if you like; use celery or fennel; balance the seasoning. It says nothing about the qualities of the taste or the eating experience the dish is supposed to offer the person who eats it.

A novice would probably need a lot more information to be successful with this dish; an experienced chef, a lot less. An inexperienced chef might need something closer to an algorithm with detailed information about how to accomplish each step, maybe even photographs that record the qualitative features used to assess the stages of cooking. An experienced chef, even one who's never made osso buco, might need to know only the list of ingredients and that the dish is a 'braise.' Somewhere in between the novice and the master chef is a cook who might need a gen-

eralized sequence as follows: Brown meat, then add aromatics, deglaze, add stock, braise, finish sauce, and serve with garnish. In the right hands, these three different conceptual renditions could lead to the same dish, or at least a similar dish … differences in ingredients aside.

An Educator's Perspective
When you're actually teaching, you're honing everything; you're customizing everything. Every question you're asking, every decision you make, you're reacting to what's happening at the moment with the children, whether it's one child or whether it's a group of them. *Gerry, Mabin School founder*

While missing the visceral immediacy and detail of experience, Conceptual Knowledge has three advantages that this common recipe illustrates.

• First, Conceptual Knowledge is abstracted from experience and captures complex Experiential Knowledge in a wide range of simplified forms.
• Second, unlike Experiential Knowledge, Conceptual Knowledge can be made tangible and is shared easily with others.
• Third, Conceptual Knowledge can be reviewed in your imagination before being applied in the concrete world of experience.

These three features mean that you can learn Conceptual Knowledge without encountering the risks of experiential learning. Thinking, reasoning, and learning are freed from the actual constraints of media, of real-time demands, and of the consequences you can't avoid when developing Experiential Knowledge. Unconstrained by reality, working conceptually is an act of imagination.

On the downside, these same features can mean that we can learn concepts without ever being involved in anything. When learned 'by the book,' Conceptual Knowledge has two potential liabilities. First, it means, whether you know it or not, you know more in your mind than you can do with your hands. When you try to get things done, this imbalance will create problems at every turn. All of us have experienced the rude awakening of finding we are less capable than we imagined.

Second, when the Conceptual Knowledge we learn is isolated from action, it can seem uselessly dull and disconnected from what we feel in the moment. Impatient with learning seemingly irrelevant ideas, many

budding practitioners and professionals skip over Conceptual learning. Unable to resist the Experiential thrill of action, they jump in and trip over what might have been avoided, or they invest energy in reinventing the wheel.

Varieties of Conceptual Knowledge

Every discipline has a storehouse full of shared Conceptual Knowledge; every practitioner has a set of personalized variations of this same knowledge. Acquiring Conceptual Knowledge will occupy much of your early learning in any discipline. Many disciplines rely on Conceptual Knowledge that is rooted in quantitative thinking and protocols. Based on physical and logical laws, this knowledge enjoys broad acceptance. It has made its way into textbooks around the world; this easy access makes learning this information relatively straightforward. The Conceptual Knowledge that's designed to work with qualitative experiences is more distributed, interpretive, and contentious, which means learning may cause you a bit more difficulty.

The Conceptual Knowledge that's tailored for qualities comes in many different formalized forms: theories, frameworks, heuristics, maps, categories, equations, taxonomies, evaluative criteria, and more. It can also come in such narrative forms as stories, anecdotes, rules of thumb, parables, and sayings. Some of this Conceptual Knowledge is explicit; much remains intuitive to those using it. Some concepts are highly detailed; others offer more global advice, such as, 'Keep your eye on the ball.' Some concepts attempt to capture predictable sequences; others predict important relationships. Still other concepts help you identify the qualitative events that signal approaching success and error.

I have included several examples of diagrams from different media that conserve Conceptual Knowledge (see figures 4.3–4.6) – a wine wheel, the dressage pyramid, the reverse engineering flow, and a summary of the different optical properties of different-size camera lenses. The wine wheel categorizes the aromatic qualities of wine, so tasters can develop gustatory sensitivity. The dressage pyramid captures the sequential steps and the qualities that accompany them in the developing dressage horse for trainers (see color section, photo 2b). The reverse-engineering diagram guides managers through a structured analysis of the categories critical to strategic choice structuring and decision making. The optics diagram captures the different optical properties each

Figure 4.3: The Wine Wheel

While such qualities as the taste and aroma and feel of wine often seem ineffable, still conceptual tools like this wine wheel can help the novice palate learn something of the connoisseur's experience. Moving back and forth from the conceptual tool to their own firsthand experiences, novices, with practice, can develop a palate of their own.

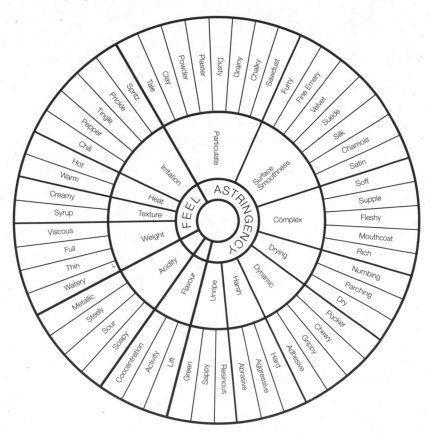

Figure 4.4: The Dressage Pyramid
Like all equestrian sports, dressage is a highly evolved discipline. The needed communication between horse and rider is developed through a training sequence that allows a shared set of cues to be understood and implemented. This training sequence also helps the horse develop both the mental and physical skills to advance correctly. A conceptual tool like the dressage pyramid organizes this effort into staged categories, and it shows how advanced stages build on more basic ones.

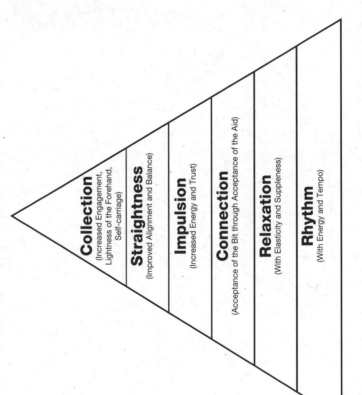

Collection
(Increased Engagement, Lightness of the Forehand, Self-carriage)

Straightness
(Improved Alignment and Balance)

Impulsion
(Increased Energy and Trust)

Connection
(Acceptance of the Bit through Acceptance of the Aid)

Relaxation
(With Elasticity and Suppleness)

Rhythm
(With Energy and Tempo)

Figure 4.5: Reverse Engineering for Corporate Strategy

The design of organization strategy is indeed an enigmatic problem that is approached diversely. This reverse-engineering conceptual diagram is one take on which categories managers should consider. It also shows how the relationship between these categories can be used to structure strategic choices. Diagram © Roger Martin.

Industry Analysis	Customer Value Analysis	Analysis of Relative Position	Competitor Analysis	Strategic Choice

Segmentation
What must we believe are the strategically distinct segments?

Industry Structure
What must we believe about how attractive the target segments are?

Channel
What must we believe that the channel values?

End-Customer
What must we believe that end-customers value?

Capabilities
How must we believe our capabilities stack up against competitors?

Costs
How must we believe our costs stack up against competitors?

Prediction
How must we believe our competitors react to our actions?

Strategic option in question

Figure 4.6: Camera-Lens Optics

Photographers shape the composition of images by choosing a lens. In order to create the image they imagine, students of photography must learn to predict the effect of each of their lenses on the subject they hope to capture. Conceptual Knowledge about the relationship between the length of a camera's lens and the resulting field of view is captured in this diagram. Connecting this information to the corresponding Experiential Knowledge is one of the keys to using photographic equipment with mastery.

kind of lens offers the photographic artist. In this graphic form, these concepts capture a summary of what advanced practitioners know and what novices must learn to experience and implement.

The hope is that, with all its varied forms at your disposal, Conceptual Knowledge will help you decide where to pay attention, know what to do in what order, interpret events, identify important relationships, predict how action will unfold over time, decide how you should approach important elements, and help you judge the products of your work when multiple outcomes are possible.

In any field, there is more Conceptual Knowledge available to you than you will ever be able to learn or use in a lifetime. Given this abundance, how do you choose it and use it when artistry is your goal?

Making Conceptual Knowledge Work for You

Conceptual Knowledge is often used like a recipe to constrain action and reduce error. While possibly useful to early learning, Conceptual Knowledge eventually presents an obstacle to artistry when it is limited to this constraining function. I explore this potential learning trap more fully in chapter 8. The artistic take on using concepts is somewhat different. In addition to providing help that both guides awareness and structures action, Conceptual Knowledge should also help you *understand* the qualities you experience, *act* in response to what you understand, and *evaluate* what you create.

In addition, because the concepts that are used to work with qualities don't often provide predetermined actions and outcomes, openness is designed into their structure. Remember Angelo Cabani from chapter 3? He said that a chef must 'learn from the pan.' This simple Conceptual notion gives a student of culinary qualities an operating principle that helps ensure he or she will be able to:

1. Learn to connect important qualities to the Conceptual Knowledge that drives action.
2. Find overlooked or novel qualities by keeping an eye out for surprises.
3. Design experiments that might lead to the redesign of prior knowledge in all three categories.

None of these three features is native to concepts that are designed to work with quantities. But they surely do characterize the concepts that make artistry possible.

Understanding, Acting, and Evaluating

Understanding your experience
Concepts are interpretive devices. They allow you to make sense of what you perceive. Using different concepts, you can see differently, generate different interpretations, and evaluate different elements differently.

Acting in response to what you understand
Concepts guide action by providing information about causality and relationship and by suggesting different routes to different possible outcomes.

Evaluating what you create
In the absence of instruments that measure qualities, Conceptual Knowledge can provide criteria. Criteria can be used to evaluate experience, performance, and results. Again, those using different criteria will value things differently.

While most people treat their Conceptual Knowledge as true and fixed, this attitude means you will miss the bulk of your Conceptual alternatives. Artistry can be enhanced by the willingness to try on different ways of seeing, acting, and assessing performance.

As you build your own Conceptual Knowledge, remember to (1) match the level of simplification to your level of experience, and (2) seek out concepts that both guide experience and sustain openness.

This brings us to a point I haven't yet addressed. Without standardized methods and clearly defined measurable goals, how do artists evaluate the *quality* of *qualities*?

In some areas of practice, this question might seem easy to answer. When dishes taste bad, when speeches are boring, when games or positions are lost, when performances are embarrassing, or when conditions worsen, audiences and colleagues usually have negative opinions about the quality of the work. The crowd boos: simple as that. But often, different audiences and practitioners have different opinions about what works and what doesn't; in those cases, confusions and conflicts can arise.

Few artists find assessment straightforward or simple. When you apply an artistic mind to the qualities you produce, what at first looks

great can soon evaporate, and what seems a failure can suddenly become the start of something great. Also, artists know that consensus simply means that people agree – but not that they're right about what works or what doesn't. So what can artists rely on in the face of such indeterminacy? The magnetic idealism generated by their *Directional Knowledge*.

A Directional Compass: Motivation and Progress

Conventional wisdom tells us that the road to progress is paved with systematic steps toward measurable goals and rewards. Corporate compensation programs, a lucrative motivational industry, the nation's educational infrastructure – they're all built on this premise. But true artists have an uncanny ability to elude this external pressure. Instead, they rely on their unquenchable desire to connect the immediate qualities they produce in any given effort to the somewhat ill-defined, ideal qualities they can imagine.

Like a compass, Directional Knowledge provides a heading without establishing the final destination; it is felt like an ever-present magnetic pull.

Though individually held, Directional Knowledge is developed through the everyday process of living (see figure 4.7). This social feature of Directional Knowledge means its elements – ideals, purposes, identities, directions, paradigms, traditions, and missions – are woven together from a combination of influences. These influences may include where we live, the people who live and work around us, the events that we experience throughout our lives, and even more importantly, what we make of these influences.

Artists often like to say they are simply being spontaneous. Yet as they work, we can see them making *deliberate* selections, choices, and decisions. Often, the choices artists make may surprise others, because what drives their selections is not always obvious to an observer. Artists rely, in large part, on an internal reference to guide their progress. It's not that external criteria are completely irrelevant to these choices and decisions, but they're seldom the overriding concern of artists. Instead, the benchmark against which choices are made is an internally conceived Directional ideal. It's against these ideals, rather than external standards, that both actions and results are forever evaluated.

Joanne Weir, cooking teacher, author, and TV personality, started her cooking career at now-legendary Chez Panisse restaurant in Berkeley, California. But the food experience that still, decades later, stands as her ideal occurred before she became a food professional. She describes

Figure 4.7: Directional Knowledge

Of the three knowledge categories, Directional Knowledge is the one most connected to a practitioner's very identity; it comprises the ideals that motivate further practice toward deeper artistry. Like a magnet, it pulls a person toward the particular work he or she feels compelled to create.

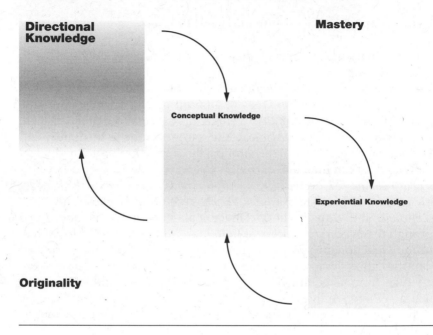

that moment, when she lived in a time and a culture uninitiated into the qualities of delicious food:

> I was twenty-four years old and teaching in Boston. I moved into a new apartment and my friend gave me a bottle of wine, a Mouton Cadet. It was six bucks, and that was a lot of money. We drank half the first night and the second half the second night. And on the second night, I was holding the glass in my hand and I looked in the glass and there was a fly clinging to the inside of the glass.
>
> So, I decided to package up this fly in aluminum foil, and I sent it to Chateau Mouton Rothschild in France. I told them I found this fly, and I was appalled by it. Well, they wrote back to me immediately and said that they were so upset, this never happened, they couldn't believe that

this happened, and what could they do for me. If I ever happened to be in France they would like me to be their special guest for lunch.

So, my friend and I went, we had on Diane Von Furstenberg wrap-around dresses and espadrilles! Both of us! She had the green and I had the blue. We walked across the stones; I can still hear the sound. We were a little bit late and these two gentlemen walked across the lawn to greet us and, my god, they were good-looking! They had on white linen suits and they were much older...maybe thirty! And, we had this lunch that was extraordinary!

We started with a bottle of 1966, then 1948 and the last one 1916. And, we had this lunch that was just unbelievable. We had a blast with them; we drank all afternoon. Oh my god, we were wild. And, I had studied every single book I could find on wine ... there were only three ... but, I knew everything! I knew that chardonnay and pinot noir came from Burgundy. I knew what grapes came from Bordeaux. I had studied wines from around the world as much as I could study. That was when I learned about wine. I was twenty-four.

We had duck liver on toast; it was the most delicious thing. The toast was the best pain de mi, and it was just soaked in butter ... it was to die for, honest to god. It was grilled, and then with the liver – and I didn't even like liver – it melted in my mouth. And the next thing we had, they made a point of telling us, duck breast from the same duck. I don't remember the vegetable on the side, but I do remember the strawberry tart. It was an incredibly delicious lunch.

Then they brought out this strawberry tart and they gave us Chateau d'Yquem. They started with a '43; it was the last one they had. They had them in these HUGE carafe decanters. And, we finished with an 1898. I can't even imagine what the cost of that was. We kept saying, 'nectar of the gods,' and by the end we were speaking French.

It was unbelievable! Honest to god, it just changed me. It changed my life. It was the most extraordinary eating experience of my life. I have had great meals, but nothing can really measure up to it, because I was young. It was over the top. It would be over the top now.[8]

In a very different discipline, psychiatrist Melanie Carr tells this story about the beginnings of her career working with people.

One of the really important, amazing moments for me was early on in my career. Before I was a psychiatrist, I worked in the social work department of a boy's 'reform school,' working with boys from twelve to eighteen who

had been in trouble with the law. Even though I was only partway through an undergraduate degree in psychology at the time, I was given the position because they were a little desperate in the seventies to find people to fill those roles.

So, that was my first experience working with people, and what an eye-opener it was. Here I was, this really middle-class kid, wide-eyed and naïve, listening to these kids tell me their stories. The stories were pretty wild, including attempted murder, arson, lots of car thefts and several kids were in gangs. They all had multiple charges and fairly long-standing involvement with the police, even though some of them were barely out of middle childhood. The training school was sometimes the family alma mater, with two or even three generations of the family having been in attendance at one time or another. It sounds hokey, but I had a recurring dream for the first couple of months that I would bring one of those big yellow school buses up to the front door of the dormitory and load all the kids on. I'd take them to my family home. I'd rescue them.

Of course I started that job without any real theoretical framework. They just needed someone to fill the position, and I was too naïve to realize what I didn't know. I had always been really interested in people and why they behaved the way they did. I had read much of Freud's works by the time I was eighteen, not for school but because I was interested. So, I think I convinced myself that if I was an understanding person, if I just loved them, they would be fine.

Over the first year there I recognized that compassion wasn't going to be enough. It was a tough lesson, but it allowed me to say, 'I need some theory here. I can't be flying by the seat of my pants ... I need to know what I'm doing.' Of course, there's something really important about being an understanding, caring person, but that wasn't going to be enough to help those kids. Giving support wasn't going to be enough.[9]

As the reality of these experiences fades, the motivations and sense of purpose they leave behind do not. Indeed, an accurate memory of these events is less important than how Weir and Carr have converted them into Directional Knowledge. As ever-present ideals in their personal Knowledge System, these experiences have become unique, motivating aspirations.

Becoming innate, these ideals reflect the blurring of the boundary between the person and the work. Brother Thomas Bezanson, a Benedictine monk and acclaimed ceramist, describes this integration in a short movie about his work and his life, *Gifts from the Fire*.[10] 'I had this

dream of an absolutely perfect pot,' he said. 'It was a very simple shape, pure white.' His art derived not from external goals, he said, but from trying to achieve the perfect pot he'd dreamed. He describes the years he spent, pursuing and pursuing the dream, until by degrees it faded. Eventually, even his efforts to reproduce the pot faded. 'And then,' he said, 'I realized that it was myself I was trying to make pure, better, a more beautiful person, a more truthful person, a person concerned with uniting and not dividing what he encounters and meets along the journey in this world.' The pot, he realized, was a metaphor for himself.

When the passion to pursue work in a medium is composed of internally generated, idealized notions about identity and purpose, this is the signature of Directional Knowledge that supports artistry. The passion with which artists pursue these ideals is akin to the passion that drives true love.

With this fire burning, Directional Knowledge then generates meaning, motivation, and orientation. Artistic practitioners do often refer to passion as a consuming drive, an unquenchable curiosity, a deep joy, an addictive thrill. When artistry is involved, progress and motivation are fueled by an intrinsic source and measured by the progress made toward an ideal.

Ideals with this kind of energy behind them generate a motivation that can withstand the difficult experiences that always come with practice. Progress toward idealized directions is often marked by measurable wins and losses; but no matter how exhilarating the wins or how devastating the losses, these experiences are used only to mark progress. Unlike in the quantitative realm, success and failure are not used to determine the realism or absolute possibility of reaching an ideal.

An Educator's Perspective

Nothing is more exciting than when you've got kids really interested in something, and they're enthusiastic, and they're coming up with ideas. Those are the times when you get the perks, the joys. We wanted the Mabin School to be a place children loved to come to. *Gerry, Mabin School founder*

During my graduate work at Stanford University, I had the opportunity to study with the organization theorist James G. March. He offered a course on organizational leadership with a surprising reading list: *War and Peace, St Joan, Othello, Don Quixote*. March's affection for Don Quixote led him to make a film entitled *Passion and Discipline: Don*

Quixote's Lessons for Leadership. His film explores what modern leaders can learn from the adventures of the illustrious man from La Mancha. March anticipated the skepticism this subject might generate. In the introduction of the film he says, 'Why Don Quixote, you may ask? We live in a world that emphasizes realistic expectations and real successes; Don Quixote had neither. But through failure after failure he persists in his visions and his commitments because he knows who he is.'[11]

Sharing this commitment to ideals, artists display Quixote's stubborn commitment, despite the difficulties they often endure. In an April 2008 interview, professional cyclist Tom Boonen commented on his experience of winning the Paris-Roubaix race: 'It is a day full of pain. You suffer and you suffer and you suffer, and the guy who can suffer the most wins the race.'[12] Direction imposed by mere doctrine and motivation driven by merely external rewards and punishments would be poor substitutes in the face of tough situations such as these.

The Virtues of Variety

The individuality of directional ideals allows practitioners working in the same medium to create a wide variety of outcomes, even when they share much of the same Conceptual Knowledge. For example, two painters with the same paint, brushes, and canvas, having learned the same theory of color relationships, can use differences in Directional Knowledge to create images as different as Da Vinci's *Mona Lisa* and Van Gogh's *Starry Night*. Using the same economic information, two CEOs can point their respective organizations toward different strategic directions, be it 'customer service' or 'product design.' Musicians with different Directional Knowledge can use the same notational system to write orchestral symphonies or country-and-western ballads.

Plates 2a, 2b, 3a, and 3b in the color section illustrate the dramatic range of variation that different personalized ideals makes possible. Each horseman uses the commonly available ideas about how the horse learns and behaves to create a performance that strives to match his or her Directional desires. Robin Gates makes the relationship she calls 'the Bond' her priority with her horses. Teri Rich seeks lightness and the self-carriage in her horse, the pinnacles of performance in her sport of dressage. Eric Thomas rides his horse to achieve the responsiveness

and athleticism he describes in chapter 1. Jack May and Ted Draper put their horse to the task of pulling a carriage for both work and competition. Each horseman creates a different kind of relationship and style of performance to pursue a specific type of sport. An even closer look at each Directional orientation would reveal the same kind of variation, albeit perhaps a less dramatic one, within these particular sports.

Any enigmatic problem, activity, or discipline holds the potential for this kind of variation; the key is to take advantage of the opportunity rather than fear it. This is a skill often learned in childhood. In his 1985 article 'Why Art in Education and Why Art Education,' Professor Elliot Eisner reminds us of this as it relates to learning and the arts.

> The school's curriculum is currently heavily weighted toward a rule-governed view of learning; there is a correct answer to each question raised, and the teacher knows the correct answer. The student's task is to get it right.
>
> In the arts no comparable 'comforts' exist. There is no single correct answer to an artistic problem: there are many. There is no procedure to tell the student with certainty that his or her solution is correct.[13]

For those with the courage to embrace enigmatic problems in their discipline, variety is possible because Directional ideals replace clearly defined goals, specified methods, and right answers. This makes room for variety.

Why is this variety important – especially when we're so often preoccupied with finding the best alternative, rather than generating many alternatives? Further along in *Passion and Discipline*, Jim March says, 'Great acts of leadership in history have often involved the capability to see things that other people could not.'[14] This exceptional vision isn't possible when we focus on solving predefined problems, reaching predefined goals, and insuring our success relative to others. March's lifetime of organization and leadership research demonstrates that such conservative urges as these unduly constrain originality and learning.

An Entrepreneur's Perspective
It's amazing how many good ideas you get when you don't stop at the first one. The best idea is never the first idea somebody walked in with, it's a combination of ideas. *Scott, Intuit founder*

Qualitative Problem Solving

How, then, can we generate this variety in action? We do it by solving problems according to a process that's quite different from the powerfully objective, scientific problem-solving methods many of us learned in school – to define a problem, generate hypotheses, test hypotheses, and finally identify the solution to the defined problem. In artistic action, the qualitative interface that each artist has with a medium pulls us into the subjective process of *qualitative problem solving*.

David Ecker, a professor of fine arts, has written cogently about this kind of problem solving. His article 'The Artistic Process as Qualitative Problem Solving' describes how qualitative problem solving progresses when predetermined steps and measurable goals are absent – that is, when an artist is in search of what is possible or of what might manifest an imagined ideal. In the course of solving a problem, most of us proceed in one direction: using established means, we work toward defined ends and goals. But, as Ecker suggests, *ends and means influence each other as they occur*. This is often why artists reply, 'it depends,' when queried about what they will do and how they will get it done.

Ecker offers new ideas and language to describe how qualitative problem solving unfolds, and he identifies six predictable phases. As you read through these phases, think back to the watercolor painter in chapter 2 and the process of painting she describes. An image initially attracts her; she establishes a color relationship that organizes the painting; she finishes the feather textures so that the image as a whole reads believably.

In the first phase, artists engage what Ecker calls the *presented or initial relationship* between existing qualities. Action in a medium presents artists with already-existing relationships between immediate qualities. Some of these relationships may be problematic, others intriguing, and so they attract the artist's attention. Different practitioners may see different qualities and make sense of what they see differently, depending on the ideals, concepts, and sensibilities they bring to bear on the situation.

When beginning her image of the swan, this painter was attracted to such initiating qualities *as aliveness, strength and foreboding.*

In the second phase, working with these initiating qualities and their interrelationships, artists enhance some and destroy others. In the course of doing this work, they begin to imagine possible ends – what Ecker calls *ends-in-view.* Artists enhance, destroy, shape, and reshape

initiating qualities, ultimately turning these qualities into the means they can use to reach the qualitative end-in-view they have imagined. This end-in-view is less concrete than a preconceived, measurable goal because it emanates from the very qualitative relationships that are being constructed, reconstructed, and sometimes destroyed in the process of creating the work.

The painter must figure out how to paint good edges, with visual qualities such as softness and shininess, for the image to work. Her end-in-view – a strong composition and a believable image that comes to life – is dependent on a process of painting in which everything changes each time you add a brush stroke.

The third phase that Ecker identifies can be recognized because a *pervasive quality* eventually takes hold of the work in progress. This pervasive quality can be an extension of the artist's existing style, or it may be the beginning of something new. In either case, the work begins to hold together so that, in the fourth phase, the artist can make subsequent choices based on how they fit, or don't fit, with this pervasive quality. Using the relationship she has established between the pervasive quality and the end-in-view, the artist can anticipate and infer next steps.

Painting the eye of the swan, she establishes the pervasive quality – *the organizing dynamic of color and composition – that drives the rest of her work toward the believability she wants.*

In the fifth phase, exploration and experimentation still occur, but they do so as tests of what will and will not sustain the pervasive quality. Inferred and anticipated qualitative steps are not predetermined, and many may fail in execution; but the artist can use the pervasive quality as a backdrop to make judgments about what moves bring the work closer to the end-in-view and the *total quality* that will signal approaching completion.

By her own assessment, the painter struggled to create the details of highlights and textures in a way that captured the essence of the swan and qualities of drama. And, yet the overall qualities hold the image together – in a total quality – *well enough to call it complete.*

Finally, in the sixth phase of Ecker's sequence, a *total quality* is shaped, and the work is judged complete. However, completeness is a tentative assessment. Evaluative criteria evolve with experience, and what counts as finished can change over time.

When ideals stimulate effort, the journey from initiating qualities to the selection of a pervasive quality to the completion of a total quality replaces the

work of defining and solving problems with means that go in a straight line to clearly defined ends.

Without the presence of Directional ideals this qualitative work would be impossible. Without a faithful navigational reference, an artist would be adrift as she travels to an unknown destination.

Having explored in this chapter the components of an artistic Knowledge System – Experiential, Conceptual, and Directional Knowledge – we'll turn our attention in the next chapter to ways we might use that Knowledge System to overcome the problems that systematically arise when seasoned practitioners try to pass along what they know to novices.

IN ITS BEST LIGHT

Now imagine *crafting* strategy. What springs to mind is not so much think-
ing and reasoning as involvement, a feeling of intimacy and harmony with the
materials at hand, developed through long experience and commitment.

Henry Mintzberg, 'Crafting Strategy'[1]

Investigating artistry is a bit like playing tiddlywinks – the more you
apply direct pressure, the farther artistry jumps away from you. Ask
artistic practitioners what they do and how they do it, and chances are
the answer you hear won't be one you can easily use. Talking about
how they do what they do tends to annoy artists; most won't let you
near them when they're deeply at work. And when they do describe
their inner working experience, most artists will say some very odd
things.

Take David Sudnow. In his book *Ways of the Hand*, Sudnow describes
his own initiation into playing improvisational piano. This is a finger-
by-finger, note-by-note phenomenological account of learning the key-
board, the structure of jazz, and the patterns – in hands, in seeing, and
in music – that provide the basis for 'improvised conduct.' He ventures
where most fear to tread, and the results affirm our far-reaching aver-
sion. Listen as Sudnow describes an initial stage of learning when, after
hours of practice, he begins to play chords rather than notes.

As my hands began to form constellations, the scope of my looking
grasped the chord as a whole, a consistency developed in seeing not its
note-for-noteness, but the pattern of its location as a configuration emerg-
ing out of a broader field of vision.[2]

For my part, I studied classical guitar as a kid, so Sudnow's account – obscure though it is – actually does resonate for me. My own transition shifted me from looking at strings and frets and thinking about playing notes to in-hand knowledge about the shape of my hand and its place- ment on the neck of the guitar. Somehow it just happens: awareness of mechanical fingering fades away. Replaced by a more sophisticated way of knowing how to play a particular instrument, attention can migrate from mere fingering to the music.

Yes, it's hard to put into words. But this kind of shift is a prerequisite to playing music with artistry; that is, to playing with skill, spontane- ity, and feeling. This kind of transition happens in every discipline as artistry develops – when piece parts come together into holistic under- standing – even as *how it happens* generally remains below awareness.

This kind of learning reflects the emergent nature of artistry, and it's a sign of developing unity with a medium. For dancers, practiced arm and leg positions become gestures that express feeling. Painters who have been learning to depict recognizable objects begin to create compositions that evoke meaningful emotional responses. And, as I've already described, the task of chopping onions transforms into the work of creating flavor. Ironically, this kind of shift can happen even before skills become advanced. Even primitive or crudely crafted works of art can evoke a felt response beyond what the workmanship accounts for. In all disciplines and levels, the embodiment of feeling in form is an artistic advance that eludes detailed description.

If you find this notion puzzling, try a simple exercise. Can you wig- gle your ears? If so, find someone who can't, and try to teach them how. Listen to the things you say, and notice what part of your own experi- ence you can and can't describe. If you can't wiggle your ears, find someone who can, and ask them to teach you. Again, pay attention to the teaching difficulties involved. When one of you figures it out, see if you can articulate how it happened. This simple act of physical learn- ing defies description. Now imagine the difficulties in transmitting and achieving more complicated experiential accomplishments. The road to artistry is paved with these indescribable transitions and connections.

Knowing that this kind of learning is frustratingly elusive, teachers, mentors, and coaches often gloss over it, hoping it will just come to students naturally. Alternatively, they add more pressure in the form of hard practice and threatened consequences, hoping to push ama- teurs to more coherent ways of working. And, indeed, sometimes this works. But even if it does, teachers inadvertently conceal from students

the most important steps in learning an art. Many hopeful students are defeated by this typical dynamic.

The research effort leading up to this book focused on helping teachers and students solve this problem. The personal Knowledge System is an effective response: it helps artists explain and students of artistry understand how to progress.

May the Force Be with You

YODA: So certain are you. Always with you it cannot be done. Hear you nothing that I say?

LUKE SKYWALKER: Master, moving stones around is one thing. This is totally different.

YODA: No! No different! Only different in your mind. You must unlearn what you have learned.

LUKE: All right. I'll give it a try.

YODA: No! Try not. Do. Or do not. There is no try.

LUKE: I can't. It is too big.

YODA: Size matters not. Look at me. Judge me by my size, do you? And, well you should not. For my ally is the Force. And a powerful ally it is. Life creates it, makes it grow. Its energy surrounds us and binds us. Luminous beings are we ... not this crude matter. You must feel the Force around you. Here, between you ... me ... the tree ... the rock ... everywhere! Yes, even between this land and the ship.

LUKE: You want the impossible. I don't ... I don't believe it.

YODA: That is why you fail.[3]

The unavoidable situation is this: whether for the advanced practitioner or the novice, artistry is hard to comprehend and achieve because it is an emergent, holistic way of being. On the one hand, it can't be simplified. It can't be broken down into accessible parts without generating misleading, fragmented, and confusing distortions. On the other hand, if artistry isn't dismantled, novices can't even begin to learn. This can appear to be an inescapable trap – one that repeatedly leads to frustrating consequences.

Attempting to simplify what they know, even the most well-intentioned practitioners generate a mixture of perplexing and disconnected information. As we've seen, they systematically say one thing and do

another. They can't speak easily in the moment; yet neither can they explain later exactly what they saw or felt in the course of accomplishing their work. They use abstract words like 'feel' or 'judgment' or 'balance' or 'timing' – words that defy detailed explanation. In addition, different practitioners say different things about the same phenomenon. They pursue different ideals, and they employ different skills and sensibilities in the same discipline.

A Professional's Perspective
If someone needs an immediate kind of cause-and-effect model to structure his or her thinking, is unhappy with metaphorically wandering in unknown territory for a while, or can't tolerate occasional ambiguity, then I think maybe I'm not the right therapist for this person. *Melanie, psychiatrist*

Novices are hardly better off. They seldom have an effective way to cope with the dynamics of learning artistry. Their natural impulses cause them to focus on the wrong details, ask the wrong questions, or at best the right questions at the wrong time. The novice cook asks, 'How long do I cook a chicken?' – to which the advanced chef replies, 'Until it is done.' This typical interchange is common enough to both teacher and student, yet satisfying to neither.

Often distracted by their own emotional reactions to what they're doing, their hopes and fears, and their immediate failures and successes, novices struggle to pay attention and act the way advanced practitioners do. As Yoda reminds Luke Skywalker:

A Jedi's strength flows from the Force. But beware of the dark side. Anger … fear … aggression. The dark side of the Force they are.[4]

In chapter 1, Eric Thomas and I illustrate this struggle in our own conversation about fear. To the novice horseman, fear is a warning signal of impending disaster; to the master rider, fear is a distraction that interrupts focus on the horse – the very focus that is the gateway to the unity he seeks.

This situation often positions novices and seasoned practitioners out of sync: the novices juggle disconnected parts, while the practitioners are engaged in a way of being that they can't really dismantle. Using the Knowledge System is one way out of this dilemma. It gives anyone teaching or learning artistry an effective way to penetrate this holistic phenomenon without destroying it. Practitioners actually do reveal

their Knowledge System in what they say and what they do – even when they sound as if they're speaking in code. Students observing and listening with the Knowledge System in mind can make sense of the overwhelming stream of information that practitioners generate in both word and deed.

To illustrate how using the Knowledge System can guide learning, let's closely observe fine-art photographer Steve Dzerigian at work. Whether or not photography interests you particularly, the key here is to recognize that artistry can be closely observed only in the context of a particular medium. As you follow this chapter, examine your own practice, your own medium, and make the connections between what Steve illustrates and what you can learn about developing your own Knowledge System. I'll suggest prompts along the way.

One more caveat: You may find moments when this detailed discussion feels overly analytical. But a certain degree of analysis is unavoidable if you want to understand an artistic practice well enough to build your own. Without some way to analyze what we see when we watch a practitioner in action, we can't get under the surface. Like the paper of an onion, superficial observation can conceal more than it reveals. Observing more deeply lets us see more deeply. Getting beneath the surface can make your eyes smart, but this is where the flavor lies.

Beneath the Surface

It's just a few minutes before sunrise in California's arid Alabama Hills. Two off-road vehicles kick up dust as they wind their way along the dirt road. The landscape of cactus, granite, and dry creek beds is barren and dark. Grotesque, towering rock formations loom in the headlights' narrow beams as the cars bump and lurch along the track. It's easy to recall John Wayne, Errol Flynn, and Gary Cooper galloping through this familiar Hollywood backdrop of low scrubland in the foothills of the Sierra range. From the cover of the jutting piles of boulders that Steve has come so far to photograph, these big-screen heroes shot their six-guns at black-hatted villains.

As the sun rises, the eastern sky fills slowly with the soft, warm light of dawn. The cars pull off to the side of the road, and people scramble out. Doors fling open, heavy bags are hoisted on shoulders, energy bars and water bottles are passed around, and the little group begins to make its way into a vast, flat prairie.

Steve and I head west toward mountain-size boulders that stand

between us and the Sierra's distant silhouette. As we walk, I pin my remote microphone to Steve's shirt collar and hit the record button on my machine.

HILARY: We're headed out to take some pictures – talk to me.
STEVE: This is a spot where there is a group of rocks that is a particularly great place for sunrise. You get an alpenglow all along the tips of the mountains. It is really great. The only problem is this time of year; unless you have stormy conditions, it's not as spectacular as in the fall or the very early spring. Very early spring is my favorite time because the escarpment has snow on it. So we are going to shoot down among the rocks. There are great forms there all the time.

As we walk, I question him further.

HILARY: What kinds of things are you looking for?
STEVE: Okay, along the way I'm keeping my eyes open for possible things to photograph. What I'm looking for is anything that excites me – that resonates conceptually or spiritually, and here anthropomorphically for that series. I am not thinking very much. I am just trying to be here in this space. I am just seeking images. It will be an object, or light, or color, or a shape, or some kind of situation will grab me. If it doesn't happen, I'll backtrack a bit and pick any place that felt the best.
 Look, the light is just starting to get interesting!
HILARY: When you say 'interesting,' what do you mean?
STEVE: I see a rock wall in relationship to the sun, and the movement of the sun. There will be certain times of day when light will skate across the surface and certain times when it hits the surface head-on. It also depends upon which direction the wall is facing. Three-dimensional objects get light from all different directions and can look totally different when light is coming from the west or east side, or straight down from above. What's usually most exciting is the late-afternoon and the early-morning color and the softness of that kind of light. But hot midday light can sometimes be the best because some relief shows only in that particular time of day.

Steve stops dead in his tracks. He points to the crest of the Sierra mountain range. These mountain peaks, rising thousands of feet above our heads, feel oddly close. At the same time, they look distant, angular,

and sharp to the touch. They make an unending backdrop for the massive boulders that surround us.

STEVE: Watch the top of those boulders and the tops of the mountains.

I turn and watch as the sun climbs above the edge of the eastern horizon, as the towering Sierras turn shades of muted lavender, red, and blue. At the same time, the highest boulders that surround us materialize inside a transparent layer of golden light. I turn back to query Steve further, but he's gone. He is running. I watch as he speeds out onto the flats with camera and bags bouncing precariously on his shoulders. Our conversation forgotten, he sets up his camera in seconds and begins to shoot.

Steve is an artist of Armenian descent, with a full black beard and a curling mustache. He is a photographer who finds his images in the natural and human world around him more often than in the studio. This choice reveals critical elements of his Directional Knowledge, as does his desire to 'see more than the surface of things,' to capture his subjects 'in their best light,' and to 'make an image say its best.'

When you listen to an artist like Steve talk about his work, he will reveal his Directional Knowledge by expressing open-ended, sometimes unattainable, ideals he hopes to achieve. These ideals can be about self, about action, and about the products of action. I categorize ideals as Directional Knowledge because they guide and motivate practitioners without determining action in any given moment. We can begin building a summary of Steve's Knowledge System by adding these ideals to the representation of his Knowledge System (see figure 5.1).

Ideals are not static. They alter and evolve as experience accumulates, and so differ among novices and seasoned practitioners. Thousands of photographs later, showing a subject in its best light certainly means something different than it once did. Yet this one ideal remains a beacon that guides all of Steve's work.

In the development of artistry, these Directional ideals operate as virtually unattainable destinations – as progressive hopes and desires that motivate effort better than any proffered carrot or stick. When you hear such ideals uttered, they'll be expressed with passion. The person who lacks passion and motivation in his work almost surely lacks Directional ideals.

In Steve's case, ideals draw him into the natural world and inform his selection of images in this environment; another photographer's

Figure 5.1: Steve Dzerigian's Personal Knowledge System (Part 1)
As Steve talks about his practice, we begin to recognize the contents of his
Directional Knowledge – the ideals that motivate him to create a body of work
that's all his own. Another photographer with the same technical skills but different Directional Knowledge would surely create a very different body of work.

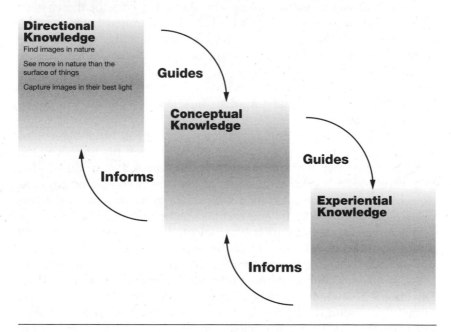

ideals might lead her into the studio where she can deliberately arrange
images that she wants to take. Steve's ideals drive him to develop the
kind of capabilities this kind of photography demands; another photographer's ideals will lead her to take a very different route.

An Entrepreneur's Perspective
I can't find MBAs who are confident going to observe. I can't find MBAs who
are constantly checking back and running experiments with customers so that
the real world is teaching. *Scott, Intuit founder*

In your own medium, different practitioners will formulate ideals
differently and hence orient themselves toward practice differently.
You can expect ideals to be expressed with certainty and passion,

even when they obviously conflict with the ideals of others. These differences between the people that surround you may be disconcerting; at the same time, they can reveal the breadth of possibilities in your field.

Ask Yourself

About Directional Knowledge:
- What is the range of ideals within your discipline?
- How are ideals expressed differently among practitioners?
- Toward what actions and products do ideals drive practitioners?
- Which ideals compel you?
- How does the selection of ideals change the constraints and opportunities you face?
- How could these different constraints and opportunities affect the nature of your work?

When we pursue ideals, Experiential Knowledge develops through the effort to be aware of qualities. When Steve is working, he looks for *initiating qualities*. (For definitions and descriptions of David Ecker's distinct aspects of qualities, see chapter 4, under 'Qualitative Problem Solving.') In the field, Steve describes himself as being 'more aware than normal.' He considers awareness a multisensory experience; he uses all his senses to guide 'a process of discovery that evolves' as he explores the environment. His actual experience of being multisensory is one of those experiences that words can't easily express.

For your part, take a moment to imagine how this might work in your own discipline. What kinds of awareness must you develop? What would multisensory awareness in your discipline yield?

When Steve directly encounters the qualities of his environment, it sometimes produces 'excitement.' Excitement is his catch-all term for the internal cue that means he's onto something. It can be awareness of a quality. Or maybe it's the recognition of an image that matches his Directional and Conceptual interests. Or perhaps it's a response to the discovery of something new. Ultimately, something irresistible will 'grab' him, and he starts to work. In a potentially overwhelming world of possibilities, both Steve's excitement and his ability to surrender his

attention completely to the objects and scenes that grab him help him select out what matters to him. Finding this, he begins to work with the initiating qualities a subject presents.

A Professional's Perspective

The person tells me their story and I'm listening a lot, but I'm also asking questions. And of course my questions aren't neutral. They're guided by what's interesting to me and by me trying to make sense of their story. We're building a meaning together. *Melanie, psychiatrist*

Excitement also means it is time to 'see' in the special way that is tied to his medium. Many people can look without seeing; artistry is rooted in special ways of seeing that artists achieve through a learning effort. Noting these achievements can help reveal the composition of an artist's Experiential and Conceptual Knowledge.

Steve has learned to see the visual qualities in the world that are relevant to his medium. Some of what Steve sees he can describe. These include qualities of 'space,' 'of the shape and relationship of objects,' and especially of 'light.' Light can be soft, harsh, flat, bright, contrasty, warm, cool, eerie, or dramatic. Light can be 'the wonderful light that saturates color and brings out detail,' or it can 'skate across surfaces' or 'hit surfaces head-on.'

When Steve sees qualities of space, shape, and light through his Conceptual understanding of how each quality is transformed by lens, paper, and chemicals, he can predict how his equipment will capture these qualities, and he knows how to use his equipment to make it happen. In addition, when choosing to do his black-and-white work in the tradition established by Ansel Adams, he implements a sequential process of predetermined steps. Each step generates a different physical and chemical incarnation of the original image, leading ultimately to the final image on paper. Steve sees the world through the unfolding of this sequence. He can make the visual transformations that occur between stages in his imagination. This imaginary work guides his technical choices in the field. He says:

If you are a painter, you can put any value or any color anywhere you want. You can change the elements of the image to make the compositions work. Photographers who work with what they find don't do that.

When you look at a scene, you need to know what you're going to emphasize, or de-emphasize, or whether you want no emphasis. For a photographer, these compositional choices turn into technical choices about point of view, format, lighting, lenses, and film. An image might read well in black and white, but not in color. A wide-angle lens, a macro lens, or a telephoto lens can make a composition work where a regular lens might not. (See figure 4.6.)

Work in any discipline requires the imaginary manipulation of qualities. This allows practitioners to predict results and select actions; it means they're connecting their awareness of the qualities they experience to the application of skill. Testing these predictions, they create and reshape qualities to establish the *pervasive qualities* (again, see chapter 4) that guide further action toward an imagined *end-in-view*. Imaginary transformations may be inexpressible, but *when* they occur, *what* they reveal, and *how* they generate action is critical information for you to collect when observing artistry in action.

When you hear artists like Steve talk about what they do in the moment, there are a couple of things to remember. First, you can sort what they say about experience into two different categories. One includes perceptual awareness (attention, focus, and feeling); the other includes skills. Second, Experiential Knowledge will probably be the most challenging of the three knowledge categories to collect concrete information about. Paradoxically, Experiential awareness eludes both conscious awareness and verbal description at the very moment that it becomes most useful to an artist.

This means that by the time people can easily articulate what they know, they will typically be relating Conceptual Knowledge – knowledge that can be shared in abstract, generalized forms, like the examples included in chapter 4. Steve can talk more easily about the properties of lenses than he can talk about either the particular feeling his choice of lens will create or about why he would make that particular choice. Practitioners often blend Experiential and Conceptual knowledge together in self-reflective speech. When listening, your job is to find out which qualities you must be able to feel and imagine, which skills are needed, and how Conceptual Knowledge allows skill to be selectively applied in response to the qualities at hand.

We can capture Steve's personal Knowledge System (see figure 5.2), as described thus far.

Figure 5.2: Steve Dzerigian's Personal Knowledge System (Part 2)

Further conversation with Steve reveals the store of technical knowledge he's amassed in order to bring about the work he's drawn to create.

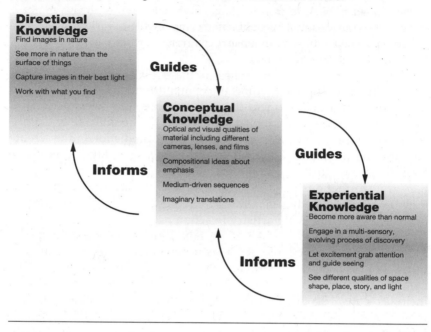

Directional Knowledge
Find images in nature

See more in nature than the surface of things

Capture images in their best light

Work with what you find

Guides

Conceptual Knowledge
Optical and visual qualities of material including different cameras, lenses, and films

Compositional ideas about emphasis

Medium-driven sequences

Imaginary translations

Informs

Guides

Experiential Knowledge
Become more aware than normal

Engage in a multi-sensory, evolving process of discovery

Let excitement grab attention and guide seeing

See different qualities of space shape, place, story, and light

Informs

Of course, sorting out a Knowledge System is not as simple as filling in three boxes. As the arrows in the diagram above are meant to indicate, the categories within the Knowledge System must interact usefully to generate artistry. Directional, Conceptual, and Experiential Knowledge – often developed at different times and through different activities – must eventually come together in action.

When this connection is made in Steve's practice, he sees qualities of light through the knowledge of equipment and materials he uses to represent them; he knows how the distorting optics of lenses will translate into feeling qualities in an image on paper; he understands how a photographic gray scale is used to create a successful image with an exposure that presents the subject in its best light. Making these connections between knowledge categories is the basis of artistic action. Only by doing the work can you achieve these connections.

Ask Yourself

About Experiential Awareness:
• On which senses do practitioners in your medium rely?
• How can you refine your sensory awareness?
• How are qualities recognized?
• How can you cultivate awareness of these qualities?
• What internal cues help you connect qualities to ideals?
• What do these cues tell you about the meaning of your experience?

About Experiential Skill:
• What skill sets do advanced practitioners display?
• How do Directional choices about a medium affect their skill set?
• How are awareness and skill connected?

About Conceptual Knowledge:
• What concepts inform your medium?
• How do these concepts help identify and assess critical qualities?
• How do these concepts inform action?
• How do your concepts guide your skills to create important qualities?
• Can you predict how action will move you toward ideals?

Working in the field as Steve does requires an ability to integrate the components of this Knowledge System in a way that is both rapid and reliable. He is not in a studio where he can control light, adjust his subjects, or retake images that he might want to improve. The natural phenomena that create the mood, gesture, and light that Steve wants to capture on film are fleeting. Missing a shot or, worse yet, 'getting it wrong' has consequences; it means 'losing a shot forever.' One of Steve's Directional ideals is, 'I don't want to miss a shot.' Imposing his own pressure on his practice, Steve has put in the effort needed to take successful images with automatic reliability.

This reliability reflects unity and *mastery* in a medium: Steve is able to use his medium to capture what excites him, in photographic images that also excite. Excitement about an image – the internal cue that directs his attention – triggers action in his medium. This action, set in the field, then later in the darkroom, has generated hundreds of images that have clustered into thematic bodies of work. Once established,

5.1 'Steve Photographing for His Ascending Series,' 2009; photograph by Sally Stallings

these themes can then inform his immediate work: what grabs him in the field, how he handles it, and so on. These interactions reflect a personal Knowledge System at work.

The arrows in figure 5.3 highlight this interaction. Experience influences the development of Conceptual and Directional Knowledge. Once developed, these categories of knowledge also serve to guide and shape experience. The figure summarizes these additions to Steve's Knowledge System.

Much disciplinary Conceptual Knowledge is both generic and shared among practitioners. It is usually accessible to novices in school curricula and textbooks. However, the creation of personalized concepts like *themes* is a more private process. These ideas are rarely shared, as they generally operate only in action; as we've seen, they're difficult to express. Developing this personalized knowledge is a critically important step because it is the basis for the *originality* that is characteristic of artistry. When analyzing a personal Knowledge System, look for these unique elements and seek to understand their function.

Figure 5.3: Steve Dzerigian's Personal Knowledge System (Part 3)
The more we learn about Steve's approach to his work, the more we see how
the different components of his Knowledge System interact and influence each
other – his firsthand experience informing the very ideas that guide his further
experience.

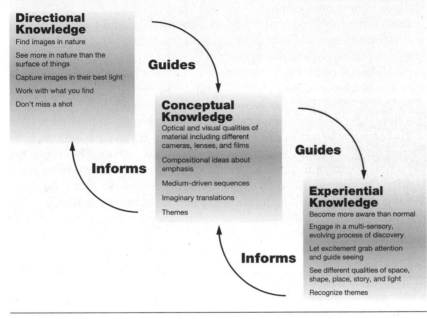

Steve's themes are elements of his Conceptual Knowledge that
organize the thousands of images he's already taken and will organize
the thousands more that are yet to come. This way of organizing has
resulted in a body of work that is both systematic and original.

For a theme to be a theme, it 'has to hold together.' Each image in a
theme is part of a coherent story that satisfies the demands of all three
knowledge categories. Each is an exciting discovery in the world; each
displays both technical qualities to his standard and the feeling quali-
ties he responds to; and each is an image that says its best, relative to
past images he has created.

Steve's themes are both flexible and enduring. He juggles multiple
themes over periods of years. Several of his most enduring include
anthropomorphic natural and rock formations (see color section, plate
4), western landscapes, the human landscape, Maya land, painting with
light (nighttime long exposure), and autobiography (see color section,

plate 5). Work in themes can wax and wane, generate diversions, and spawn experiments – all the while providing a structure to his work. In producing each of these themes, Steve has built up a bank of images and a repertoire of skills. This store of knowledge can be referenced for comparison, applied for results, and modified as themes develop and shift, or as new ones emerge.

In addition to shared content, Steve's themes are held together by format (camera size and film), development (how film is handled and the image is put on paper), manipulation (hand coloring and collage), and presentation format. But inclusion in a theme, or a grouping within a theme, has a more loosely defined qualitative element; it is a judgment about what 'fits.' However loosely he has conceived this notion, Steve has developed a 'keen eye for finding images that fit' in his themes.

The decision about fit can be categorical, or it can be based on how he responds to images when they're grouped together. This room for personal judgment means that theme categories don't have to be used rigidly. On the one hand, with past images as his standard, he says, 'It takes a really unusual situation for me to shoot nature images.' On the other hand, he wants to 'see everything' and 'not edit' himself 'too much.' Image after image, he chooses between consistency with his themes and variations that excite him. He thinks of these variations as 'eddies' in the flow of his work that might take him in a new direction, or might not. These variations may be something he comes back to at a later time.

When you uncover how artists create and use concepts like 'themes,' 'fit,' and 'eddies' to organize action, you're finding the pot of gold at the end of the rainbow. You're getting access to the hidden knowledge that allows artists to use the enigmatic features of practice – such as qualities, ambiguity, indeterminacy – to create work in their own style, to their own taste.

These concepts replace the quantitative Conceptual tools that determine and measure experience or physical features. In so doing, they aid artists in three different ways. First, concepts like these allow practitioners to interpret internal responses to the qualities they experience when specific measures are unavailable. Second, they help practitioners focus attention, organize action, and evaluate results without limiting themselves to entirely predetermined categories, steps, and criteria. This means they can sustain a mix of both flexibility and purposeful action as they work. Third, every artistic practice exhibits a unique combination of mastery and originality that is generated by the unique

Knowledge System each artist composes. These concepts help practitioners manage the dynamic tension between mastery and originality. This tension will be explored in depth in chapter 6.

Fully understanding these concepts can be tricky. Words like 'fit' and 'feel' can roll off the tongue; but when using them, different practitioners may mean different things. Because the meanings of these words are rooted in an individual's personal experience of qualities, their interpretation is tied to each artist's unique life experience. You can better understand the particular meaning of words like 'feel' and 'fit' by listening to an artist's self-revealing stories rather than by turning to clear dictionary definitions. These stories can reveal how practitioners have put together a way of working that is an extension of themselves rather than simply applying a generic collection of techniques, skills, methods, and goals.

Steve reveals how 'tracking' images became part of his Knowledge System in a story about his dog 'Namer.'

> One of my teachers was my dog, Namer. We called her Namer because we couldn't decide what to name her!
>
> We were living in the country, and Namer would chase the neighbor's cattle, so we had to keep her roped up. I used to take her for walks on our triangular piece of property. All of a sudden I thought, 'Why am I forcing her to go on my little path?' So, I decided from that point on I would follow her; I would never let the lead get tight.
>
> If she ran, I ran; if she stopped, I stopped. If she sniffed something out, I would follow. She became my teacher: I learned my tracking techniques from this dog.
>
> I plan to go back to certain places over and over again. I pick certain times of day and seasons. At the same time, there is a freedom and variety that comes with meandering around. Sometimes I move quickly without thinking too much. If I suspect something, I stop and sniff it out and see what happens. If it excites me, if it means something, then I'll make an image. It may just happen by chance.

This experience has influenced the development of his knowledge in all three categories. Directionally, he thinks of himself as 'a tracker of images,' rather than, say, a recorder of events. In natural settings, as a tracker, he thinks ahead about his destination, then allows what he experiences in the moment to draw him along instinctively. Conceptually, the idea of being a tracker of images allows him to apply his

current level of mastery (attentiveness to themes and light) and still 'meander with openness' to find unexpected opportunities.

An Educator's Perspective

You can't go in with a set agenda and force that agenda. Sometimes it works that way, but other times you have to be tweaking and changing and going in another direction. You have to be doing that all the time to be a good teacher.

Gerry, Mabin School founder

Looking in beginners' books on photography, you'll find many exercises to help newcomers figure out what kind of image they're interested in creating. Every advanced photographer has his or her own way of dealing with this aspect of this medium; every novice has to sort it out. I doubt any authority, probably not even Steve, has ever told a student to spend a day shadowing his dog to help sort out this issue. Yet, each practitioner builds his own Directional interests from experiences like this, rather than from adhering to a set curriculum composed of routine exercises.

The point here is not to replicate what Steve did. It's to understand how Directional, Conceptual, and Experiential elements combine and evolve to create an artistic way of working. In this example, Steve's story about his relationship with Namer and the use he makes of this experience in terms of his photographic work help us understand the origins of originality.

We can update the summary of Steve's Knowledge System with the additional Directional, Conceptual, and Experiential elements described above (see figure 5.4).

Creating a Way of Being

This look into Steve's Knowledge System is incomplete. But even this partial analysis illustrates how you can open a door into the workings of artistry in practice. Again, if you happen to be a student of photography, the point would not be to copy Steve's Knowledge System but to learn from it. You could find out what elements are critical to each knowledge category, how these elements interact, how each informs what he does, and what kinds of experiences and outcomes these elements make possible.

Knowing this, you'll know what kinds of things you need to learn

Figure 5.4: Steve Dzerigian's Personal Knowledge System (Part 4)

The point of analyzing Steve's personal Knowledge System is not to replicate it; that would be as impossible as it is undesirable. What it shows us, though, is where the elements of a knowledge category come from and how they interact with each other. Understanding this, we can begin to assess those elements in our own life and practice.

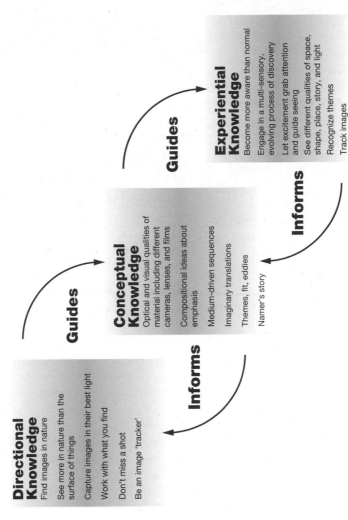

Directional Knowledge

Find images in nature

See more in nature than the surface of things

Capture images in their best light

Work with what you find

Don't miss a shot

Be an image "tracker"

Guides

Conceptual Knowledge

Optical and visual qualities of material including different cameras, lenses, and films

Compositional ideas about emphasis

Medium-driven sequences

Imaginary translations

Themes, fit, eddies

Namer's story

Guides

Experiential Knowledge

Become more aware than normal

Engage in a multi-sensory, evolving process of discovery

Let excitement grab attention and guide seeing

See different qualities of space, shape, place, story, and light

Recognize themes

Track images

Informs

Informs

in each category. You can also see how what Steve does compares with other photographers' practice by assessing their different ways of working and the outcomes these produce. Most importantly, you can use Steve's Knowledge System to plot a learning course that suits your own ideals and aptitudes.

Once we recognize that inarticulateness is a natural part of artistic work, we can avoid asking artists and teachers to overcome this obstacle alone. By learning to listen differently and apply what they hear to their own learning more effectively, students of artistry in any discipline can use the Knowledge System model to build an artistic knowledge system that's all their own.

Ask Yourself

Step One: About Mastery
- What automatic capabilities are necessary in your medium?
- What kind of practice develops this facility?
- How can different concepts be used to interpret and organize qualities?

Step Two: About Originality
- Are you aware of qualities that others miss or ignore?
- Do you make sense of what you experience in a different way than others do?
- Do your personal ideals suggest different interpretations?

Step Three: About Building Your Personal Knowledge System
- Using the personal Knowledge System diagram below as a guide (see figure 5.5), what are the knowledge components of your discipline?
- Who are the practitioners you admire?

Step Four: About the Enigmatic Problems in Your World
- What enigmatic features will you confront?
- How will you recognize these features?
- How do amateurs and professionals act and think differently in response to enigmatic features?
- What kinds of Conceptual Knowledge do practitioners have that helps them maintain focus and openness in the face of these features?

Figure 5.5: The Knowledge System Model (Review)
As you look at your own life and work, ask yourself what the components of your own Knowledge System are.

Mastery

What automatic capabilities are needed?

What ways of thinking guide attention and action?

What qualities must be felt, imagined, and assessed?

Directional Knowledge

What ideals about self, about action and results are possible?

How do these ideals guide the selection, development, and application of conceptual knowledge?

How are these ideals influenced by current and new understanding?

Conceptual Knowledge

What concepts are used to organize action?

How are concepts used to guide attention and interpret qualities?

What concepts have been created to deal with enigmatic features, and the tension between structure and openness?

Experiential Knowledge

What qualities can be experienced?

What skills can be developed?

How are awareness and skill linked?

How can experience be used to create new conceptual knowledge?

Originality

What ideals and concepts sustain openness?

How are new alternatives noticed and assessed?

How is experience uniquely understood to shape practice?

chapter **6**

AN UNEASY PARTNERSHIP

If it were easy to identify visionary genius, we would embrace it without hesitation. Unfortunately, the difference between visionary genius and delusional madness is much clearer in history books than in experience. Without the advantages of retrospection, what we see are deviants – heretics, fools, and eccentrics. We cannot reliably identify the geniuses among them until the quality of genius emerges in the unfolding of history.

James G. March, 'Wild Ideas: The Catechism of History'[1]

In previous chapters, we've begun to explore mastery and originality, and the ways they relate to artistry. Let's now take a closer look. But first we should clarify a common misconception. Students tend to equate *one or the other* of these capabilities with artistry itself. Yet neither alone can succeed as a stand-in for artistry; both must work together, and usually under tension (see figure 6.1).

Some but not all of conventional wisdom about mastery and originality is consistent with my conception of artistry. Familiar ideas about personal mastery are captured in our ideas about excellence, best practice, expertise, success, winning, and effectiveness. Achieving mastery means identifying, capturing, and repeating our best work. Familiar views about personal originality are captured in our ideas about vision, creativity, brainstorming, invention, spontaneity, free play, and exploration. Being original means we can escape the known, thus freeing ourselves to discover what we have yet to perceive or imagine.

When working to develop your Knowledge System, achieving mastery means learning to apply developed knowledge; achieving originality means learning to generate new knowledge.

Figure 6.1: The Knowledge System Model Revisited

Having closely explored the components of Experiential, Conceptual, and Directional Knowledge, we'll now turn our focus toward the links between these knowledge categories and the fundamental differences between the model's two sides: mastery and originality.

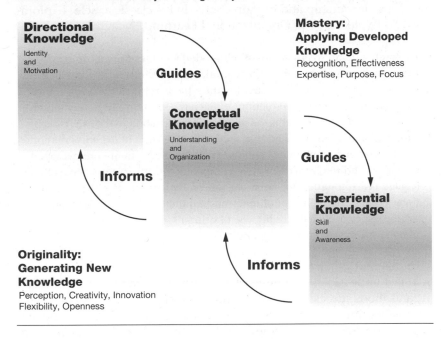

Popular ideas often suggest that these two activities can work in a complementary, even integrated partnership. This is where my view departs from the conventional one. As much as we want the association of mastery and originality in practice to be a product of balance and integration, and as much as we'd like the relationship to be natural and easy, the hard reality is that it just isn't.

In our dreams we imagine a harmony of creativity and skill; on the ground, it's more like a love-hate relationship. The forces that drive these two capabilities do mutually attract; at the same time, they remain fundamentally at odds.

In the real world, we see everywhere this tension between opposing forces. We see organizations attempt to manage the discord by functionally and structurally protecting think tanks or research-and-design groups, the 'creative folks,' from the pressures of day-to-day business.

Organizations designate times and activities – brainstorming sessions, problem-solving retreats, and prototype testing – where originality can be *stimulated*, yes, but also safely contained.

Stanford organizational theorist Jim March provides a basis for the fundamental disharmony between mastery and originality in his writings about leadership and organizations. In his classic article 'Exploration and Exploitation in Organizational Learning,' March says,

> Exploration [akin to *originality* in my model] includes things captured by terms such as search, variation, risk taking, experimentation, play, flexibility, discovery, innovation. Exploitation [*mastery*] includes such things as refinement, choice, production, efficiency, selection, implementation, execution. Adaptive systems that engage in exploration to the exclusion of exploitation are likely to find that they suffer the costs of experimentation without gaining many of its benefits. They exhibit too many undeveloped new ideas and too little distinctive competence. Conversely, systems that engage in exploitation to the exclusion of exploration are likely to find themselves trapped in suboptimal stable equilibria. As a result, maintaining the appropriate balance between exploration and exploitation is a primary factor in system survival and prosperity.[2]

In this and other articles, March explains why this critical balance is in fact impossible to achieve in organizations. Ironically, even when organizations successfully escape the two potential traps March identifies – suboptimal stability versus an abundance of new ideas but no distinctive competence – they never find the hoped-for balance. Instead, they find themselves in the midst of a *dynamic disequilibrium* that leaves little time for pause, much less for integration or a sustained and stable balance.

In a dynamic disequilibrium, the conservative forces (ideas, goals, and activities that drive the *exploitation of current capabilities*) discourage and sometimes even attack open-minded exploration. Likewise, the disruptive forces (ideas, goals, and activities that fuel *exploration of new capabilities*) disarrange the structures and systems that accompany effective exploitation. Responding to this ongoing tension means that organizations must continuously adjust their strategy, organization structure, personnel, customer base, and other structures. Talk about disruptive!

It's not only organizations that struggle in the grip of this predicament. People do, too, one at a time. Pursuing artistry in your medium

1 *Black Swan*; watercolor by Hilary Austen

2a Eric Thomas riding a reining pattern on Prime Time Gem © John O'Hara

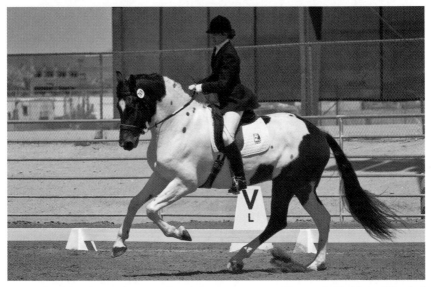

2b Teri Rich riding a training level dressage test on Fresco © Kathleen Wattle/ captivespirit.com

3a Robin Gates in 'The Bond' with Henry, photograph by Suzen Dyslin

3b Jack May and Ted Draper driving Diego

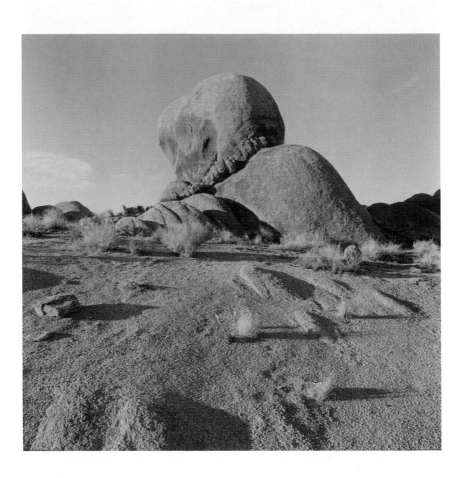

4 *Zoomorphism, Alabama Hills, California, 1995*; gelatin silver print
with color pencil, by Steve Dzerigian

5 *April 2002*, from *Visual Autobiography, 2002*; gelatin silver print
with color pencil, by Steve Dzerigian

6 *Vartan Sleeping*; drawing by Sally Stallings

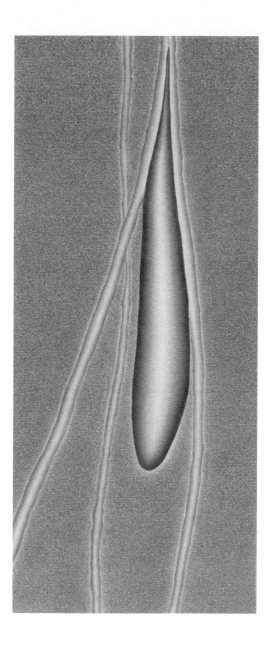

7 #2 *from the Yellow Grass Series*; drawing by Sally Stallings

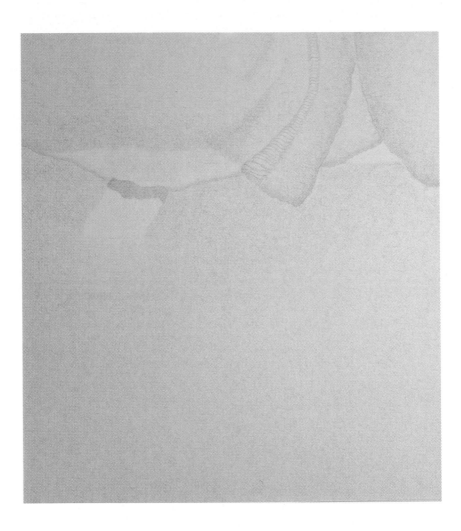

8 *Light On White*; drawing by Sally Stallings, inspired by photo 6.2,
The White Place

– working to develop *both* mastery *and* originality – forces you to confront similar dynamics and conflicts. For example, you can develop expertise and depth in your medium by committing too exclusively to mastery. The downside is that depth, like organizational stability, can lead you to overlook new possibilities and discount the importance of external change. Meanwhile, you can develop diversity and breadth by committing too exclusively to originality. The downside here is that an enthusiasm for breadth can lead you to an amateurish incompetence in many options, and competence in none.

Again, successfully escaping the pitfalls of either extreme does not bring you into to an appropriate and stable balance of breadth and depth in your medium. Balance and artistry do not coexist. Working with artistry means grappling with the interplay between mastery and originality in practice on an ongoing basis. In this effort, you will find yourself continually working your way from one extreme to the other, *passing through* happy moments of perfect balance that can be expressed in what you do, make, and say.

Cycling through the Dynamic Disequilibrium

To understand the condition of dynamic disequilibrium, imagine yourself traveling on the surface of a continuous helix. As the spiral circles, it passes through mastery on one side and originality on the other. Wherever you begin – and it doesn't matter where – you'll eventually encounter the following sequence of events.

> *Mastery is anchored by scope, time, and place. While powerfully useful to practice, mastery is also incomplete and conservative.*

When mastery is your preoccupation, you act with the intent to achieve good consequences: ones that stand up well against the status quo, or against accepted ideals about yourself and your purpose. As your learning progresses, this often means matching your knowledge, goals, and capabilities against the best in your field, as established by you or others. This effort means you are honing your ability to recognize and correctly interpret the quantities and qualities you want to understand and experience, and are using this understanding and experience to bring you ever closer to established ideals.

In the face of enigmatic problems, mastery inevitably reaches its limits.

Whenever we engage enigmatic problems by using qualities to resolve them, we begin to get personally involved.

Your path to mastery can't remain a straight shot for long. Originality creeps into practice as soon as you seek the connections between your personal ideals and experience of qualities, and as others tell you about their ideals and the qualities they experience. Seeking this connection, you inevitably get involved in your medium. Whether slight or dramatic, this shift toward originality occurs the moment you use your inner experience of qualities to make judgments in your medium, or to choose the ideals you hope to achieve. There's no stopping it: relying on inner experience will turn you in original directions.

Partnership in Tension

Mastery	Originality
Recognition	Perception
Effectiveness	Creativity
Skill	Innovation
Purpose	Flexibility
Focus	Openness

As we work toward personal artistry, mastery develops when we act in response to immediate qualities with the understanding and skill to pursue preconceived ideals. Originality develops when we act in response to immediate qualities with openness, even ignorance and foolishness, to discover what we might create.

Recognition is different from perception. Recognition means interpreting what you experience. Perception can be achieved without the same pre-existing understanding. Unblemished and receptive, the perception of qualities is the origin of originality. Likewise, effectiveness, skill, purpose, and focus originate from a developed Knowledge System; while creativity, innovation, flexibility, and openness arise when we elude our sophisticated personal and disciplinary ideals, theories, and capabilities to feel, imagine, and act anew.

Using personal involvement to build knowledge brings the disruptive forces of originality into play.

Personal involvement takes you in your own directions. Relying on an internally generated sense of the world – how it works and how it ought to be – rather than adopting the best available option, you can now generate new ideas based on your personal interactions with the world.

This effort is often an upstream swim. Unless you're perfectly isolated, you can't avoid being influenced by what's already known. You live in a world where others see no need to work differently from the way things are already done. And, while you have different ideals, ideas, and experiences than others, the significance of these differences may be difficult, even impossible, to establish. Some of your efforts may lead to wonderful new ideas and outcomes; most, however, will not. History reveals that the odds of succeeding at innovation are against us all.

Artistry emerges from the interplay of these conservative and disruptive forces.

While pursuing your personal experience toward original ideas, you can't really avoid the influences of mastery. If you defy the odds and generate original ideas and work, the forces that drive mastery quickly come back into play. The first thing most of us do with our good ideas is work to perfect and repeat them. Without this important conservative work, practice would become a hodge-podge of sophomoric and half-baked ideas and capabilities.

And yet, no matter how quickly you master new advances, the effectiveness of new achievements is often far too fleeting. When the problems we face are enigmatic, a stable state of mastery doesn't last for long. Practice inevitably brings us back to the present. In the present, we imagine options and experience things we didn't anticipate or understand. The demand for perception rather than recognition returns.

This continuous oscillation between mastery and originality is a hallmark of artistic practice. It is this traveling between extremes that yields the precious performances and products that display the perfect balance we seek. To sustain artistry, these balanced expressions are places artists pass through rather than treat as final destinations. By now, I imagine you can see what's coming: falling in love with these perfectly balanced expressions of personal artistry is the beginning of the end of artistry. This attachment can easily trap you into generating masterful copies of your own work that quickly pale in comparison to the original. As Eric Thomas says in chapter 1, you'll be caught riding yesterday's horse.

Figure 6.2: Working through Mastery and Originality
The path toward artistry is inherently unstable: involvement in a medium gives you the opportunity to perceive that medium in a new way; that new perception can lead to original insights that are likely to disrupt the knowledge you started with; as you refine those original insights, you'll attain a new level of mastery. And so the cycle goes – with few places to rest along the way.

When you realize that your efforts toward mastery must coexist with your efforts to accept original ideas, something happens: you also realize that your sense of the world, how it works and how it ought to be, is always changing. In pursuit of artistry in an enigmatic world, this cycle becomes progressive and drives practice forward.

No matter where you jump in, this cycle has it own perpetual momentum (see figure 6.2). Original ideas are refined and turned into masterful capabilities; masterful capabilities are disrupted by the stimulation of immediate involvement, which leads to original experience and ideas. And so the cycle carries you forward in your practice.

Learning Downstream and Upstream

Again, I offer the conscious development of a personal Knowledge System as a way to help practitioners with this constant and dynamic work. This Knowledge System can serve as a conceptual vehicle for understanding and responding to challenges (see figure 6.3). You can use the Knowledge System to anticipate and prepare yourself for the inevitable: that Directional ideals will migrate and transform over time,

Figure 6.3: Learning Downstream and Upstream

Learning downstream – from books or teachers at school or college or professional-development programs – occurs as you master knowledge that's already been developed. Upstream learning means developing new knowledge from your own firsthand experience; often lonelier and riskier, this is the kind of learning that stimulates innovation and originality.

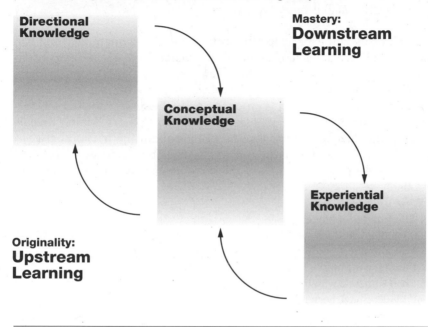

that Conceptual Knowledge will evolve as understanding changes, and finally that awareness will shift as these changes occur and when new experience is encountered.

From the perspective of the Knowledge System, achieving mastery means effectively learning and applying the knowledge you and others accept about your medium. This effort generally flows in conventional and consolidating directions, so I call it *downstream learning*. In school, at university, in professional-development programs – downstream is the kind of learning that's most familiar to most of us.

By contrast, achieving originality demands that you learn in the other direction, building your Knowledge System up from immediate personal experience. This learning often flows against currently accepted personal and disciplinary knowledge; that's why I call this effort

upstream learning. Downstream learning can be a challenge for all the reasons identified in earlier chapters, but its demands pale in the face of the difficulties of learning upstream.

> *To achieve upstream learning often means you have to let go of predictability, control, efficiency, immediate success, and – in the extreme – the support of colleagues and communities.*

Not all of us will experience the difficulties of upstream learning full force; that is, when the tension between mastery and originality rages in the society in which we live. However, original organizations, leaders, scientists, and professionals succumb or advance by passing through this storm. Again, March has much to say on the subject and depicts this unfolding drama in both scholarly papers and poetry. March reveals a sobering story in his articles and poems about the tension between exploration and exploitation; the confusions about heresy, vision, and foolishness in leaders; and the relationship between knowledge and foolishness.

The Jungles of Novelty
Someone who consistently sticks to old ideas
Will ultimately become obsolescent,
But in the meantime will almost always do better
Than someone who insists on embracing new ones.
Old ideas have been tested and refined,
And we have grown competent in them.
So, trying something different
Is usually unrewarding.
Of course, since the world is changing,
Old ideas grow stale and fresh new ones
Become necessary if we are to survive for long.
So we look hopefully for creative new ideas
To replace the old tired one we have already.
But when we do that, we discover once again
How hard it is to find good ideas
In the jungles of novelty. (J.G. March, *Late Harvest*)

Wild Ideas

In Jim March's article 'Wild Ideas: The Catechism of Heresy,' the Stanford professor explores both the promise and the profound cost of pur-

suing originality in one's life and work. The trouble with original ideas, he argues, is that so very few of them turn out to be measurably good ones. Yes, deviant ideas are necessary, but the costs of the inevitable mistakes along the way can be terribly high.

> The wild ideas of political crackpots, religious heretics, crazy artists, mad scientists, and organizational dreamers are overwhelmingly foolish, rather than brilliant. Only a tiny fraction of our heretics will ever be canonized, and we cannot identify the saints ahead of time … Society cannot support unbridled foolishness; without a considerable talent for conventional thinking, leadership fails. At the same time, society needs processes that induce and sustain craziness of wild ideas. It needs to stimulate and protect heresy.
>
> Since most new ideas will not pay off, it is on average unwise to have wild ideas. Most of the time their expected cost far exceeds their expected benefits. Thus a sensible person avoids them.[3]

Even knowing full well that most heretical leaders are not destined to become geniuses, March argues, we still need to cultivate them if we're going to find the occasional genius. Artistry may not be for the ultra-sensible; no one open to the forces of originality can safely evade the perils March describes. Yet few of us want to remain locked up in a predetermined life, especially when we know this safety and reliability will likely bring stagnation and obsolescence. Still, as original people show us and as Professor March reminds us, sustaining foolishness in the face of apparent reason can be downright harrowing.

Stepping into the river to swim upstream, many people argue that ignorance is indeed bliss. But I prefer instead some hint of preparation so that we can know what we might be in for. In March's Stanford University class on organization leadership, he assigned several classic novels, *Don Quixote* and *St Joan* among them, to illustrate the motivations and implications of this choice. I myself have turned to the working process of artists to reveal a way forward. The discussion in the next sections will take advantage of both these approaches.

The following two examples illustrate how the combination of downstream and upstream learning can generate mastery and originality, and so work together dynamically to generate artistry. The first is one person's story, that of a visual artist I interviewed. The second is a more public account that illustrates the personal, scientific, and social revolution that the combination of upstream and downstream learning can generate.

I turn first to the fine arts because these media treat the development of both mastery and originality explicitly: we can shed the light of this explicit treatment on other disciplines. Our subject, Sally Stallings, a mother of three, lives in California's Central Valley. Without the resources of art school, teachers, time, or funding, she taught herself to see and draw. Studying the Old Masters by scouring library books, working late at night, and relying on her family members and the mundane resources at hand as her subjects, she first learned to draw with mastery, and then turned herself into a multimedia artist with her own original vision and style.

The second example is captured in Erik Larson's historical narrative *Thunderstruck*. This story recounts the life and times of Guglielmo Marconi and the invention of the wireless telegraph. Along the way, it illustrates how the mastery of the times reached its limits in the face of the enigmatic problem of long-range wireless communication. It also demonstrates the disruptive influence of original ideas and the difficulties of upstream learning: a learning process during which misconceptions, dueling interpretations, flawed and incomplete theories, and confusions of experience must be endured to achieve new advances.

A Personal Story: Light on White

When Sally Stallings was a young mother, few observers would have predicted she might later stand as a model for developing artistry. In those days she had tight resources and scant time to pursue artistic dreams. Only in stolen moments could she find a way both to learn from the Old Masters about visual art – line, form, light, and composition – and then later to see with her own personal, more abstract vision.

Learning Downstream: Studying with the Masters

Sally and I both studied fine arts, but in two very different ways. For my part, I began my undergraduate career at Rhode Island School of Design. My classmates and I spent all day, five days a week, in courses on three-dimensional design, two-dimensional design, color theory, life and still-life drawing, and art history – learning from master instructors the basics of seeing and depicting the world.

Sally learned from the masters, too, but not by sitting at their feet. Instead, she sat on the floor of the Fresno County Public Library.

6.1 Sally Stallings; photograph by Steve Dzerigian, 2009

When the kids were very small, and I mean toddlers, a couple times a week I would push them in the strollers to the library, which was about five blocks away from house. I would park the three little kids in front of the clown lady who was telling stories and blowing up balloons, and I would sneak back to the art-book archives. I would pull ten, fifteen, or twenty different art books on artists that I loved. I really taught myself about art in these times at the library.[4]

By observing closely, Sally learned how basic artistic concepts were expressed by different artists pursuing different directional ideals. From Van Gogh she learned about contour and cross-contour; from Rembrandt, about line; from Lautrec, about gesture; from Cassatt, about color; and from Whistler, about composition and color harmony.

I loved Van Gogh, and how he worked with cross-contours. For instance, if he painted a flat table, his strokes were flat. If he worked with something round, the strokes would always conform to the actual roundness of the form.

I was looking at how the artists used color. I was looking closely because many of the books would have close-up shots of the paintings. I would look at the strokes, and if other colors were bleeding through the strokes. I wanted to see just how the artist used paint, how the artist used line, their sense of composition. Did the artist use a diagonal composition?

So, I was very tuned into that when I was looking at art books in the library. For instance, with Rembrandt I studied his beautifully executed fast linear drawing with some rendering, some pen-and-ink hatchings.

Mastery, Recognition, Perception, and the Influence of Involvement

Finding the chinks of time in her daily routine, Sally began her own drawing education by following *The Natural Way to Draw*, the classic book by Kimon Nicolaides.

I got the kids in bed at night, and when my husband was out of town, I would go into the kitchen and draw everything I could see with very rapid-gesture drawings. One gesture drawing would be fifteen seconds at most – dishes, pots, pans.

This investment of time made it possible for Sally to achieve visual involvement, the feeling associated with seeing, and to connect these experiences to what she learned from Cassatt, Whistler, Rembrandt, Van Gogh, Lautrec, and others.

This was really the birth of my line quality, the birth of my love of drawing. I would frequently draw myself nude, looking in the mirror while sitting on the edge of my bed. I would not be looking at my paper but looking at my image in the mirror as I drew. And, I would get the feeling that I was actually touching my head, touching my arm or body.

This method of drawing practice allows for both recognition and perception to play a role. Sally could recognize the visual elements she had learned from the masters, and at the same time, sharpen her own perceptions. (See *Vartan Sleeping*, color section, plate 6).

On the topic of *recognition*, Sally says,

Every artist I studied taught me something different. Every one taught me something I could feel in myself. I learned a great deal about form, really feeling and understanding form. I learned about conveying the sense of touch to a viewer. I learned a lot about line.

Depending on where I was in my development, I would connect with different artists. I wanted to see how they saw. What was the essence of their line? What was the essence of their vision? I figured I was learning from the best teachers in the world, throughout history.

On *perception*, she says,

So, it was an approach to drawing that was based on the tactile and sensory, where I felt like I was touching the object or subject. I was not concerned with looking to see if I was doing it right. Tactile drawing sharpened my perceptions. I had to feel my way around the drawing on paper.

I would draw plants. I would draw dolls. I would draw the kids asleep, quietly tip-toeing into their room so I didn't wake them. I drew all the time. I drew when they were playing in the park. I always drew with the sense that I was touching my subject … always!

Upstream Learning: Involvement, Perception, and the Origin of Originality

Practice time can lead to mastery, but it also creates the opportunity for new alternatives to be discovered. When perceived for the first time, original ideals, ideas, and experience can be startling to mastery, but they can also be so unfamiliar as to be completely overlooked. When disturbing and disorienting, new ways of seeing can be intentionally ignored, dismissed, or even destroyed. Instead of rejecting this disorientation, Sally describes the unsettling impact of a new vision and how the experience triggered the beginning of her own way of working.

I drew for years and years before I had my own vision. It happened one evening at the museum; there were nude models. I can remember Yolanda. She looked like she was straight out of a Rembrandt painting. Her body was worn and old. She had the most beautiful, sensitive humble face with that beautiful Rembrandt profile. She was nude and draped in black velvet, with a red velvet scarf around her neck that also wrapped around her waist.

So, I went in with canvases and paint, and I started out with a gesture drawing in paint … and then all of a sudden I no longer saw a figure.

I was going to do a more realistic image for the painting, but I started getting the shakes. I couldn't stop trembling. I was shaking so badly that the brushes were actually moving around the palette. I could hardly aim my brush into the turpentine, my hands were trembling so vigorously. I actually had to leave the room, take a deep breath calm down a little bit and wait until I was under control before returning to the classroom.

At the same time, a curtain came down in my brain and then opened again … a dark curtain going down and then opening with a new revelation. When I started painting, it was totally an abstraction from what was really before me … total abstraction.

Sally Stallings was in the disruptive presence of personal originality.

Taking Original Experience Upstream

The fundamental shift from external to internal imagery, or vice versa, is a transformative directional change for any visual artist. In addition, the effort to refine this personal vision led Sally to build knowledge she never anticipated. Letting her new way of seeing take her to new experiences was both frightening and fascinating. (See #2 *from the Yellow Grass Series*, color section, plate 7.)

I started seeing these abstractions while falling asleep. I was not totally asleep, not totally awake, but saw the most beautiful shapes. Shapes and colors, very simple forms, simple composition, and all the forms were lit from within. It was as though they had a life of their own. They had a light within them.

I was fascinated by what I saw, and it was so beautiful. The shapes and the images were so pure and so mysterious, I hadn't a clue as to what they meant. Round forms, oval forms. Blue forms. Blue oval forms. It was very scary. But the images were so intoxicating, haunting, radiant, and *beautiful*.

To create these images in the midst of her family life, Sally developed skills in a new medium. Building mastery in a new form of expression, she learned to put these internally generated images on paper in a medium that could capture her personal experience.

Well, these images … it was like dangling carrots in front of a mule. The images just kept me going. I wanted to draw every image I saw.

I turned to drawing them with Prisma color pencils. That way, I could always keep a drawing going and still supervise homework in the evening and all the things that mothers need to do for their children.

I began discovering more and more about using Prisma pencils. Not just filling in like a child would, but building soft nuances of layer upon layer. I thought of Rembrandt, actually, and how he would use many layers of transparent varnish, allowing other layers to come through. You can

do that with Prisma colors. You can let many layers come through. But this technique in drawing took hours and hours ... I mean hours!

Mastery in this new medium meant learning to control her materials to create qualities: 'edges,' 'layers,' 'textures,' and 'saturation,' as well as qualities of 'atmosphere.' Ultimately, her intention was to create a *total quality* (see chapter 4) that matched her imagined ideal, rather than matching the external reality that had once guided her eye and hand as she learned to draw.

> Even though it is invisible to the naked eye, you can feel the difference if, say, the layer of blue is not there, or the layer of lavender is there. You can feel it if it is not there. Even though you really can't see it because it is so subtle. My approach is very slow and very light. I never press too hard; it is just a whisper of a layer and then another whisper of a layer.
>
> As the layers build, the colors become more saturated, but I like to keep the grain and fiber of the paper coming through. It produces an atmospheric quality.
>
> I can let go of some edges. Then I can really nail down other edges. Some areas of the drawing I really saturate with color, appearing like a brilliant, shiny satin. Then I can play that part against a soft, subtle whisper. The drawing then begins to 'breathe.'
>
> I can see the image in my mind, and I never veer from that mental image. But the technique is revealed as I work – that is, when I choose where I will put really vibrant color and where I will leave it soft and atmospheric.

The Emergence of Artistry

The openness to new visions led to another original turn where the external and internal come together in her work – the transformation of the mundane into something magical. In this case, a task as seemingly tedious as laundry was transformed within her into a new body of artistic work.

> Again that dark curtain comes down and then lifts up, and I see something in a new way. I see it in my mind in a new way, and that's what I stick to. The outside was a trigger.
>
> It's the most mundane thing, my clothesline. I've been in love with it for years. It is about thirty feet long, has four wires, and at each end are black

6.2 *The White Place*; photograph by Sally Stallings

iron T-poles. Every single morning when the weather is nice, I hang up clothes, very early in the morning, maybe six or six-thirty. And, as the morning progresses, the light, the sun will shine on this clothing ... It is magical!

For Sally, the openness and motivation needed to reach this vision come from the expansion of personal experience the work provides – the appreciation of light on white, the meaning of spirituality, and the satisfaction of skillful self-expression that brings personal feeling into form. From this vision, she's created an entire series of compelling drawings that build from the play of light on white in the wind. (See *Light on White*, color section, plate 8.)

When I hang up clothes, I look at the blue sky and I hang up the white things so right above it is the blue. I love to look at the white against the blue and the angles of the rooftops. It's all about composition and light; it's not about jock shorts or T-shirts on the line. But as the light shines on underwear, it will penetrate right into the ovals of the legs. They become white ovals.

It is about light, it's about white and where that takes me. We are talking white ovals here, not leg holes of Fruit of the Loom. It is a group of images about shape, and about light. It is also about expressing myself.

It's a spiritual place. It's more of a spiritual place than even climbing the Mayan pyramids, or the Temples of Egypt. My husband and I have been everywhere. But who needs the pyramids when I've got my light on white on the clothesline.

Lessons from Sally Stallings's Story

- Artistry is not an elite capability.
- Mastery can be learned in and out of school.
- The pursuit of mastery demands personal involvement.
- Personal involvement with qualities often disrupts mastery learned from others.
- Current capabilities must be abandoned, at least temporarily, for new ones to emerge.
- Originality can transform the mundane into an opportunity for artistry.
- The Knowledge System elements that drive upstream learning are unpredictable and personal.

A Public Story: Long-Range Wireless

Sally Stallings's evolution toward artistry was a personal one that nobody outside her circle of acquaintances might have witnessed. But dramas of mastery and originality jerking disruptively back and forth also play out on the public stage, often during moments of great consequence. Erik Larson depicts one such moment in his 2006 bestseller *Thunderstruck*. Larson's story begins with a pivotal scene that occurred at London's Royal Institution on 4 June 1894. This was an era when Directional, Conceptual, and Experiential Knowledge were shifting at a rapid rate and in a setting where public involvement was high. Theories about science, religion, and the nature of physical and spirit life were in hot contention; at the same time, mechanisms for accurately testing these theories were virtually non-existent. It was a time when scientific theory could be argued and shaped by public debate.

Inside the hall, a physicist of great renown readied himself to deliver the evening's presentation. He hoped to startle his audience, certainly, but otherwise he had no inkling that this lecture would prove the most important one of his life and a source of conflict for decades to come. His name was Oliver Lodge, and really the outcome was his own fault – another manifestation of what even he acknowledged to be a fundamental flaw in how he approached his work. In the moments remaining before his talk, he made one last check of an array of electrical apparatus positioned on a demonstration table, some of it familiar, most unlike anything seen before in this hall.[5]

Scientists' investigations were beginning to reveal mysterious elements of the physical world that remained invisible to the naked eye. Such forces as electricity and magnetism had been discovered but were scarcely understood. Competing theories to explain these forces ranged from the scientific to the metaphysical. Directional Knowledge of the time included a mix of scientific and spiritualistic orientations; contentious identities of pure scientists and commercial 'practicians' knocked heads. The search for theoretical understanding covered a lot of conceptual ground: physicists postulated different theories about invisible waves; spiritualists promoted the idea of an invisible matrix that provided a home for the spirits of the dead. And in that time and place, the scientists and spiritualists came together far more regularly than we'd guess today. Oliver Lodge himself was a member of the Society for Psychical Research, a group of empirical researchers who, as Larson tells it, used their craft to study ghosts, séances, telepathy, and other paranormal events.

Originality Striking Sparks

When the exhaustion of mastery is experienced in social settings, the urgent development of original options often sets sparks flying. Opposing ideals and theories, too new or too outlandish to be tested, often compete for attention through the work of individuals. New, partially formed Knowledge Systems are formulated, debated, dismissed, or accepted in the midst of social upheaval. Individual efforts at upstream learning must contend with this added external challenge.

Lodge had come of age at a time when scientists began to coax from the mists a host of previously invisible phenomena, particularly in the realm

of electricity and magnetism. He recalled how lectures at the institution would set his imagination alight. 'I have walked back through the streets of London, or across Fitzroy Square, with a sense of unreality in everything around, an opening up of deep things in the universe, which put all ordinary objects of sense into the shade, so that the square and its railings, the houses, the carts, and the people, seemed like shadowy unrealities, phantasmal appearances, partly screening, but partly permeated by, the mental and spiritual reality behind.'[6]

The effort to expand Experiential Knowledge in a contentious environment, in the absence of solid theory, and the effort to expand Conceptual Knowledge without a means to access invisible phenomena generated a hodge-podge of competing, inconsistent, and bizarre explanations of confusing phenomena.

The unveiling during Lodge's life of so many hitherto unimagined physical phenomena, among them Heinrich Hertz's discovery of electromagnetic waves, suggested to him that the world of the mind must harbor secrets of its own. If one could send electromagnetic waves through the ether, was it such an outrageous next step to suppose that the spiritual existence of human beings, an electromagnetic soul, might also exist within the ether and thus explain the hauntings and spirit rapping that had become such a fixture of common legend?[7]

In front of his audience at the Royal Institution, Oliver Lodge had assembled two electrical components, the one across the room from the other and with no wires joining them. The distant appliance of his design was a tube full of metal filings that he called a coherer. When Lodge set off a spark in the appliance next to him, light flashed from the coherer across the room. This was the first time wireless technology had been demonstrated in public.

What Lodge had done was to apply theories about electromagnetic waves that Heinrich Hertz had developed years earlier. But even as Lodge harnessed the forces, he missed the potential utility. What he couldn't imagine was that these forces might someday travel a distance far enough to transform the way people communicate. That missing piece was exactly the idea Guglielmo Marconi formulated into what was a wild idea at the time: that, using invisible waves, long-range wireless communication was possible. Ignoring, or having inadvertently avoided, limiting ideas and capabilities that bound his contem-

poraries, Marconi built his own knowledge about the phenomena and mechanisms he wanted to harness.

> 'My chief trouble was that the idea was so elementary, so simple in logic that it seemed difficult to believe no one else had thought of putting it into practice,' Marconi said later. 'In fact Oliver Lodge had, but he had missed the correct answer by a fraction. The idea was so real to me that I did not realize that to others the theory might appear quite fantastic.'[8]

According to the existing Conceptual Knowledge, what Marconi proposed was, in Larson's words, 'the stuff of magic shows and séances, a kind of electrical telepathy.'

> Many years later scientists would share Marconi's wonder at why it was that he of all people should come to see something that the most august minds of his day missed. Over the next century, of course, his idea would seem elementary and routine, but at the time it was startling, so much so that the sheer surprise of it would cause some to brand him a fraud and a charlatan – worse, a foreign charlatan – and make his future path immeasurably more difficult.[9]

Immersion and Involvement

Startling originality often generates fearful attack. During his initial research, Marconi found sanctuary from assault in physical and intellectual isolation. Sheltered from the storm, he could tinker and experiment unimpeded by prevailing ideas – his only company being the personal obsession that fueled his efforts.

> Marconi immediately set to work devising equipment to transform his idea into reality, with nothing to guide him but an inner conviction that his vision could be achieved. On hot days the attic turned into a Sahara of stillness. Marconi grew thin, his complexion paler than usual. His mother became concerned. She left trays of food on the landing outside the attic door.[10]

Marconi grappled with the conundrum that everyone with original ideas faces – a Knowledge System that would not get him where he wanted to go. No current level of mastery can provide the knowledge needed to have new experience, develop a new theory, and formulate new ideals and possibilities.

New knowledge is built through imaginary and tangible involvement in a medium. In Marconi's case this meant a difficult process of imagining, experimenting, trial and error, and the interpretation and reinterpretation of findings.

> In his attic laboratory Marconi found himself at war with the physical world. It simply was not behaving as it should. From his reading, Marconi knew the basic character of the apparatus he would need to build.
>
> But Marconi found himself stymied. He could generate the spark easily but could not cause a response in his coherer. He tinkered. He tried a shorter tube than that deployed by Lodge, and he experimented with different sizes and combinations of filings. At last he got a response, but the process proved fickle. The coherer 'would act at thirty feet from the transmitter,' Marconi wrote, but 'at other times it would not act even when brought as close as three or four feet.'[11]

Here's where the theorists and the *practicians* diverged. What the academic scientists 'knew' – drawing from the best Conceptual Knowledge of their time – was that the earth's spherical shape would prevent even the most powerful signal from reaching a point on land or sea hundreds of miles distant. They didn't know what every ham operator today knows about reflecting radio frequencies off different layers in the ionosphere. Neither, for that matter, did Marconi. But through his own laborious process of upstream learning, the tinkerer ultimately found it.

Foolishness and Originality

As Jim March's research suggests, upstream efforts often require what reasonable people regard as foolish behavior. When your efforts run in the face of conventional wisdom and accepted mastery, persistence can look like madness. If you succeed in the end, this extreme originality reformulates into a new level of mastery, sometimes even genius; if you fail in the end, you remain a madman in the eyes of others, and maybe even yourself. When you are in the midst of the journey, as Marconi was, there's really no way of knowing which one you are.

> Another man might have decided the physicists were right – that long-range communication was impossible. But Marconi saw no limits. He fell back on trial and error, at a level of intensity that verged on obsession. It

set a pattern for how he would pursue his quest over the next decade. Theoreticians devised equations to explain phenomena; Marconi cut wire, coiled it, snaked it, built apparatus, and flushed it with power to see what would happen, a seemingly mindless process but one governed by the certainty that he was correct.

No instrument existed to monitor the strength or character of the signals he launched into space. Instead, he gauged performance by instinct and accident.[12]

The degree of difficulty and personal risk involved in upstream learning is different in different media. As the implications of positive and negative consequences increase, so do the pressures. To whatever degree you take on the risks of originality, commitment comes from one or all of three different places: the pull of personal ideals, the desire to reach understanding, and the compelling nature of involvement and immediacy. When you have all three of these elements working together, you will have motivation aplenty.

Work and Luck

Of course motivation doesn't guarantee reaching your ideals and goals. In addition to involvement, upstream learning often requires luck. Frequently, the difference between foolish failure and reasoned success is simply luck.

One day, by chance or intuition, Marconi elevated one of the wires of his transmitter on a tall pole, thus creating an antenna longer than anything he previously had constructed. No theory existed that even hinted such a move might be useful. It was simply something he had not yet done and that was therefore worth trying. As it happens, he had stumbled on a means of dramatically increasing the wavelength of the signals he was sending, thus boosting their ability to travel long distances and sweep around obstacles.[13]

For Marconi himself, what followed was a decades-long drama from riches to ruin and back again, together with a cycle of media frenzy that publicly amplified the failures more loudly than the successes. But what Guglielmo Marconi got for all his work in the end was his name attached to the most advanced communication system of his age. Just as Jim March tells us, it was only the unfolding of history that decided whether Guglielmo Marconi was a madman or a genius.

Lessons from Marconi's Story

- People with different Directional ideals are often at odds, build Conceptual constructs that compete, and experience the world differently.
- It is easier to preserve than to change personal Conceptual Knowledge, and so miss or deny what others understand differently.
- Building new theory, working upstream, to explain new experience takes perseverance, systematic experimentation, immersion in your medium, sometimes isolation, and often luck.
- It is often impossible to know ahead of time if you are on or off the track.
- As March highlights, to persist in building new knowledge often requires stubbornness and foolishness in the face of accepted reason.

The need to formulate personal ideals, to understand experience, to experience deeply, and finally to express these accomplishments in forms that can be shared is a universal and undeniable urge. In our effort to follow this urge, few of us will do so like Marconi in the midst of social and scientific upheaval. Like Sally Stallings, more often we pursue this learning within a smaller more personal sphere. However, even in the more intimate world of an individual life, the development and testing of new knowledge can be extraordinarily demanding. In the next chapter, you find a lot of what you need to succeed.

chapter **7**

LEARNING ARTISTRY

In a practitioner's reflective conversation with a situation that he treats as unique and uncertain ... he shapes it and makes himself part of it. Hence, the sense he makes of the situation must include his own contributions to it. Yet he recognizes that the situation, having a life of its own distinct from his intentions, may foil his projects and reveal new meaning.

Donald Schön, *The Reflective Practitioner*[1]

Now we can turn to the nitty-gritty of learning artistry. Let me first say that when it comes to competition and expert performance, there are already many good 'how to' sources to help you. There are books on practice, innovation, motivation, mindfulness; there are books on neurology and learning, how to become a critical thinker or an expert, and how to win if you're a competitor. I won't recap their advice here. Instead, I hope that focusing on what is unique to artistry will add to these ideas.

The single distinguishing feature that makes artistry artistry, *and not something else, is your ability to use qualities to help you solve enigmatic problems.* This is *qualitative reasoning*, the reasoning that practitioners use to take initiating qualities and turn them into products and outcomes with 'total qualities' they approve.[2] (See chapter 4, under 'Qualitative Problem Solving.')

This reasoning is rooted in the unity artists achieve with their medium. Qualities, rather than symbols or quantities, are the elements artists manipulate through reasoning. However, in the face of enigmatic problems qualitative reasoning is useless if your Knowledge System is too rigidly held. What you need is a Knowledge System that can refor-

mulate in response to the qualities you experience rather than one that simply imposes itself on the medium. This chapter is about how you can build responsiveness into your Knowledge System, so that you can put qualitative reasoning to work for you in practice.

Qualitative reasoning is different from quantitative reasoning. Each serves its own set of purposes, and developing one does not mean abandoning the other. Achieving artistry means being able to use qualities to help you work, when that's what the situation demands; it doesn't mean rejecting quantitative methods. And indeed, qualitative reasoning, while often necessary, is not always sufficient for handling enigmatic problems.

When you do take your sensitivity to qualities as the route into enigmatic problems, there are three dramatic learning implications.

- First, when you use qualities, your sensitivity, your judgment, and your involvement make the work what it is. In essence, you become part of the instrumental *means* by which problems are structured and resolved.
- Second, because enigmatic problems are what they are – that is, means and ends are intertwined and evolving simultaneously – you as part of the *evolving means* will change in unison with the *evolving ends* you have in view.
- Third, different practitioners with different Knowledge Systems will experience and reason with qualities differently. This potential variety means you will be fashioning a personalized way of working and generating unique outcomes.

As I've said before, the Knowledge System model offers a clear way to organize this learning effort; it should also help you take a more active role in your own learning. For qualitative reasoning to work effectively, your whole Knowledge System must work like a well-oiled machine – at least some of the time! I'll say it plainly: If you develop useful knowledge in all three knowledge categories; if you sustain both downstream and upstream connections between the categories; and if you build knowledge that helps you work the tension between mastery and originality, you will be well on your way toward achieving artistry.

Every discipline exists in its own medium; each has characteristics that make it unique. Sports are kinesthetic, and often both risky and competitive. Painting is visually demanding, immediate, dexterous, and personal. Cooking is manual, gustatory, textural, and usually

social. Organizational practices are interpersonal, intellectual, complexly quantitative, and often associated with high financial and public stakes. What that means is that reasoning with qualities in each discipline asks you to develop the particular sensibilities and the particular contents of a Knowledge System that are unique to that discipline.

Fortunately, many of the difficulties of learning artistry are similar across disciplines. By anticipating these difficulties, we're in a much better position to prepare for them. But let me emphasize: *prepare for*. For the most part, they cannot be avoided altogether; our best hope is to work through them with courage and panache.

Let the Material Tell You

> The challenge for investigators in every field is to break free of the hidden constraints of their tacit assumptions, so that they can allow the results of their experiments to speak for themselves. 'I feel that much of the work is done because one wants to impose an answer on it,' McClintock says. 'They have the answer ready, and they [know what they] want the material to tell them.' Anything else it tells them, 'they don't really recognize as there, or they think it's a mistake and throw it out … *If you'd only just let the material tell you.*' (Evelyn Fox Keller, *A Feeling for the Organism*)[3]

Barbara McClintock was a geneticist who pursued marginalized, even unpopular, scientific ideas throughout a career that eventually led her to a Nobel Prize. In Evelyn Fox Keller's biography, *A Feeling for the Organism: The Life and Work of Barbara McClintock*, the author poses artistry's critical question.

> What enabled McClintock to see further and deeper into the mysteries of genetics than her colleagues?
>
> Her answer is simple. Over and over again, she tells us one must have time to look, and have the patience to 'hear what the material has to say to you,' the openness to 'let it come to you.' Above all one must have a feeling for the organism.
>
> 'No two plants are exactly alike. They're all different, and as a consequence, you have to know the difference,' she explains. 'I start with the seedling, and I don't want to leave it. I don't feel I really know the story if I don't watch the plant all the way along. So I know every plant in the field. I know them intimately, and I find it a great pleasure to know them.'[4]

Keller's passage holds the secret of developing qualitative reasoning and artistry in any discipline.[5]

Before we explore just what that secret is, bear in mind that McClintock is talking about the thousands of nearly identical corn plants she raised and used for her genetic research. These are not the thrilling motion Eric Thomas rides on his horse (see chapter 1), nor the sensuous flavors Angelo Cabani tastes (see chapter 3), nor yet the beautiful forms or colors that attract Steve Dzerigian and Sally Stallings (see chapters 5 and 6). To ensure that her qualitative experience could inform what others would see as tedious scientific protocol, McClintock's secret is to rely on 'intimacy,' 'patience,' 'pleasure,' and 'feel' rather than only established disciplinary methods. Take the time, she says, to 'look' and 'hear.' This 'openness' to the qualities of her subjects allows her to understand what the material can tell her. Instead of imposing current ideas, she remained open and thereby developed an understanding that was inaccessible to her colleagues. Her words remind us that openness is critical because when status-quo knowledge is too rigidly held – even if it's masterful – it can extinguish the qualitative sensitivity and reasoning that often generate new knowledge.

This last idea is the reason artistry is not solely about expertise or mastery or excellence. While it's tempting to pursue these highly admired levels of performance, such a pursuit can also doom the original notions that qualitative reasoning generates. Ironically, if you are too smart, it can be hard to generate new ideas. The following passage written by polymath Michael Polanyi also speaks to the extinguishing power of existing knowledge, when downstream learning can simply wash away efforts at upstream learning. (See chapter 6, under 'Learning Downstream and Upstream.') Polanyi's monumental intellectual work spanned physical chemistry, economics, and philosophy, yet he describes how 'ignorance' allowed him to escape some of the forces typically exerted by existing knowledge. Polanyi's words recall Jim March's appeal to foolishness.

> I would never have conceived my theory, let alone have made the effort to verify it, if I had been more familiar with the major developments in physics that were taking place. Moreover, my initial ignorance of the powerful, false objections that were raised against my ideas protected those ideas from being nipped in the bud.[5]

Elliot Eisner's ideas help explain how a lopsided Knowledge Sys-

tem can work to produce this artistry-crushing effect. Eisner refers to the models, theories, frameworks, ideals, and purposes that compose Directional and Conceptual Knowledge as 'structures of appropriation.' These abstract structures help organize the potentially overwhelming sensory information that surrounds us, allowing us to take in this information as experience and make use of it. However, at the same time that these knowledge structures can help us see in the way McClintock sees, they can also blind us. It's a conundrum that American educator and pragmatic philosopher John Dewey addressed in the 1930s: while pre-existing knowledge allows us to *recognize*, it also can actively block our *perception* of the unfamiliar, unexpected, and surprising qualities and events that lead to new concepts and directions.[6]

On the one hand, knowledge that provides practice with focus, heading, understanding, and organization is useful. At the same time, though, artistic practitioners don't want this knowledge to control, blur, or limit their immediate perceptions. It takes *recognition* to achieve the downstream learning that leads to mastery; it takes *perception* to achieve the upstream learning that leads to originality. Reasoning with qualities in the face of enigmatic problems requires both.

To avoid lopsided practice, artistic practitioners build knowledge that allows for recognition and perception to coexist. In McClintock's reference to the need for openness, intimacy, patience, and pleasure, we can hear echoes of what Eric Thomas, Angelo Cabani, Steve Dzerigian, and Sally Stallings all say about their work.

Each has built Conceptual Knowledge – displayed in their personalized way of working – that sustains the needed combination: recognition of known qualities, and the perception of new qualities. For instance, Eric rides today's horse, so that his immediate feel keeps repetition from becoming mindlessly, if masterfully, repetitive; Angelo juggles tradition with what he experiences immediately in the pan as he cooks; Steve establishes themes that direct his attention without limiting him in the moment 'too much'; Sally employs hard-earned technical skill in the service of her unpredictable inner vision. Barbara McClintock lets her *feeling for the organism* interpret her systematically designed experiments. For each of these practitioners, the importance they place on cultivating their sensitivity to qualities is at the root at all these capabilities.

How do they do this? How would you do this? There is no single answer about how to build this artistic knowledge; each artist, in each medium, develops this knowledge in a personal way. However, the approach to this learning is universal.

Learning Loops

> Excellence is a range of differences, not a spot. Each location on the range
> can be occupied by an excellent or an inadequate representative, and we
> must struggle for excellence at each of these varied locations. In a soci-
> ety driven, often unconsciously, to impose a uniform mediocrity upon
> a former richness of excellence – where McDonald's drives out the local
> diner, and the mega-Stop & Shop eliminates the corner Mom and Pop – an
> understanding and defense of full ranges as natural reality might help to
> stem the tide and preserve the rich raw material of any evolving system:
> Variation itself. (Stephen Jay Gould, *Full House*)[7]

Your Knowledge System involves two learning loops you can use to pre-
vent a lopsided way of working (see figure 7.1). Sustaining these loops
means practitioners can both recognize the qualities important to mastery
in their discipline and perceive the new qualities that drive originality.

Before you read this section, and reflect on your own medium and
practice, take a deep breath and *loosen your grasp on the truth.* Perception
is rooted in curiosity rather than certainty. A person building a Knowl-
edge System that is progressive builds it on a foundation of curiosity
and a focus on qualities that this curiosity makes possible, rather than
on the certainty of what he or she already knows.

To illustrate how the development of your Knowledge System can
unfold, let's look at each learning loop in turn.

Loop-One Learning

Most of the learning you did at school or university was downstream;
this is the course that learning takes when we direct our awareness and
apply skill that's based on established disciplinary concepts. Transfer-
ring concepts is generally taken to be a straightforward process; yet,
as we've discussed earlier, such formal education can break down in
practice. To reliably transfer what you understand into action takes the
development of sensitivity and a lot of practice time.

To be good at *loop-one learning* in your own discipline, you must look
within yourself and your medium to accomplish four things:

- undergo qualitative experience and build skill;
- build a stock of relevant concepts;
- use your stock of concepts to make sense of and guide your re-
 sponse to what you experience;

Figure 7.1: The Learning Loops

Artistry depends on the interactions of mutual influence among the knowledge categories. Loop-One learning describes the interactions between Conceptual and Experiential Knowledge. Loop-Two learning describes the interactions between Directional and Conceptual Knowledge.

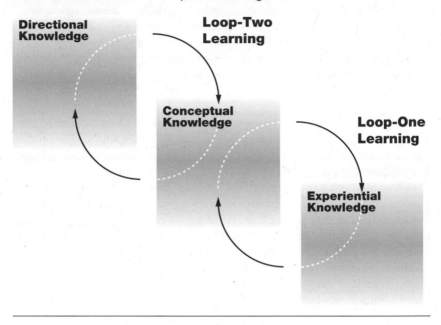

- connect experience to available Conceptual Knowledge, or use it to build new Conceptual Knowledge.

In the pursuit of artistry, this process of learning becomes as natural as breathing. To help move in this direction, answer the questions and follow the steps in the 'Loop-One Learning Guide' at the end of the chapter.

Loop-Two Learning

To be good at *loop-two learning* in your own discipline, you must look within yourself and your medium to accomplish four different things:

- identify possible ideals, headings, and identities that drive you to act;
- build a stock of relevant concepts;

- use your ideals, headings, and identities to sort and select from available concepts;
- use your store of concepts to enrich or alter your ideals, headings, and identities.

Again, this process of learning must become as natural to you as breathing. To help move in this direction answer the questions and follow the steps in the 'Loop-Two Learning Guide' at the end of the chapter.

Conceptual Knowledge and Model Building

Model building is not an empty academic exercise. It is cognitive work we all do every day, though often below the level of awareness. When building models, we are always asking Directional and Experiential questions. What do we care about? What do we see, hear, and feel? Model building allows us to bring these two concerns together in practice.

A Professional's Perspective

I like the juxtaposition of pattern recognition and being mindful. People are like a puzzle. There are patterns and there are recurring patterns. But no one is the same. So you can never just pull out one thing and say, 'I'm going to do this every time.' *Melanie Carr, psychiatrist*

There is an advantage to a focus on building Conceptual Knowledge. You will notice that Conceptual Knowledge is safely nested between Directional and Experiential Knowledge. Building Conceptual Knowledge is mental work; it is analytic, abstract, and imaginary. This kind of knowledge building is primarily a reflective act; as such, it is somewhat buffered from the emotional turmoil and physical risks that can pervade Directional and Experiential knowledge building.

If you start by following the learning-loop guides at the end of this chapter, you will be learning downstream at first. This means taking available disciplinary models, modifying these to your liking, and ultimately building your own. Angelo Cabani illustrates this kind of effort as he takes what he learned during his 'stage' in France and modifies it to help his regional restaurant cooking. Sally Stallings illustrates this in her effort to learn about form, composition, contour, and color from the masters and later let this *inform* rather than determine her own style.

Guglielmo Marconi (see chapter 6) and Barbara McClintock illustrate how practitioners achieve upstream loop-one learning. The systematic,

arduous, and often lonely upstream work this part of the learning demands is daunting to most folks. When artists invest in the knowledge-building effort, they expose themselves to the risks of personal experimentation. But it is also from this effort that new Conceptual Knowledge – new models – can be created. New models provide the artist, and ultimately the rest of us, with new ways of seeing and shaping the world.

This work is a very important part of an explicit pursuit of artistry, and while providing a complete primer on model building is beyond the scope of this book, the guidelines below will get you started. (See 'Uncovering the Models That Guide What Advanced Practitioners Say and Do.') If you want to be in charge of what you know, model building is a skill worth developing explicitly.

Uncovering the Models That Guide What Advanced Practitioners Say and Do

The models that make up Conceptual Knowledge can be organized in general categories. If you can recognize them, the content of these categories will tell you a lot about how practitioners understand their medium.
Listen for:

- *Salience:* What elements and qualities are *important?*
- *Categories:* How are elements and qualities *related and grouped?*
- *Sequence:* What happens in what *order?*
- *Cause:* What *leads* to what?
- *Criteria:* How are elements and qualities *evaluated?*
- *Predictors:* What happens *before* what happens happens?
- *Relationships:* What is *connected* to what? What *influences* what?
- *Maps and Architectures:* How is the whole *organized?*

Advanced practitioners use the answers to these questions to build the models, theories, and frameworks they use to capture and generalize their Experiential Knowledge.

You can ask these same questions of yourself. The answers will reveal how you are building your Conceptual Knowledge as your experience in your medium advances. If the answers are hard to come by, capture your practice in a form that you can observe – video or audio – and be your own scientist. What you feel, do, and say as you work will give you clues to how you are reasoning and thinking as you work.

Figure 7.2: The Learning Loops (Comprehensive)

What drives artistry is the mutual influence of the contents of your three Knowledge System categories working together.

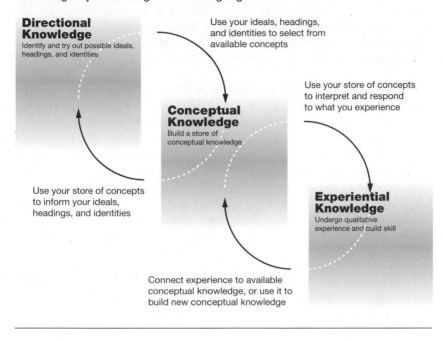

When It All Comes Together

When loop-one and loop-two learning become a natural part of your practice, your Knowledge System will develop through the processes depicted in Figure 7.2. When this responsiveness is designed into your Knowledge System, it allows you take new, unusual, surprising qualities – whether dramatic or subtle – into account as you work, while simultaneously applying what you already know.

To help you build knowledge in each category and then make the connections that make the learning loops run smoothly, use the guides provided at the end of the chapter.

Thinking about the ideas presented above, you might not have imagined yourself to be a qualitative reasoner, conceptual model builder, or paradigm shifter. But, in fact, this is exactly what you are. And it's a good thing, too. If you were otherwise, progressive learning would be impossible. In *The Reflective Practitioner*, Donald Schön identifies reflection-in-action as a defining feature of artistic practice in any context.

Reflection-in-action is very similar notion to qualitative reasoning. As Schön says,

> When the practitioner reflects-in-action in a case he perceives as unique, paying attention to phenomena and surfacing his intuitive understanding of them, his experimenting is at once exploratory, move testing, and hypotheses testing.[8]

In short, artistic practitioners are knowledge building in action; that's what you'll be doing, as well. Most of this work is done automatically, below your awareness. When things are going well and the situation at hand is well within your grasp, this tacit status is fine. But enigmatic problems by definition can't be fully grasped; what's necessary in these situations is to make knowledge building a conscious effort.

What kind of knowledge do you need to build? The Knowledge System guide in Figure 7.2 and the learning-loop guides at the end of the chapter can lead you through building disciplinary knowledge for your Knowledge System. But there is another kind of knowledge you need to build as well. It is not only the content-oriented elements in your Knowledge System that enable you to be responsive when engaging with enigmatic problems; equally important to the process of knowledge building are the elements that keep upstream and downstream learning in motion.

We all need elements in each knowledge category that allow us to sustain openness to our material and so allow the material to tell us what it wants to say. Though all artistic practitioners create this kind of knowledge, few do so consciously. Even fewer can describe it. These are not knowledge elements that we can easily label; any shorthand words we use often come out sounding glib. Finding someone to shed light on this kind of knowledge building in action makes all the difference.

Keeping a Strategic Dialogue Moving

> The most erroneous stories are those we think we know best – and therefore never scrutinize or question. (Stephen Jay Gould, *Full House*)[9]

Diana McLain Smith: Think Murphy Brown and Molly Brown wrapped into one. Wit, energy, curiosity, and an unsinkable desire to make things better have fueled Diana over a thirty-five-year career in organization-development consulting. I was lucky to study her practice as part of

7.1 Diana McLain Smith

my early research, and later to become a colleague. During our work together, she consulted to Fortune 500 companies, helping them build strategic capabilities within upper-management teams. Her work encompasses both the content of the strategic issues in question and the interpersonal dynamics surrounding these issues. This is a high-stakes, high-pressure profession.

Organization consultants are usually brought into firms to fix something or to effect some kind of beneficial change. In these change efforts, the problems they address are enigmatic in the truest sense: they cut across organization levels and functions; they're influenced by local and far-reaching economic events; they involve the interactions of internal individuals and external organizations; they generate vast amounts of

quantitative data that are difficult to interpret; and they require predictions about immediate consequences, as well as the longer-term responses of competitors and customers. This expansive terrain leaves room for many different ideals, interpretations, and ways of working.

There are as many takes on the consulting media as there are practitioners and consulting firms. Different economic and intervention theories lead different practitioners to offer a wide array of services. These range from recipe-like programs to completely open-ended interventions; and they can focus on every possible aspect, from personnel education to global restructuring. Diana positions herself to work at the interface of interpersonal interaction and strategic decision making, where upper-management teams work together to understand the marketplace and then design an organization that can thrive. Her practice involves extended work with both individual managers and teams. Her 2008 book, *Divide or Conquer*, showcases her core ideas about leadership and building great partnerships.

Diana is skillful with issues related to complex organizations. But her disciplinary knowledge is not what we'll focus on here. Rather, it's her way of working that stands out as an example of artistry in practice. She engages the challenges of enigmatic problems with enthusiasm. She accomplishes loop-one and loop-two learning as she applies, builds, and revises her Knowledge System in response to what she can recognize and perceive. She reasons her way forward using the qualities displayed by client participation. She works with feel by resolving the tension between involvement and detachment. She pursues emergent ends by intertwining ends and means. She allows open-ended ideals to inform her practice. And, all the while, she uses mistakes and conflict to build knowledge and to create solutions.

As I illustrate these capabilities through Diana Smith's practice, I'll also use marginal comments to suggest some of the ways you can apply to your own practice what she demonstrates in hers.

On Enigmatic Problems

'I am infinitely curious, and this is a complicated field, which is why I love it. I find it very intellectually challenging.'[10] Her job is one where the rich mix of business problems and human dynamics is so interesting that to Diana it has 'emotional Velcro.'

Diana's practice is set in a complex organizational environment that involves multiple players who often have conflicting goals, where reli-

able data are hard to come by, and where different people count different kinds of data as information. She enters this arena with tremendous enthusiasm. In the beginning of the work, it is common for everyone involved to be 'contending for his or her own view of the future to prevail.'

Imposing artificial simplifications onto this rich mix of conditions can lead to problems, she says. 'As soon as you pull the thread in one area, you discover you're dealing with other areas as well. Problems are nested, and collapsing complexity contributes to getting stuck.'

Rather than deconstructing and using preconceived solutions to resolve these nested problems, Diana works with clients to 'frame problems so we can understand them fruitfully. This often means resolving what can be resolved and then managing inherent ongoing tensions that evolve but never go away.'

Diana accepts, sustains, and sometimes even enjoys tensions, ambiguity, and complexity – features that most people work to eradicate. For example, she says, 'I just happen to like the ambiguity. You can create what you want out of ambiguity. If something is clear, you are constrained.' Eliminating constraint, at least in the early stages of the work, sustains her and her clients' 'openness to possibilities.'

Diana thinks of her practice as 'organic' because it develops and re-forms as she finds ways to 'make things work.' Making things work is not about disciplinary competence only, but also about pushing forward when 'things get tough or don't go the way I expect. Things will turn out wrong, and so I try again to see if I can't somehow make it turn out right.' With Quixote-like

Working with Enigmatic Problems

Problems are nested.
Complexity is sustained.
Tensions are ongoing.
Simplifications are potential traps.

Difficulty and variance are inherent.
There are no clear answers, only fruitful understandings.

She enjoys ambiguity and openness.

She works organically to sustain openness.

She sets open-ended Directional ideals.

dedication she says, 'You don't just walk away because it's hard.' Trying to make things turn out 'right' is the Directional beacon for her effort and progress.

She is guided by the personal ideal of making things right.

To Take On Enigmatic Problems in Your Own Practice:

1. Find your own way of framing the enigmatic features of your discipline or profession. Is it 'nested problems,' 'organic practice,' or something else?

2. Find out how those you admire think about and work with the elements most difficult for you. For instance, can you turn ambiguity into an opportunity for creativity? Can you sustain tensions rather than collapse them?

3. Find the most attracting features of your practice and use them to motivate persistence. Can you find something that makes you say, 'I love it'? What do you need to make right?

Conceptual Knowledge at Work

Diana's overriding concern about her Conceptual Knowledge is that it should help her and her clients understand the situation they all face 'without constraining too much.' That's why she has a strong preference for frameworks over prefabricated categories such as 'He's an *introvert*,' 'She's *achievement-oriented*,' and the like.

To generate the fruitful understanding she seeks, Diana says, 'I start with a diagnosis that frames the situation. To achieve this, I have to spot, select, and explain certain things. Then, I reflect on how I have framed the situation and ask myself, What will that framing do for us? I may look for different things or come up with a different interpretation that will be more useful.'

Using Conceptual Knowledge to Sustain Loop-1 and Loop-2 Learning

Repeated cycles of reflection generate new ways to frame problems.

Creating new ways to frame problems often means, 'developing a fundamentally new capacity.' Re-educating how she and

New transformative ways of understanding the problem can shift

her clients see the situation can be a 'transformative process that fundamentally shifts the way we see the problem and each other.' Ultimately, Diana wants the framing that will give her and her clients 'greater degrees of freedom to act.'

Directions, as well as immediate Experience.

The dynamic nature of her work has led Diana to develop conceptual frameworks that help her take into account many different levels of relationships. She says, 'If I can't see relationships, I can't see the connections between people, or between people and the organization. I want to understand how different aspects affect each other. Then, when I have to make choices about where I am going to focus, I can predict the consequences in areas where I am not focusing.'

She uses personalized Conceptual Knowledge to recognize and understand the interactions, as well as to focus and then predict consequences.

These relationships and interactions take place over time and across both functions and organizational levels. 'To design an intervention, I have to think about the parts of an intervention in relationship to the whole intervention. All the parts must fit into a sequence – an overarching architecture – that will produce some kind of insight, or learning, or something new.'

She uses the same Conceptualized Knowledge to:
– scale work,
– sequence work,
– predict outcomes,
– take multiple dimensions into account.

Her conceptual tools allow her to use them for multiple purposes. Frameworks like 'Diana Smith's Interaction Framework' (see figure 7.3), help her identify important relationships that inform the design of her intervention. 'I can use this framework not only to explain what's happening but to design and stage my intervention. I can make decisions developmentally about where I ought to focus first and to a certain extent predict how things will evolve over time and where difficulties will arise.'

While powerful shapers of perception, these frameworks are not rigid, nor are they rigidly applied. Reflecting on both how

Both recognition and perception – downstream and upstream learning – are continuous.

Figure 7.3: Diana Smith's Interaction Framework

The Interaction Framework is a powerful component of the Conceptual Knowledge Diana employs in her consulting practice. In an intervention with two or more clients, she employs this framework to demonstrate the ways each person's actions influence the other's actions – even as each person sees only one half of the interaction. Framework © Diana McLain Smith.

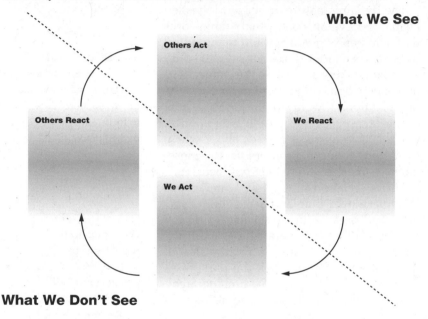

What We See

Others Act

Others React

We React

We Act

What We Don't See

these frameworks are designed and how they are being applied in the moment is a continuous process in Diana's way of working. She says, 'I don't want my mastered skills or frameworks to limit what I see. I want to stay open, not edit too much what I am feeling and thinking. I try to stay open to discovery because things not immediately salient can easily fall off my plate.'

Her overarching framework, or 'intervention architecture,' is designed to 'intermingle' her purposes and her clients' purposes. 'I keep designing and revising until I come

Repeated reflection on all three Knowledge System categories helps sustain loop-1 and loop-2 learning.

up with a design that will allow me to pursue their purposes and mine and explore the differences between the two.' This explicit mingling of her and her clients' purposes helps her sustain the upstream learning that keeps her work relevant to particular clients in their unique situations.

Intermingling of purposes and stakes fuels loop-2 learning.

Diana often tests how well her designs will accomplish this goal by using her imagination. This imaginary design work is guided by what Diana has learned from her clients, the explicit frameworks she has designed around her practice, the purposes she and her clients have formulated, and past interventions she has shaped: 'All this design work is imaginary. I have imaginary moves, sequences, and an overall architecture. The action and reflections occur, and imagination takes over again before I act.'

Imagination expands Experiential Knowledge by simulating designs, directions, and how these may unfold in concrete events over time.

To Sustain Your Learning Loops:

1. Build Conceptual Knowledge that provides focus and understanding without overly constraining your alternatives or your progress.
2. Build Conceptual Knowledge that allows you to take multiple dimensions of perspective, time, and scope into account.
3. Build Conceptual Knowledge that keeps you open to what your materials can tell you.
4. Use your imagination to test how your Conceptual ideas can inform what you pursue and how you pursue it.

On Feel and Feelings

As every practitioner has reported, Diana does what she does because she loves the medium. This connection motivates the involvement that ultimately leads to developing *feel*; however, it presents the challenges that come with emotional intensity. She has a mechanism that sustains

her connection to her qualitative experience that she calls *aesthetic distance*. This aesthetic distance allows her to stay involved with the qualities she uses to reason her way forward even as emotions rise and feelings 'get hot.'

'I'm profoundly moved by my work,' she says. 'I feel deep appreciation, affection, love, concern, compassion, care, and happiness. I can also experience anger, impatience, frustration, anxiety, fear, and sadness. I can be swept away and captured by what people are going through. This is hard work; it takes a lot of courage from me and from my clients.'

Working the Tension between Involvement and Distance
Emotional intensity is an inevitable and attractive element of this high-risk medium.

The physiology associated with strong feeling can flood the mind, making it difficult to listen, reflect, inquire, analyze, or articulate. And yet Diana doesn't try to avoid this condition. She says, 'When I feel myself feeling something deeply, I pay attention to it, even if is only on the periphery of my awareness.' When feeling strong emotions, Diana has developed the ability to 'simultaneously feel puzzlement or surprise.' Achieving this interruption, she can begin to reason with the qualities she is experiencing.

Three mechanisms help Diana turn feeling into feel:

1) Cognitively driven emotions like surprise and puzzlement;

Quickly following surprise with curiosity allows her to apply analytic processes to the qualities she perceives. 'Then,' she says, 'I can have a kind of internal dialogue about what it means and how I might use it, or not, to inform my next move. Then I test this meaning in my head: "Is it going to serve the interest? Will it help us make progress?"'

This qualitative reasoning process is guided by her evaluation of the qualities of participation displayed by her clients – such qualities as willingness, attention, understanding, and readiness – using concepts she has created. This personalized Conceptual Knowledge helps her create the 'right kind

of distance,' so she can interpret qualities and events, and design in the midst of the action. She says, 'I have concepts that help keep me from being overwhelmed by too much input. I can use them to recognize a pattern, a story about what is going on, and then design on the fly.'

2) Conceptual frameworks that sort events into categories that inform design and action;

Diana believes that when her openness to emotion can coexist with her analytic capability, it gives her practice the combination of intimacy and aliveness that 'would be lost with too much feeling or too much distance.' The tension between involvement and distance is resolved in 'aesthetic distance.' She says, 'You can be so close that emotions flood your ability to see, or so distant that you can't be moved. Instead, I need to have an internal appreciation of what is happening; I have to make myself vulnerable in that way. I am always working to use my internal experience of emotion as information. It's constant.'

3) An *aesthetic distance* that means qualitative experience can be turned into information.

To Sustain Feel in the Midst of Intensity:

1. Cultivate your cognitive emotions[11] – surprise, curiosity, fascination, attentiveness – so you can call on them in the midst of intense moments.
2. Build Conceptual Knowledge that turns the flooding emotions into qualitative information.
3. Find your version of the state of being – aesthetic distance, mindfulness, flow, or what have you – that resolves the tension between involvement and distance.

On Mistakes, Conflict, and Progress

Working artistically, Diana sustains progress in the midst of inevitable mistakes and

Sustaining Progress
Progress is not directed

conflict about different points of view. She is not interested primarily in pushing clients toward finding right answers, but rather in 'moving ahead, making headway, or carrying the ball one step further.' Instead of setting established destinations, she 'wants to engage them in a rigorous kind of messing around that generates a good direction and several candidate ends-in-view.'

Some practitioners might be leery of the spontaneity and immediacy that drive this approach. But philosopher John Dewey would say Diana is embodying the artist's approach to progress: she's being *flexibly purposive.* Her destination emerges as ends and means interact; that is, as she, her clients, and the situation interact.

Taking this indeterminate approach means that mistakes are inevitable along the way. Mistakes bring consequences: financial for the organization; personal for the managers involved. Everyone understands what's at stake, yet Diana knows mistakes are unavoidable. 'Making mistakes is par for the course,' she says. 'There's no way to get from here to there without making them. I take that seriously; the costs are high. I have tremendous empathy for my clients. They're facing some incredibly tough questions. So, I have got to work hard to minimize the potential costs. What's important is being willing to look at mistakes when they occur. You can't stick your head in the sand.'

What do you do with these unavoidable mistakes? As Dewey tells us, artists take an atypically optimistic view of mistakes. 'The artist does not shun moments of resistance. He cultivates them, not for their own sake, but because of their "potentialities."' For Diana, this potentiality is found in the important signals mistakes send. 'I don't

toward a pre-established goal but emerges from the work itself.

Mistakes and errors are explicitly treated as part of the process.

Mistakes and errors are used as information that guides Knowledge System development.

mind errors,' she says, 'but I want them to be new errors. If I make repetitive errors, that's a sign to me that I'm missing something. I need some help or some coaching to scrutinize the work I am doing.'

In organizations, mistakes and errors are public events for Diana and her clients, and so are often surrounded by conflict and different opinions. Diana takes this feature of her medium head-on: 'I don't mind finding out I'm just dead wrong or helping someone else see they are wrong. The question is how do you use differences to become more capable of responding to the situation we are up against … to the nuances of life?'

Errors, mistakes, and differences are in themselves less important than the quality that is conflict that can surround them. In Diana's way of working, she strives to use this conflict to her and her clients' advantage. She has built extensive Conceptual Knowledge to help her achieve this benefit. 'Almost all the conceptual material that I have created,' she says, 'has a lot to say about conflict, how you put conflict to work. I'm not as interested in how you settle conflict, but how you can use conflict to create something that you couldn't otherwise create.'

Mistakes and errors stimulate knowledge building about conflict and difference.

Conflict is a quality so important it has become a theme around which her knowledge is built.

Diana builds knowledge that helps her and her clients use conflict to generate upstream learning.

To Make Progress When Work Isn't Going Well:

1. Build the knowledge you need to make progress without clearly established goals. What would being *flexibly purposive* in your discipline look like?
2. Learn to use mistakes as signals of knowledge gaps. Design learning to fill in these gaps.
3. Build knowledge that allows you to be creative with qualities that other people squelch or fear.

Qualitative Ends-in-View

Out of this creative conflict and rigorous messing around, Diana and her clients must generate ends they believe will get them where they want to go; that is, strategies, solutions, and decisions and choices about what to do. In a scientifically run process, hypotheses would exist to be tested. By contrast, in a quantitatively driven process, benchmarks, targets, quotients, cost-benefit analyses, and feasibility and sensitivity analyses would exist as markers against which to measure options. In this expansive organizational setting, few such concrete elements exist to provide clarity about action and its implications.

Sustaining client engagement in the face of this daunting ambiguity is difficult. To achieve this, Diana 'forges' the qualities of relationship between herself and the members of the team that will increase their tolerance, willingness, and effectiveness. These qualities include 'purchase,' 'strength,' 'resilience,' 'understanding of others,' and the ability to 'stand up to tough issues.' Relationships with these kinds of qualities mean people can take on the kind of difficult problems that qualify as enigmatic problems and work on these with determination and energy.

She builds qualities of relationship that help her and her clients work on enigmatic problems effectively.

Diana and her clients don't abandon market data or quantitative analyses when they are useful. But such data do not always give them everything they need to make a clear and obvious choice about the future.

When quantitative measures are lacking, she uses qualitative features to assess effectiveness.

When quantitative information is lacking, contradictory, or inconclusive, Diana turns everyone's attention to the qualitative indicators displayed by the alternative ends she and her clients have generated. In

the early stages, a key quality may be something as vague as a 'fuzzy sense of rightness.' Later, as views and solutions come together, the qualities used to assess alternatives are akin to those used by fine artists. Do the options, decisions, and choices display superior qualities? Are they 'sound,' 'balanced,' and 'internally coherent'? Are they 'well-formed' and 'believable'? Do they 'fit'? Are they 'compelling,' or do they leave people 'flat'? Do they 'hang together'? Judging qualities like these allows Diana and her clients to move forward with enigmatic problems, even as others get bogged down in numbers (too many, not enough, or the wrong ones altogether).

When Quantities Fail You in an Enigmatic World:

1. Find out what qualities exist in your medium, even when they are not familiar topics of education, conversation, and practice.

2. In areas where quantitative data are missing, contradictory, overwhelming, or inconclusive, look for the qualities that provide insight.

3. When qualities are all you have, and you are unfamiliar with how to proceed, look to those who use them effectively in any field and learn.

Loop-One Learning Guide

Investigate Conceptual Knowledge:

1. Make an inventory of available concepts – common and unique to practitioners you admire.
 - This information is revealed in what people write and say about How, What, and Why.
 - Make inferences from what you see practitioners do.
2. Ask the people you admire what they see and how they make sense of this.
 - First ask them to point out the stimulus, the sensation they experience, what they make of it, and how this leads them to act.
 - Find out how they see and make sense of the work differently than you do.
3. With competing concepts, evaluate the merits and limits of each.
 - Try different conceptual frameworks; see how they change how you understand, evaluate, act.
 - How do these differences effect what you can do and not do in your medium?
4. If other practitioners experience qualities, or get desirable results you can't – what models, frameworks, or other conceptual structures are they using?
 - Make this Conceptual Knowledge explicit if you can.
 - What do these concepts allow you to experience and not experience?
5. Build new models.

Investigate Experiential Knowledge:

1. What qualities do practitioners believe are critical to your discipline?
 - Which can you experience?
 - Which do you miss? Ask others what they see, hear, etc.
2. Design the involvement necessary to have qualitative experiences within and beyond your conceptual frameworks.
 - Spend time paying attention before getting things done.
 - Work only as fast as you can stay in touch with important qualities.
3. Do you experience qualities that available concepts do not explain?
 - Search for surprises.
 - Do you have unexplained responses?
4. How do different concepts lead you to experience, or miss, specific qualities?
 - Try on different ways of selecting and interpreting what you experience – how do these change what you experience?
5. Use experience to build new Conceptual Knowledge:
 - Look for new connections and relationships.
 - Rearrange your evaluations of importance.
 - Include elements you have previously excluded.
 - Create explanations you can try out in practice.

Loop-Two Learning Guide

Investigate Directional Knowledge:

1. Make an inventory of available ideals and identities in your medium.
 - Which of these ideals motivates you to act?
2. If there are different ideals, headings, and identities, evaluate the merits and limits of each.
 - What kind of Conceptual Knowledge do these directions highlight or exclude?
 - What kind of new Directional Knowledge might compel you to act?
3. How do these ideals, headings, and identities limit or expand your choice of concepts?
4. Take on different ideals and see how they change what theories, frameworks, and approaches you adopt.
5. If other practitioners use different concepts to effectively shape qualities – what ideals, headings, and identities allow them to accept these concepts?
 - Spend time with the people you admire and those who create interesting differences.
6. Update where you are headed, what you care about, and who you think you are.

Investigate Conceptual Knowledge:

1. Make an inventory of available concepts – common and unique to individual practitioners that you admire.
 - This information is revealed in what people write and say about How, What, and Why.
 - You can also make inferences from what you see practitioners do.
2. How do different concepts allow you to inform, challenge, pursue, or reformulate your Directional Knowledge?
 - Try on different concepts and see how they generate new directions.
 - Does your store of Conceptual Knowledge support the ideals that guide you?
3. Do the concepts you have take you where you want to go? If not, investigate:
 - What different concepts lead others to the directions they pursue?
4. Design the involvement necessary to find the concepts relevant to your ideals.
 - Include elements you have previously excluded.
 - Look for new importance and relationships.
5. Create a new concept and try it out in practice.

chapter **8**

TENSIONS, TRAPS,
AND ALTERNATIVES

I made a decision that I was going to live by my wits. And by the way, I didn't
think it was gonna work. I thought I was gonna be working at some lousy job,
doing something I hated ... and then on my break I'd be drawing cartoons.

Matt Groening, creator of *The Simpsons*,
quoted in Ken Robinson's *The Element*[1]

Sir Ken Robinson's interview with Matt Groening foreshadows it: by
choosing to pursue artistry, you step right into the fray. Groening's
teachers and parents all pushed the budding cartoonist to do some-
thing different with his life – go to college, find a more solid profession.
When artistry is your aim, adversity of all kinds is unavoidable. Begin-
nings are vulnerable to countless interrupting forces, generated both
internally and externally. Fortunately, getting your Knowledge System
up and running is the first big forward step toward artistry. As you
work in your medium, things will really start to get interesting. Once
you're underway, you can expect to encounter six inevitable learning
traps. By anticipating them, you can more likely learn to handle them
before you find yourself mired.

These traps are set by:

1. Ongoing tensions
2. The ambiguities of experience
3. Inevitable clashes of ideals
4. Confusing feelings with feel in a medium
5. Misunderstanding failure
6. Beginner status

Remaining unaware of these traps, and therefore unprepared for

them, you can find yourself thrown into waters so turbulent that you'll be tempted to grab a life raft – in a word, recipes. Indeed, it's more reliable to follow a recipe to a predetermined destination than to follow the less traveled path of artistry. In the end, though, the recipe will prove disappointingly commonplace.

1. Tension Traps

In January 2010 the NPR radio talk-show host Bob Edwards devoted an hour to interviewing Peter Ames Carlin, who'd recently published a biography of Paul McCartney. One of their exchanges speaks directly to the ways that fame can trap and cripple artistry.

'Remember what a breakthrough "Yesterday" was?' the show's host asked.

Carlin responded with an anecdote he relates in his book. It was 1963. Beatlemania had already hit in England, but not yet in America. The band was on tour in Paris, and the writer Chris Hutchins came into their suite one morning after a particularly hedonistic night. There he found Paul, the only person awake, playing the piano. Paul poured him a cup of tea and went back to playing a slow, melodic piece Hutchins had never heard before. Paul didn't have words for it yet, just the chord progression and la-la-las to fill the syllables.

> Their publisher at the time, Dick James, came in and said, 'Hey, have you got any new songs?' Paul began to play 'Yesterday' for him ... And Chris Hutchins describes seeing Dick James's face fall. And when it was over, he said, 'Yeah, um ... But you got anything with "yeah, yeah, yeah" in it?'[2]

As Carlin tells it, Paul's face went white – and that was the last anybody heard of 'Yesterday' for the next year and a half.

The tension that exists between mastery and originality operates between many paired elements in every kind of practice. Every medium has its own characteristic tensions. For example, athletes work continuously to sustain both flexibility and strength; practitioners in any field must work continuously to sustain the right combination between breadth and depth; organizations move between local and distributed control as each reaches predictable limits; and famous practitioners manage the pressure to replicate success against the need to create something new.

Focusing too exclusively on either element in these kinds of pairs

leads to lopsided learning and a repetitive practice that will not sustain artistic performance. As in the tension between mastery and originality, the attractiveness of competence in one element sets the trap. Temptations to replicate, and further augment, what we are good at often stagnate practice and therefore artistry. Even the world's strongest athlete can't ignore flexibility, any more than the world's most flexible yogi can ignore strength, without peril. Tensions must be sustained and worked with, not merely collapsed.

The temptation to collapse tensions is strong. Diana McLain Smith (see chapter 7) reveals that in her work these ubiquitous tensions can be 'tricky,' 'messy,' 'exhausting,' 'intellectually challenging,' and 'exciting.' Doing artistic work requires being 'highly focused' and the ability to 'pay attention' to 'the different nuances.' For Diana, it also takes a certain kind of directional stance; that is, 'not being too tense about tensions.'

In *The Opposable Mind*, Roger Martin digs deeply into how business people succeed at this effort. They achieve what he calls 'integrative thinking' – the ability to face the tension of opposing ideas constructively. Instead of choosing one idea at the expense of the other, the integrative thinker generates a creative resolution in the form of a new idea that contains elements of the opposing ideas but is superior to each.

Such ideas are indeed works of art. Attempts to replicate them competitively pale when compared to the original. Martin's book is full of examples of the integrative mind at work. In one story, he tells of the hotelier Isadore Sharp, whose first property was a small roadside motel that offered intimacy and comfort and whose second property was a large convention hotel in a city center.

> The two types of lodging stood in fundamental and apparently irreconcilable conflict. Guests could choose the small motel's intimacy and comfort or the large hotel's location and range of amenities, but no hotel could offer the best of both worlds. So just about everyone in the lodging business chose one type or another and accepted the drawbacks that came with their choice. But not Issy Sharp. Rather than choose one model or the other, each with its attendant shortcomings, Sharp used his opposable mind to create a new model, a hotel with the intimacy of his original motor inn and the amenities of a large convention hotel.[3]

The result of this integrative thinking came to be Four Seasons Hotels and Resorts, Ltd, with its unparalleled reputation for luxury service.

While tensions remain ever present, it is their very presence that stimulates endless variation within a practice and across practitioners.

While not all variations will be equally successful, certainly many will have virtues. Evolutionary biologist Stephen Jay Gould reminds us that excellence and variation can co-exist: 'Excellence is a range of differences, not a spot.' Artistic practitioners display this variation in their work.

For example, to create a great western performance horse, Eric Thomas (see chapter 1) must train for both 'flexibility and responsiveness.' Yet each horse will achieve a different balance of the two, and this balance will shift throughout the training process. Across his profession, different trainers will seek to create a different ratio of these elements and will produce variation in the animals they train.

Even with the difficulties these tensions present, artistic practitioners seek rather than fear them. What do they understand about tensions that the rest of us don't? As the philosopher John Dewey wrote, 'The artist does not shun moments of resistance. He cultivates them, not for their own sake, but because of the potentialities.'[4] Artists know that sustaining the relationship between opposing qualities is what creates the exciting variation that distinguishes one practice from another. Working progressively to sustain the relationship among elements, forces, and qualities in tension, practitioners can create new ways of working, and new resolutions, over and over again.

Likewise, each chef works to sustain the relationship between unctuousness and brightness in each dish, because she knows this qualitative relationship excites the palate. She knows different ingredients can be used to sustain this qualitative relationship differently. Each chef can work differently toward the momentary balance of these qualities in the same dishes and in different dishes.

Artistic practitioners learn to command the range, and this range generates extreme variety. The presence of tensions means that artistic solutions are unlimited: there is no one best answer.

To Handle Tension Traps:

- Identify the tensions that are characteristic to your medium.
- Look for the kind of variation working the relationship between elements can generate.
- Build knowledge, especially Conceptual Knowledge, that allows you to sustain these tensions as you work.
- Discard the ways you think and act that drive you toward lopsided action or singular solutions.

2. Ambiguities of Experience

> Experience may possibly be the best teacher, but it is not a particularly good teacher. (James March, *Ambiguities of Experience*)[5]

You will be surprised at how difficult it is to gain intelligence from experience. To explain this difficulty, I turn again to the ideas of organization researcher Jim March. I vividly remember sitting in his class at Stanford, no longer hearing the lecture or discussion, distracted by the troubling notions he'd just presented. Until then, learning, especially experiential learning, had always been my unquestioned ally. But in March's lecture I heard it for the first time: the complications of experiential learning could actually confound the artistry-in-practice that I wanted to foster.

March develops these ideas in his 2010 book, *Ambiguities of Experience*. While these ideas might seem academic at first glance, they're crucial to anyone interested in developing artistry. As we've already seen, Experiential Knowledge is rooted in our sensitivity to qualities. But *developing* sensitivity is one matter; *using* this sensitivity to learn is another matter altogether.

Again, the philosopher John Dewey sheds light on the topic: 'The action and the consequence must be joined in perception. The relationship is what gives meaning; to grasp it is the object of all intelligence.'[6] In my mind, grasping the relationship between action and consequence was best achieved through experiential learning. Yet, as I've come to understand, in this regard experiential learning has some serious weaknesses.

Our personal experience is both limited and compelling. This combination leads us to overvalue the importance of the very small sample of experience our lives bring. While meaningful, this limited life experience can be very difficult to interpret; usually our interpretations are flawed in the many ways that March identifies. All these flawed interpretations lead us to build Conceptual Knowledge that is often incomplete and misdirecting. This is the very issue we saw Marconi struggling with in chapter 6.

One of these flaws is particularly problematic when it comes to developing artistry. When we experience effectiveness, the gravitational pull of this success often keeps us from exploring further; when we learn quickly in the moment, we often miss better options. As March says, 'Experience is likely to generate confidence more reliably than compe-

tence and stop experimentation too soon. As a result, there is a persistent disparity between the assurance with which advice is provided by experienced people and the quality of the advice.'[7]

When I first encountered this notion, it floored me. Could my basis of artistry – the personal experience of qualities – be an unstable platform? Yet even as I worried about this, I recalled that it's the same stubborn belief in the relevance of one's own experience that keeps so many artists going in the face of resistance. Guglielmo Marconi, Michael Polanyi, and Barbara McClintock were all drawn to work against the grain by their belief in personal experience. A short review of the history of innovators reveals countless other examples.

Indeed, March's own words also caution us about the superficial similarities of heretics, visionaries, and fools (see chapter 6), and tell us that a foolish belief in the efficacy of the self can protect new, potentially better ideas from the crushing force of realism. The tension between these conflicting features of Experiential Knowledge has become a fundamental element in my conception of artistic practice. This is captured in the ongoing tension between mastery and originality that fuels artistic progress.

To Handle the Ambiguities of Experience:

- Expand your experience by asking others what they experience.
- Develop your ability to perceive with ever more discrimination.
- Add breadth and depth to your Conceptual Knowledge to reduce its perception-limiting features.
- Systematically build knowledge from your personal experience and test its efficacy.
- Investigate your experience, rather than treating it as self-evident.

3. Inevitable Clashes of Ideals

While people can argue about differences in what they experience and what it might mean, differences in Directional Knowledge can lead to blows both metaphoric and real. Directional Knowledge includes pragmatic elements, such as hoped-for consequences, identity elements about the kind of person we want to be, and loaded ideals such as commitments to faith in family, nation, and religion. I have also talked

about Directional Knowledge as composed of personal imagined ideals that draw practitioners forward. Motivated people all have a version of Brother Thomas's perfect white pot (see chapter 4). A composite of these elements provides you with your values, as well as the orientation, heading, and stance you take to work in your medium.

Fundamental differences in Directional Knowledge often generate a clash of ideals. Thomas Kuhn in his 1962 classic, *The Structure of Scientific Revolutions,* describes this clash of conflicting directions as a clash of *paradigms.*[8] Kuhn contended that these paradigms are held so strongly that those sustaining status-quo knowledge must literally die off before new directions can be embraced.

On a grand scale this rigidity can contribute to disagreements between societies and countries. On a disciplinary level, scientists debate whether they should be involved in what they study or remain objectively distant. Economists debate the virtues of pursuing shareholder value versus a sustainable economy.

You will be learning artistry at a practical level, and when you explore directional possibilities you will likely find yourself in the middle of one big argument about who's right and who's wrong even before you have a clear idea about your own directions. It's easy to imagine how this conflict begins. For example, the ideal of 'authenticity' can mean different things to different artists. For Angelo Cabani (see chapter 3), it is adopting regionality: 'Fish at the sea, meat in the mountains.' Another chef might think: 'Be true to your origins wherever you are,' and so open a Tuscan restaurant in Manhattan. Both may be equally vehement about their own versions of 'authenticity.'

To Handle the Clash of Ideals:

- If the directional ideals you have don't motivate you to act, change them.
- When shifting ideals, expect transformations and disruptions in your Knowledge System.
- If you automatically reject others' ideals, update your Conceptual Knowledge so you can better investigate the possibilities different ideals make available to you.
- If you find yourself fighting about which ideals are right and which are wrong, realize that you're trading artistry for an argument.

You might ask: Who is right? You might even find yourself joining in the argument as you formulate early directional self-concepts – how will you be authentic? Being distracted by these disagreements, let alone participating in them, will do little but distance you from artistry. They shut down the learning that allows you to develop your personal Knowledge System.

4. Confusing Feelings with Feel

> I hold that cognition cannot be cleanly sundered from emotion and assigned to science, while emotion is ceded to the arts, ethics, and religion. All these spheres of life involve both fact and feeling; they relate to sense as well as sensibility. (Israel Scheffler, *In Praise of the Cognitive Emotions*)[9]

As confusingly alike as identical twins, 'feel' and 'feelings' are as different as apples and oranges. Emotions like sadness, fear, joy, anger, frustration, exaltation, boredom, and even hope have little to do with developing feel in response to the qualities you experience in your medium – except to provide an unwanted distraction. These emotions are unavoidable in practice because qualitative work often stimulates these reactions. Yet, following these distractions traps you in emotional feelings that disconnect you from the very qualities that inspire them, the qualities you want to experience and shape.

At this point you might be thinking, 'If I don't care enough to have strong feelings about the work, why would I bother making the effort to achieve artistry?' And I say, 'Yes, that's right.' Indeed, there's the rub. All the practitioners discussed here work in the medium they choose because it incites passion, makes life meaningful, and thrills them. At the same time, they understand that these feelings are best enjoyed upon reflection rather than in the midst of work. Working artistically means the medium gets your full attention.

Disciplines ranging from behaviorism to Buddhism offer advice about emotional management. Typically, these disciplines offer their particular version of detachment as a way to keep emotional flooding from overcoming our ability to reason in action. Again you should be raising an objection to this kind of advice: 'But artistry is about involvement, not detachment.' Again I say, 'Yes, that's right.' If you want to manage the tension between feel and feeling in an artistic way, you have to achieve the right kind of involvement.

There is confusion about the value of our natural impulses and responses to the achievement of artistry. Many people advocate trust-

ing natural impulses or instincts; they believe that, being natural, these impulses must be correct. But not so. Take skiing. We all lean backward when we're first learning to ski downhill, yet it's the last thing we ought to do. Novices need to re-educate out of themselves many automatic impulses to match the learned impulses of advanced professionals. In *The Empire Strikes Back*, Yoda reminds Luke Skywalker to trust the connection he feels with the Force, not his automatic feelings of self-doubt. Qualities are an artist's version of the Force. The artist's commitment to be involved, even immersed, in a medium's qualities allows feel to override feelings when feelings threaten to distract.

Reasoning with qualities is what keeps reasoning afloat in a qualitative world where feelings and feel are so closely associated. Fortunately, there is a family of feelings, or *cognitive emotions*, that support the work of qualitative reasoning. Each practitioner discussed in the book has mentioned them: curiosity, fascination, peace, intimacy, concentration, openness, and commitment. These feelings have emotional overtones that sustain involvement; they fuel and sharpen our sensitivity and attention to qualities rather than distort them.

To Sustain Feel in Your Medium:

- Take time to develop both recognition and perception of the qualities in your medium.
- Identify the emotional state that allows you the closest and clearest connection to these qualities: curiosity, fascination, peace, intimacy, concentration, openness, commitment, and the like.
- Find a way to bring yourself back to this state when you find yourself distracted by more dramatic emotions.
- Explore what reasoning with qualities means in your medium; develop this unity ... whatever it takes.

While these feelings don't carry the same emotional drama we associate with strong feelings, their impact on practitioners should not be underestimated. Evelyn Fox Keller describes how these kinds of feelings are sustained and the feel they facilitate for Barbara McClintock.

'This intimate knowledge, made possible by years of close association with the organism McClintock studies, is a prerequisite for her extraordinary perspicacity. "I have learned so much about the corn plant that when I see something, I can interpret it right away."'[10] Both literally and figuratively, her 'feeling for the organism' has extended

her vision. At the same time, it has sustained her through a lifetime of lonely endeavor, unrelieved by the solace of human intimacy or even by the embrace of her profession.'

Imagine an experiential connection to the qualities of your medium so strong it overrides emotions like fear or loneliness and difficulties like tedium or discouragement.

5. Misunderstanding Failure

> Seeing and using the power of mistakes does not mean that anything goes
> … when a mistake occurs we can treat it as a grain of sand around which
> we can grow a pearl. (Stephen Nachmanovitch, *Free Play*)[11]

In 2007 the *Washington Post* set up an experiment. Later, more than two million people watched the YouTube video of what followed.

The scene that greeted D.C. commuters at the L'Enfant Plaza Metro station that January morning was of an unassuming young man in jeans, cotton T-shirt, and a Washington Nationals baseball cap. He stood with a violin, its open case in front of him containing a few dollars; he'd seeded the money himself, in veteran busker fashion. He performed for about forty-five minutes, then packed up his case and left.

The man playing the violin that morning was Joshua Bell – at thirty-nine, one of the most internationally acclaimed musicians in the classical world. Three days before the experiment, he'd sold out Boston's Symphony Hall, where the cheap seats go for $100. The instrument he played was a 1713 Stradivarius, valued at more than $3.5 million. The first piece he played was the fourteen-minute Bach 'Chaconne' – a piece Bell later described as 'not just one of the greatest pieces of music ever written, but one of the greatest achievements of any man in history.'[12]

In the quarter hour that he played the Bach, the Schubert, the Manuel de Ponce, the Massenet, 1,097 people hurried passed him. Of those, twenty-seven dropped money in the case, and seven stopped to listen. All told, Joshua Bell collected $32 that morning.

This story perfectly illustrates how we can miss experience, even dramatic experience, if we're unprepared to recognize or perceive it. Think about it from Joshua Bell's perspective. What if he'd been a less famous person? And what if he had taken this lack of attention as a negative judgment about his ability? He might easily have taken his performance to be a failure.

Conclusions about failure originate in two places: first, when you fail

in the eyes of others; second, when you fail in your own eyes. In any artistic pursuit, you can expect both forms of failure.

Successful people who struggled early on in their career have similar advice about what do to do when you are failing in the eyes of others. Emilio Estefan shared his version of this familiar advice in an interview with Rachael Ray, shortly after the publication of his 2010 book, *The Rhythm of Success*. Now publicly recognized as the winner of nineteen Grammys, Estefan began his life in America as an impoverished, orphaned immigrant. In his memoir, he tells the story of starting very poor with his wife, Gloria, and later rising to success in the U.S. entertainment industry. The following excerpt from the interview captures his advice about dealing with early failures.

> I remember when I produced my own first conga. They said. 'Oh no, that will never happen!' And, then it became number one ... Believe in yourself, when you believe in something, do it ...
>
> I always wanted to be successful, but I never wanted to forget where I came from. That is important. If you're Italian, you're Italian; if you're Jewish, you're Jewish; if you're Latin, you're Latin. It is good to be proud of where you come from.

In short: work hard, be yourself, and believe in yourself. Estefan worked for fourteen years before winning his first Latin Grammy. This is the prevailing advice about how to persist when you fail in the eyes of others.

This kind of advice implies the presence of knowledge that reframes the normal meanings of failure: there is opportunity in it. Estefan found meaning and joy in the struggle; Nachmanovitch makes a metaphoric pearl out of the sand of failure; others find the greatest possibility in their lives; geniuses end up overturning established thought; and scientists can achieve the greatest human purpose by eventually realizing their fantastical dreams.

How do those of us in the midst of the effort incorporate this hindsight in the way we handle immediate failure?

First, knowing this about failure, failure will not surprise you. Knowing what you now know about the tension between mastery and originality, you can predict the likelihood of failing in the eyes of others. You can build the knowledge and support you need to be prepared. Achieving this, you can avoid stepping into failure traps triggered by your reactions when you fail in the eyes of others.

Second, you can sustain the beliefs that successful people use to

persist. This translates into faithful commitment to the content of your knowledge categories: Belief in your identity or ideals, belief in the way you understand the world differently, and especially, belief in the way you experience the qualities in your medium. This last belief comes from dedicated and unrelenting involvement.

To Use Failure for What It Is Actually Good For:

- Let failure test the power of your conviction. If you waver in the face of criticism or resistance, bolster your Knowledge System. Do you need:
 - ° Stronger ideals?
 - ° More compelling ideas?
 - ° A closer connection to qualities?
- Test the knowledge in your knowledge categories, as well as the connections between categories and across categories.
- Remember, protecting your originality takes the same commitment as developing mastery.
- Slow down, take a breath; artistry is not a sprint but a marathon.
- Find out whatever it takes for you to sustain focus on qualities in your medium and dedicate yourself to achieving it.

That still leaves a question: What should you do when you are failing in your own eyes? The competitive sports and positive-thinking industries have generated a lot of useful advice about how to handle this kind of failure: practice, visualization, focus – action! From a Knowledge System perspective, your work is a bit more reflective. You can see failure as system failures that usefully reveal three gaps in your developed knowledge:

- Incomplete or flawed knowledge in a category
- Breaks in the connections between categories
- Inconsistent knowledge across categories

System failures are inevitable, and uncovering them is critical to advancement. System failures are neither about you nor about your potential. If you conclude either, you have stepped into one of the failure traps set by your own overdramatized conclusions. Overdramatizing the meaning of failure distracts, just as the dramatizing emotions dis-

cussed earlier distract. The artistic countermeasure to this kind of learn-
ing trap is simply to pay attention. Of course, while simple, it's not easy
when your body and mind are screaming at you to do something else.
There are many routes to building your ability to focus. Use them all.

6. Beginner Status

Achieving a beginner's mind has become a romantic idea. It denotes a
childlike openness that is appealing in its innocence. But being a begin-
ner in a new practice isn't all it's been cracked up to be. For one thing,
while you can be a novice at any age, it gets harder as you get older.
Also, once you've become good in one discipline, it's that much harder
to bear beginner status in another. Yet there's no way around it. With
beginner or amateur status comes its own set of challenges.

The journey from novice to advanced practice is a bit like Bilbo Bag-
gins's journey through the forest to Lonely Mountain in J.R.R. Tolkien's
The Hobbit. Despite Gandalf's warning, straying from the path into dan-
gers is unavoidable. On this journey, here are some of the foreseeable
diversions and the learning traps to which they lead.

i. Learning in a medium is a serial experience.
This is of course one of the big problems with building knowledge from
experience: You can only have one experience at a time, and you can't
jump ahead. We meet potential spouses one at a time, not knowing who
might come along next. Just think how different it would be choosing a
spouse from a line-up of all possible candidates. How many times have
we all said, 'Had I known …'?

The only realistic way to expand experience is to broaden what you
experience through association and take in what you can from the expe-
rience of others. This is not easy. If you watch mentors coaching devel-
oping practitioners, you will see much of what they say apparently
rolling off the backs of these students; that is, the students seem unable
to take it all in. For the purposes of learning artistry, there are a few
important things about this situation that you can consciously change.

You can predict the sequence that unfolds in the process of learning
any particular medium. For instance, new photographers inevitably
take pictures from the bottom of a tree straight up when they 'discover'
perspective. Surprisingly, you can read about perspective in a book and
still have to 'discover' it in practice. These kinds of learning steps exist
in every medium. Unfortunately, they are often either denigrated by

those who are somewhat more advanced or treated too preciously by the students producing them. These reactions and interactions are distractions. Expect them, and keep moving ahead to your next step.

By definition, beginners lack experience. One way to expand experience is to let the person helping you work through you; let the person take your hands and shape your actions; let him or her treat you like a marionette. This submission is important for two reasons. First, we can't experience the things our helpers have experienced, and this transfer of control is a way to have virtual visceral experience that might awaken new awareness. Second, our own experience has so much gravity for so many reasons that we return to it over and over again no matter how inadequate the performances it has led us to produce.

To the extent my abilities allow, Eric Thomas is achieving this kind of teaching in our riding lessons (see chapter 1). If you find teachers, mentors, or colleagues who will make this effort and who are skillful enough to shape your actions to generate new experience, don't miss this rare opportunity. Let them do it, and see what you learn. Adopt their way of seeing and evaluating, and find out if this can evoke new experiences you might otherwise miss.

You can also expand your experience through the mechanisms that exist in your medium, or borrow mechanisms from other fields. Designers in every discipline use prototyping; visual artists use sketching; scientists design experiments; architects build scaled models; the military runs simulations; business people imagine multiple scenarios and strategies; coaches craft playbooks. All these activities can be used to increase the number of experiences you can sample, as well as decrease the cycle time between them.

When you show either early aptitude or inability, keep in mind that it's easy to make too much of this. Our interpretation of early performance is often wrong; yet having such interpretations changes how we orient to the work, so they have an effect. You have to be a little bit Zen about your performance levels; otherwise, you can get mired in competence traps or completely miss the possibility of a great performance that you can't even imagine at your stage.

ii. Learning occurs in all knowledge categories simultaneously but not synchronously.
Your knowledge categories have a way of developing at the same time but out of phase with one another. This means you may find yourself pursuing ideals for which you have no skills, being excellent at doing

something you no longer value, or having new understanding you don't know what do with.

This happens in part because learning occurs in each category through different processes. Experiential Knowledge is immediately adaptive; Conceptual Knowledge evolves over time; and Directional Knowledge shifts are often dramatic and transformational. This out-of-sync learning will generate inconsistencies in what you say, do, and seek.

These knowledge inconsistencies produce practice inconsistencies. When they're noticed, they can be upsetting. This disturbance is often more troubling to the learning process than is the inconsistency itself. When caught in inconsistency by ourselves or by others, we often feel caught in an embarrassing error. This embarrassment is usually an impediment to learning. However, since inconsistency is unavoidable, it might be better not to treat it as a punishable offense. Instead, as Jim March says in a related context, 'Treat hypocrisy as a transition.' This treatment allows learning to proceed.

iii. Novices can see few elements and relationships in their medium; advanced practitioners see many.

Here's another frustrating but unavoidable feature of artistic learning. No matter what you come up with, advanced practitioners will always come up with something different than you will. This can discourage newbies and sap their confidence. But as we have all learned from watching spaghetti-western shoot-outs, there is always a faster gun. Instead of letting this back you off, say, 'Good, that's what they're here for.' Then you can use this sophistication to your advantage.

Uncover the difference between what advanced practitioners see and what you see, then focus on what they do and what you do. This will help you figure out what Conceptual Knowledge they have and how they use it. Personalized Conceptual Knowledge is often tacit. It is revealed in action, and only rather vaguely in words. Practitioners are often criticized for saying more than they can actually do. But the opposite is true as well: they often do more than they can say.

In quiet certainty, the philosopher John Dewey reminds us where we are headed on the trip from beginner to advanced practitioner:

> Until the artist is satisfied in perception with what he is doing, he continues shaping and reshaping. This making comes to an end when its result is experienced as good – and that experience comes not by mere intellectual

or outside judgment but in direct perception. An artist, in comparison to his fellows, is one who is not only especially gifted in powers of execution but in unusual sensitivity to the qualities of things. This sensitivity also directs his doings and makings.[13]

When pursuing artistry, the measure of your progress is the extent to which you are sensitive to the qualities of your medium, and then are able to use this sensitivity to guide your actions.

iv. The beginner's mind can take you there.

I opened this section by saying that a beginner's mind is not all it's cracked up to be. Having made that case, now I'm going to flip the coin over to reveal what's on the other side. The best advice I have found in this regard comes from Jim March's book *A Primer on Decision Making*. When I found the following short list resting innocuously at the end of this book, I copied it and pinned it on my wall. I suggest you do the same. It's the best brief advice I've found on cultivating the openness to experience that is the greatest strength of a beginner's mind.

I will let his words speak for themselves.

Treat the self as a hypothesis.
Treat intuition as real.
Treat hypocrisy as a transition.
Treat memory as an enemy.
Treat experience as a theory.[14]

THE SEVEN HALLMARKS OF ARTISTRY

If you want to assess
A man's capability
For doing essential things,
Ask whether he can act
Without assurances
Of good consequences.

James G. March, 'Essential Things'[1]

Before Bode Miller hit the slopes to compete in the 2010 Vancouver Winter Olympic Games, he sat down for a televised interview with NBC's Tom Brokaw. Brokaw probed Miller about his reaction to past Olympic failures. Was he disappointed? Yes, he replied, but in the context of competition athletic failure is common, and in Miller's words 'not that hard … to deal with.' Brokaw went on to describe Miller as 'the best skier in the world' and, at the same time, as filled with an 'internal conflict' about his 'all-or-nothing style' that leads to 'unforgettable triumphs and spectacular failures.'[2]

Throughout the interview, Miller expressed more concern about the possible implication of his internal conflict than about the extreme range in performance that others highlight. For him, pulling back from the extreme, and instead skiing to win, could mean leaving behind 'the one hundred percent' – leaving behind the way he loves to ski. While this choice could mean 'less crashes' and 'more wins,' to Miller it also means 'less heart.' For Miller, without heart, winning loses meaning. Brokaw pressed him further in the interview about having learned his lesson about failing in Turin and coming to Vancouver with a new atti-

tude. Miller gave him a surprising answer: that these lessons in realism and reliability were the lessons he wants to forget, because they are the kind of lesson that makes him want to quit.

Miller's heroes aren't the realists. His heroes are the skiers of the 1970s and 1980s. To him, these were the men who skied at 'the very edge of what was possible.' The business of today's skiing industry brings him far less inspiration. Yet through the 'amazing journey' that has led him now to his fourth Olympics, he went to Vancouver to ski at the highest level possible, to dig deep, and to do something he could never do under normal circumstances. He said he was here 'with the intention of giving everything.'

In these Olympic Games, Miller went on to win a bronze, a silver, and then a gold medal. Afterwards, NBC Olympics analyst Alan Abrahamson spoke with Today Show host Matt Lauer about the implications of Miller's success.[3] While both men acknowledge his accomplishment, they raised the likelihood that the unconventional Miller would remain the focus of much criticism. Finally, both commentators agreed with Abrahamson's conclusion: 'Bode is an artist on skis. He finds passion and purpose in skiing. The rest ... is just so much noise to him.'

This short discussion just about says it all. Miller and these commentators echo the words of every person speaking about artistry throughout these pages. Rather than seeking only to win, artists on skis or in any discipline seek the purity of the 100-percent performance that rides the edge of what is possible, the kind of performance where heart and predictable reliability seldom meet. It's the kind of performance that spans the extremes of unforgettable triumph and spectacular failure, and so becomes a form of self-expression that demands giving everything. It's a kind of performance that requires, then ultimately provides, both passion and purpose. And, all the while, it's a kind of performance that's attacked by the noisy pressures of success and the nagging criticisms of those who would choose reliability.

Many people who pursue this kind of artistic performance don't choose it consciously. They just do it, maybe sometimes wishing they could walk away. Others do make a conscious choice. And then, without the pre-existing native drive, they have to figure out how to either make it happen or let it happen. This difference in approach can be compared to a familiar example: the difference between falling in love and choosing to love.

When it comes to artistry, I belong to the second group. Recognizing that, I've worked to understand the territory and draw the map as I go.

My lifelong occupation has been to find and understand true artistry rather than be fooled by look-alikes. Of course, while it's impossible to escape infatuations with 'the wrong guy,' fortunately these temporary diversions ultimately make distinguishing the real thing easier when it finally comes along.

And now, what about you? When you go in search of artistry in others or choose to develop it in yourself and in the discipline you pursue, keep in mind seven hallmarks of true artistic capability.

What True Artists Know That the Rest of Us Need *to Learn*

1. Pursue ends and means interdependently.
Artists develop means and ends in concert. Sometimes this happens on a grand scale, as when Marconi developed his wireless solution to communication, or as Sally pursued her emergent vision over years of drawing. Sometimes this happens on a more finite scale, as when Eric adjusts in response to today's horse, or as Steve tracks and shapes images in a particular photographic session, or as Angelo learns from a particular ingredient in his pan. What is common to all is what Donald Schön called, the 'conversation with the situation.' This conversation generates and then reshapes both ends and means as the situation changes in response to the artist, and the artist learns.

2. Cultivate unity with a medium.
To achieve the first capability – working with interdependent ends and means – every artist needs to achieve the unity with the medium that comes from both total involvement in the work and full immersion in the medium's qualities. Despite my use of the words 'total' and 'full,' this is an elusive, unending learning process. What can be experienced changes from day to day. Qualities that haven't been experienced remain overlooked until subtle and startling shifts of awareness bring them into focus. Once experienced, qualities can be interpreted and used to guide action. Achieving this unity, artists acquire *feel* in their medium.

3. Reason with qualities.
Using qualities to guide action and problem solving with interdependent ends and means, artists are *thinking* and *reasoning with qualities*. Qualities like taste, sound, motion, fit, and attitude replace words, symbols, and numbers. Artists use qualitative reasoning to pursue inde-

terminate or emergent ends; they take *initiating* qualities that capture their attention and shape them – in unpredictable ways – into *pervasive* qualities, then finally establish *total* qualities that signal completion of the work. To accomplish this, artists are reasoning with qualities, and the relationship between qualities, to order, shape, create new qualities, and evaluate.

4. Sustain the dynamic partnership of mastery and originality.
To reason with qualities progressively, artists demonstrate mastery in response to the qualities they recognize and, simultaneously, generate original responses when the situation inspires. Artists are committed to building *skill*, working effectively, and achieving control in their medium; yet, they also sustain openness, seek novelty, generate variety, and court *surprise*. Achieving an ideal balance of these competing activities is a temporary achievement that artists know they must leave behind. In transient moments of balance, artists combine mastery and originality to create ideas, products, performances, and outcomes that are both excellent and unique.

5. Remain unfazed by failure and unfixed by fame.

> I don't see myself as a famous person. If I ever see myself as you see me, then I have to retire. I couldn't work anymore, because that's when I'll start copying myself. (Steven Spielberg)[4]

Failure and fame are two sides of the same coin, but not a coin of great value in the artistic realm. No matter how devastating failures may be, and no matter how awe-inspiring successes may be, the *measure* of performance is not what matters most to artists. In fact, both failure and fame produce performance traps that true artists work assiduously to elude. Artists rely predominantly on their own *evaluations*. They compare what they produce to the ideals they pursue; they evaluate how effectively they can create what they intend, and they judge what they produce by assessing the qualitative quality of the qualities displayed.

6. Develop cognitive emotions.
True artists know the difference between emotional feelings and *feel* in their medium. They know that the feelings they have for their work – whether they be upsetting reactions or motivating passions – can distract their attention from the critical connection they have to their

medium, that is, their *perception* and *recognition* of qualities. To sustain this receptive and perceptive presence of mind in the face of failure, success, drama, difficulty, exhaustion, discouragement, challenge, derision, hurt, fear, anxiety, grief, uncertainty, and the like, artists cultivate *cognitive emotions*. When feeling threatens to flood perception, the artist says, 'I am curious; I am empathetic; I am interested; I am fascinated; I am open; I am determined; I am brave; I am sensitive; I am intrigued; I am surprised; I am puzzled; I am attentive; I am focused.'

Or as Don Quixote might say, 'I am myself, come what may.'

7. Express personal ideals, understanding, and awareness in action.

The creation and contemplation of imaginative understanding is distinctly and gloriously human; but it is not the only thing that is so. Adaptive improvement through deliberate problem solving is also an exquisite feature of human distinctiveness. Intelligence involves the beauties of crafting understanding of experience, as reflected in the grace of storytelling and elegance of model building. It also involves the efficiencies of adaptation, as reflected in the use of experience for careful analysis and pragmatic improvement. (James March, *Ambiguities of Experience*)[5]

True artists learn by every mechanism at their disposal. Jim March highlights many of the possibilities in the quotation above. Imagination, deliberate problem solving, the crafting of understanding, storytelling, model building, adaptation, analysis, and practical improvement must all come together if knowledge and knowing in practice are to advance. The last hallmark of artistic practice is the comprehensive development of knowledge in a particular medium that I have depicted as a personal Knowledge System.

Experiential Knowledge is the root of artistry and provides the fuel for expression in every discipline. Experience demands engagement, effort, and risk. Artists gain it by being present and involved with the qualities that pervade life. Conceptual Knowledge provides interpretation and understanding. Its flexibility fuels variation. Artists use it to generate varieties of understanding. True artists have the ability to formulate and reformulate the 'truth' as their Conceptual Knowledge grows, without the usual internal conflict that this process generates. Directional Knowledge is composed of evolving imagined ideals that create draw and motivation. Artists use these ideals about self, per-

formances, products, and outcomes as internal beacons that both moti-
vate and guide action.

Artistry Unleashed

While these hallmarks describe artistic practice in any discipline, the
most important thing to remember is that they have little utility as mere
abstract ideas. Using these hallmarks to learn artistry depends on find-
ing a teacher or mentor who embodies them – or, better yet, embodying
them yourself. A group of thought leaders arrived at a similar conclu-
sion during a recent conference called 'The Ideas Economy: Innova-
tion,' at the Haas School of Business in Berkeley, California.[6]

Moderated by the *Economist*'s global correspondent Vijay Vaithees-
waran, the conference featured high-profile business-school deans and
authors of books about innovation, as well as the founders, CEOs, and
managers of a wide array of innovation-aware companies and non-
profit organizations. The group's goal was to stimulate revolutionizing
conversations around global issues involving innovation, intelligent
infrastructure, human potential, and beyond, all based on the premise
that human progress relies on the advancement of good ideas.

Over the two-day conference, the conversations encompassed sev-
eral themes you will recognize after reading this book: the inherent
tensions between the quantitative and qualitative approaches, interde-
pendence and independence, and working across different fields; con-
fusions about what innovation is and how the value it creates can be
determined; how to deal effectively with uncertainty; how to develop
innovative individuals; how to train managers to manage innovators;
how to build a team that can innovate together; how to treat errors
effectively; how to buffer the effects of success and failure; and how to
build creative confidence in individuals.

By the end of the conference what emerged was an overall theme
about artistry. Each step of organizational innovation – generating it,
managing it, implementing it – involves elements of art. In order for
innovation to thrive, individual people must accomplish these steps. If
we are to find and use the good ideas that can advance human progress,
artistically skillful people in all walks of life and business are the ones
who will do it. *What remained an open question by the end of the conference
was just how to develop this kind of artistic person.*

So here we've come full circle. In the spring of 2010, these leading
minds in business, education, and personal and social transformation

arrived at a conclusion remarkably similar to the one Chester Barnard proposed eight decades ago. It's a perennial fact, and there seems to be no way around it: the most important parts of work and life cannot be reduced to numbers alone. Even as information accumulates and technology advances, the need for artistry grows. Many might say the need has intensified in proportion as uncertainty, ambiguity, and possibility have intensified in the world. Indeed, as machines – computer programs, mobile-phone apps, and other algorithms – handle progressively more of our numbers-driven activity, what work does that leave for us humans to do? The answer is – a whole world of qualitative activities that are in ever-greater need of our energy and focus.

Living as we do in a time when the top analytic minds among us – financiers, bankers, economists, insurers, risk managers, auto executives, regulators – got caught riding yesterday's horse, old questions press on all of us with new force. How will we unleash the qualitative intelligence that our most challenging problems demand? How will we cultivate the artistry needed to make the world a better place? How will we ourselves become artists in our life and work – honing those same executive functions of feeling, judgment, sense, proportion, balance, and appropriateness that Chester Barnard called for so many years ago?

These are the questions I've spent all my working life pursuing. I hope the results hold some answers for you.

ACKNOWLEDGMENTS

Every good book is created by the efforts of a bunch of great people. You can judge for yourself how good this book is; what I know for a fact, though, is just how great the bunch of people who helped make it happen really are.

First, a big thank you to all the University of Toronto folks who encouraged this project. The Desautels Centre for Integrative Thinking at the Rotman School provided support made possible by the gifts of its generous benefactor, Marcel Desautels. The Rotman School's advancement team, notably Steve Arenburg and Karen Christensen, were an unflagging cheering section, as were their Rotman colleagues Suzanne Spragge, Jennifer Riel, and Melanie Carr. Dean Roger Martin has been a steadfast collaborator and champion. Thank you as well to Dominic Ayre of Hambly & Woolley, Inc. for expertly rendering the diagrams. Jennifer DiDomenico, the business and economics editor at University of Toronto Press, calmly helped me make this a book of which I am proud.

Without my writing partner Tim Murphy's gentle and persistent reminders to speak to my audience, I'm sure this book would be a lot less useful and fun to read. If it is a good read, it's in large part due to Tim's commitment to communicating well and to his hard work pulling the whole book together into one big clear idea.

This book would not have been possible without the willingness of my characters to play their parts. Eric, Angelo, Steve, Sally, and Diana spent hours sharing their experience, helping me understand their work, and reflecting with me about their practice. I have done my best to honor their effort, and I hope my deep appreciation for each of them and their work comes through. This is also true of the larger

group of business people who let me add their words about artistry and learning, joy, hard work, passion, problems, business, and life to these pages.

Finally, my ideas about artistry build on the more expansive ideas of both Elliot Eisner and Jim March. I thank them both for encouraging, humoring, and challenging me over the years as I worked my way to this destination.

CREDITS

Chapter 1, p. 12 – epigraph; chapter 2, p. 40; chapter 7, p. 132 – epigraph; and p. 142: Quotations from Donald A. Schön, *The Reflective Practitioner*, copyright © 1984 Donald A. Schön. Reprinted by permission of Basic Books, a member of the Perseus Books Group.

Chapter 2, pp. 23–4: Quotations from Theodore Sorensen, *Decision-Making in the White House*, reprinted by permission of Columbia University Press.

Chapter 4, p. 58 – epigraph: Copyright Alvah Simon 1998. Used by permission.

Chapter 4, p. 61: In the United Kingdom, quotation from *The Book of Unholy Mischief*, by Elle Newmark, published by Doubleday. Reprinted by permission of the Random House Group Ltd.

Chapter 4, p. 71 – Figure 4.3: 'Mouth-Feel Wheel' from R. Gawel, A. Oberholster, and I.L. Francil, *Australian Journal of Grape and Wine Research* 6, 3 (2000): 203–7. Reprinted here as 'The Wine Wheel' with permission of Wiley-Blackwell.

Chapter 6, pp. 125–30: Quotations from *Thunderstruck*, by Erik Larson, copyright © 2006 by Erik Larson. Used by permission of Crown Publishers, a division of Random House, Inc.

Chapter 6, p. 116 – poem: Reprinted with permission of James G. March.

Chapter 6, p. 117 – excerpt from James G. March, 'Wild Ideas': Reprinted with

permission from *Stanford Magazine*, published by Stanford Alumni Association, Stanford University.

Thank you to the following individuals who granted permission for their interview quotations and/or their photographs to appear in the text:

Angelo Cabani
Melanie Carr
Steve Dzerigian
Craig Keller
Claudia Kotchka
Steve Luczo
Gerry Mabin
Diana M. Smith
Sally Stallings
Eric R. Thomas
Joanne Weir

NOTES

Foreword

1 Eisner, *Cognition and Curriculum*, 49.
2 See chapter 2, under 'Qualities in Everyday Life.'
3 Ibid., under 'Quantitative Versus Qualitative Thinking.'
4 Ibid., under 'The Intelligence of an Artist.'
5 Schön, *Reflective Practitioner*, 16.
6 See chapter 2, under 'Elliot Eisner and the Case for Qualitative Intelligence.'
7 Scott Cook, from 'Re-Thinking Business.' Discussion, moderated by Roger Martin. Design Management Institute Conference (www.dmi.org). The Stanford Court, San Francisco, 17 June 2009.

Introduction: On Business, and Other Arts

1 Barnard, *The Functions of an Executive*, 235.

1. Yesterday's Horse

1 Schön, *Reflective Practitioner*, 68.

2. Presidents and Painters

1 Weiner, 'Robert S. McNamara,' *New York Times*.
2 Sorensen, *Decision-Making in the White House*, 7.
3 Ibid., 10.
4 Robinson, *Out of Our Minds*, 4.

5 Ibid., 8.
6 Eisner, 'Why Art in Education,' 64–9.
7 Ibid.
8 Schön, *Reflective Practitioner*, 16.
9 Cook, 'Re-Thinking Business.'

3. Angelo's Kitchen

1 Angelo Cabani, in discussion with the author, October 2008.

4. The Territory, the Map, and a Compass

1 Simon, *North to the Night*, 9.
2 Newmark, *The Book of Unholy Mischief*, 43.
3 Kembel, 'Awakening Creativity.'
4 Diana Deutsch; visit her website (http://deutsch.ucsd.edu/) to learn more about her research on perfect pitch.
5 Sortun, *Spice*, x.
6 Wallace, 'Federer as Religious Experience."
7 Dave Kalama, interviewed in *Riding Giants*, DVD.
8 Joanne Weir, in discussion with the author, April 2009.
9 Melanie Carr, in discussion with the author, June 2009.
10 Brother Thomas Bezanson, *Portrait of an Artist: Gifts from the Fire*, DVD.
11 March, *Passion and Discipline*, DVD.
12 Tom Boonen, interviewed on Versus Network's *Cyclism Sunday*, 20 April 2008.
13 Eisner, 'Why Art in Education,' 64–9.
14 March, *Passion and Discipline*, DVD.

5. In Its Best Light

1 Mintzberg, 'Crafting Strategy,' 66.
2 Sudnow, *Ways of the Hand*, 90.
3 Lucasfilm Ltd., *Star Wars Episode V: The Empire Strikes Back*.
4 Ibid.

6. An Uneasy Partnership

1 March, 'Wild Ideas,' 61–3.
2 March, 'Exploration and Exploitation,' 71.

3 March, 'Wild Ideas,' 61–3.
4 Sally Stallings, in discussion with the author, fall 2009.
5 Larson, *Thunderstruck*, 9.
6 Ibid., 10–11.
7 Ibid., 12.
8 Ibid., 15.
9 Ibid., 19.
10 Ibid., 23.
11 Ibid., 24.
12 Ibid., 24–5.
13 Ibid., 44.

7. Learning Artistry

1 Schön, *Reflective Practitioner*, 163.
2 Ecker, 'The Artistic Process,' 289.
3 Keller, *A Feeling for the Organism*, 179.
4 Ibid., 198.
5 Polanyi, 'Potential Theory of Adsorption,' 1013.
6 Dewey, *Art as Experience*, 44.
7 Gould, *Full House*, 229.
8 Schön, *Reflective Practitioner*, 147.
9 Gould, *Full House*, 57.
10 Diana McLain Smith, in discussion with the author.
11 For more, see Israel Scheffler, *In Praise of the Cognitive Emotions*.

8. Tensions, Traps, and Alternatives

1 Robinson, *The Element*, 6.
2 Peter Ames Carlin, interviewed on *Bob Edwards Weekend*; aired 25 January 2010.
3 Martin, *Opposable Mind*, 11.
4 Dewey, *Art as Experience*, 15.
5 March, *Ambiguities of Experience*, 103 (manuscript).
6 Dewey, *Art as Experience*, 44.
7 March, *Ambiguities of Experience*, 103 (manuscript).
8 Kuhn, *Structure of Scientific Revolutions*, 168.
9 Scheffler, *In Praise of the Cognitive Emotions*, 3.
10 Keller, *Feeling for the Organism*, 198.
11 Nachmanovitch, *Free Play*, 90.

12 Weingarten, 'Pearls before Breakfast.' You can watch the YouTube video 'Stop and Hear the Music' online at http://www.youtube.com/watch?v=hnOPu0_YWhw; accessed 3 April 2010.
13 Dewey, *Art as Experience*, 49.
14 March, *Primer on Decision Making*, 262–3.

9. The Seven Hallmarks of Artistry

1 March, 'Essential Things,' in *Late Harvest*, 41.
2 Miller, interviewed by Tom Brokaw.
3 NBC Olympics coverage, aired 24 February 2010.
4 Spielberg, *Inside the Actors Studio*.
5 March, *Ambiguities of Experience*, 107 (manuscript).
6 'The Ideas Economy: Innovation,' sponsored by the *Economist* magazine, Berkeley, CA, University of California campus, Haas School of Business, March 2010.

SOURCES

Barnard, Chester. *The Functions of the Executive.* Cambridge, MA: Harvard University Press, 1938; renewed 1968.

Bell, Joshua. See Gene Weingarten, 'Pearls before Breakfast.' Or watch the video 'Stop and Hear the Music' on YouTube: http://www.youtube.com/watch?v=hnOPu0_YWhw.

Bezanson, Brother Thomas. *Portrait of an Artist: Gifts from the Fire – The Ceramic Art of Brother Thomas.* VHS, 1992.

Boonen, Tom. Broadcast profile. *Cyclism Sunday.* Versus Network. Aired 20 April 2008.

Cabani, Angelo (restaurateur, Locanda Miranda; Tellaro, Italy). Interviewed by the author, October 2008.

Carlin, Peter Ames. *Paul McCartney: A Life.* New York: Touchstone, 2010. (For interview, see Edwards, 'Paul McCartney: A Life'.)

Carr, Melanie (psychiatrist, adjunct professor at Rotman School of Management). Interviewed by the author, June 2009.

Cook, Scott. 'Re-Thinking Business.' Discussion moderated by Roger Martin. Design Management Institute Conference. San Francisco, 17–18 June 2009.

Dewey, John. *Art as Experience.* New York: Perigree Books, 1934.

Dzerigian, Steve (fine-art photographer). Interviewed by the author, over several years.

Ecker, David W. 'The Artistic Process as Qualitative Problem Solving.' *Journal of Aesthetics and Art Criticism,* 21, 3 (Spring 1963): 283–90.

Edwards, Bob. 'Paul McCartney: A Life; An Interview of Peter Ames Carlin.' *Bob Edwards Weekend.* National Public Radio and Sirius/XM Satellite Radio. Aired 25 January 2010. Available online at www.bobedwardsradio.com/blog/2010/1/25/paul-mccartney-a-life.html; accessed 6 April 2010.

Eisner, Elliot W. *Cognition and Curriculum: A Basis for Deciding What to Teach.*

New York: Longman, 1982. Rev. ed. New York: Teachers College Press, 1994.

– *The Enlightened Eye: Qualitative Inquiry and the Enhancement of Educational Practice.* New York: Macmillan, 1991.

– 'Why Art in Education and Why Art Education.' In *Beyond Creating: The Place for Art in America's Schools: A Report.* Los Angeles: J. Paul Getty Center for Education in the Arts, April 1985.

Estefan, Emilio. 'Emilio Estefan Interview.' *The Rachael Ray Show.* New York: KWP Studios Inc. Aired 19 January 2010. Available online at www.rach-aelrayshow.com/show/segments/view/emilio-estefan/; accessed 5 April 2010.

– *The Rhythm of Success: How an Immigrant Produced His Own American Dream.* New York: Penguin, 2010.

Gould, Stephen Jay. *Full House: The Spread of Excellence.* New York: Harmony Books, 1996.

Kalama, Dave. Interviewed in *Riding Giants.* Directed by Stacy Peralta. Produced by Agi Orsi. Culver City, CA: Sony Pictures Classics, 2004.

Keller, Craig (portfolio manager, Litman/Gregory). Interviewed by the author, July 2009.

Keller, Evelyn Fox. *A Feeling for the Organism: The Life and Work of Barbara McClintock.* New York: W.H. Freeman, 1983.

Kembel, George (executive director, Hasso Plattner Institute at Stanford). 'Awakening Creativity.' Lecture. Chautauqua, NY: Chautauqua Institution, 14 August 2009. Video available online at http://vodpod.com/watch/2055665-george-kembel-awakening-creativity-fora-tv; accessed 31 March 2010.

Kotchka, Claudia (vice-president for Design, Innovation, and Strategy at Procter & Gamble). Interviewed by the author, June 2009.

Kuhn, Thomas. *The Structure of Scientific Revolutions.* Chicago: University of Chicago Press, 1962.

Larson, Erik. *Thunderstruck.* New York: Crown Publishers/Random House, 2006.

Luczo, Steve (CEO, Seagate Technology). Interviewed by the author, July 2009.

Mabin, Gerry (founder, the Mabin School). Interviewed by the author, June 2009.

March, James G. *The Ambiguities of Experience.* Ithaca, NY: Cornell University Press, 2010.

– 'Exploration and Exploitation in Organizational Learning.' *Organization Science,* 2, 1 (February 1991): 71–87.

– *Late Harvest.* Palo Alto, CA: Bonde Press, 2000.

– *Passion and Discipline: Don Quixote's Lessons for Leadership*. DVD. Directed and produced by Steven C. Schechter. Schechter Films, in association with Stanford Graduate School of Business, 2003.

– *A Primer on Decision Making: How Decisions Happen*. New York: The Free Press, 1994.

– 'Wild Ideas: The Catechism of Heresy.' *Stanford Magazine* (Spring 1988): 61–3.

Martin, Roger L. *The Opposable Mind: How Successful Leaders Win through Integrative Thinking*. Cambridge, MA: Harvard Business Press, 2007.

Miller, Bode. Interviewed by Tom Brokaw, NBC. Aired 20 February 2010.

Mintzberg, Henry. 'Crafting Strategy.' *Harvard Business Review* (September–October 1987): 66–75.

Nachmanovitch, Stephen. *Free Play: Improvisation in Life and Art*. New York: Jeremy P. Tarcher/Putnam, 1990.

Newmark, Elle. *The Book of Unholy Mischief*. New York: Atria Books, 2007.

Nicolaides, Kimon. *The Natural Way to Draw: A Working Plan for Art Study*. Boston: Houghton Mifflin, 1941; 1969.

Polanyi, Michael. 'The Potential Theory of Adsorption: Authority in Science Has Its Uses and Its Dangers.' *Science*, 141 (1963): 1013.

Robinson, Ken. *Out of Our Minds: Learning to Be Creative*. Chichester, UK: Capstone, 2001.

Robinson, Ken, with Lou Aronica. *The Element: How Finding Your Passion Changes Everything*. New York: Viking, 2009.

Scheffler, Israel. *In Praise of the Cognitive Emotions. And Other Essays in the Philosophy of Education*. New York: Routledge, 1991.

Schön, Donald A. *The Reflective Practitioner*. New York: Basic Books, 1983.

Simon, Alvah. *North to the Night: A Year in the Arctic Ice*. New York: Broadway Books, 1999.

Smith, Diana McLain. *Divide or Conquer: How Great Teams Turn Conflict into Strength*. New York: Portfolio/Penguin Group, 2008.

Sorensen, Theodore. *Decision-Making in the White House*. New York: Columbia University Press, 1963; 2005.

Sortun, Ana. *Spice: Flavors of the Eastern Mediterranean*. New York: ReganBooks, 2006.

Spielberg, Steven. Interviewed by James Lipton. *Inside the Actors Studio*, Bravo network. Aired 14 March 1999.

Stallings, Sally (painter). Interviewed by the author, fall 2009.

Sudnow, David. *Ways of the Hand: The Organization of Improvised Conduct*. Cambridge, MA: The MIT Press, 1993.

Waitzkin, Josh. *The Art of Learning: A Journey in the Pursuit of Excellence*. New York: Free Press, 2007.

Wallace, David Foster. 'Federer as Religious Experience.' *New York Times Play Magazine*, 20 August 2006. Available online at http://www.nytimes.com/2006/08/20/sports/playmagazine/20federer.html?_r=1; accessed 1 March 2010.

Weiner, Tim. 'Robert S. McNamara, Architect of a Futile War, Dies at 93.' *New York Times*, 6 July 2009. Available online at http://www.nytimes.com/2009/07/07/us/07mcnamara.html?_r=1. Accessed 8 June 2010.

Weingarten, Gene. 'Pearls before Breakfast.' *Washington Post*, 8 April 2007. Available online at http://www.washingtonpost.com/wp-dyn/content/article/2007/04/04/AR2007040401721.html; accessed 29 March 2010.

Weir, Joanne. Interviewed by the author, April 2009.

INDEX

Abrahamson, Alan, 176
acting (component of Conceptual
 Knowledge), 75, 76
ambiguities of experience, 9, 158;
 James G. March on, 162–3, 178
artistry: artistic approach to busi-
 ness, 3–11, 18, 180–1; artists'
 stereotypical view of executives,
 4; barriers to artistic involvement,
 4–5, 28; critical questions about,
 19; difficulties of speaking about,
 5–6, 20, 87–91, 93, 97, 103, 106 (see
 also learning artistry: difficulties
 of transferring and achieving);
 elusiveness as a concept, 18–19; as
 emergent, 6, 21–2, 30, 42, 46, 87–8,
 89, 113, 123–5, 144, 152, 176–7;
 executives' stereotypical view
 of artists, 4; four characteristics
 of, 8, 20–2; and the qualitative
 approach, 6, 11, 15, 27, 29–35, 37,
 39, 76, 84–6, 96, 102, 132–4, 166,
 173, 176–8; recipes for (limitations
 of), 6, 14, 15, 50, 63–5, 75, 159; role
 of practice time in the cultivation
 of, 21, 56, 63–4, 65, 87–8, 121, 137;
 seven hallmarks of, 9, 174–80 (see

also hallmarks of artistic practice
 for individual hallmarks); under-
 stood in context of the medium or
 discipline in which it is pursued,
 7, 91, 133–4, 159 (*see also* feel;
 unity). *See also* involvement;
 learning artistry; learning loops;
 Knowledge System model
awareness (component of Experien-
 tial Knowledge), 46, 59–65, 95, 97,
 99, 178–9

Barnard, Chester: on executive func-
 tions, 3, 4, 5, 180
beginner status, 9, 158, 170–3
Bell, Joshua, 167
Bezanson, Brother Thomas, 80–1, 164
Black Swan (painting), 34 fig. 2.1;
 artistic judgments of painter, 8,
 29–35, 84, 85; *color section* plate 1
Book of Unholy Mischief, The, 60–1
Boonen, Tom, 82
Brokaw, Tom, 174

Cabani, Angelo (Michelin-starred
 chef), 8, 43–57, 75, 135, 136, 139,
 164, 176; on learning from the pan,